Pulses of Abstraction

PULSES OF ABSTRACTION

EPISODES FROM A HISTORY OF ANIMATION

Andrew R. Johnston

University of Minnesota Press
Minneapolis
London

The University of Minnesota Press gratefully acknowledges the financial assistance provided for the publication of this book by the Dean of Faculty and Department of English at Amherst College.

Published by the University of Minnesota Press
111 Third Avenue South, Suite 290
Minneapolis, MN 55401-2520
http://www.upress.umn.edu

Printed in the United States of America on acid-free paper

The University of Minnesota is an equal-opportunity educator and employer.

28 27 26 25 24 23 22 21 20 10 9 8 7 6 5 4 3 2 1

Library of Congress Cataloging-in-Publication Data
Names: Johnston, Andrew R., author.
Title: Pulses of abstraction : episodes from a history of animation / Andrew R. Johnston.
Description: Minneapolis : University of Minnesota Press, [2020] | Includes bibliographical references and index.
Identifiers: LCCN 2020020387 (print) | ISBN 978-0-8166-8523-3 (hc) | ISBN 978-0-8166-8529-5 (pb)
Subjects: LCSH: Animated films—Philosophy. | Animation (Cinematography)—Philosophy.
Classification: LCC NC1765 .J63 2020 (print) | DDC 791.43/34—dc23
LC record available at https://lccn.loc.gov/2020020387

For Sarah, Nina, and Flora

CONTENTS

INTRODUCTION

TECHNICAL ABSTRACTIONS

> *Mechanisms cope with the contradictions of humans.*
>
> Bruno Latour, *Aramis,*
> *or the Love of Technology*

ANIMATION MOVES. WHETHER IT IS FOUND IN LINE DRAWINGS, SILHOUETTE cutouts, claymation, digital vectors, or a number of other techniques, its aesthetic operations are rooted in a projected movement. But it is not limited to this register. Animation's history moves as well, changing with the technological context and moment used to define the term and its origins. Some claim its beginning can be found in the mid-nineteenth century with devices such as the thaumatrope or the praxinoscope, while others associate its start with the first film to be fully drawn, or nearly so, like James Stuart Blackton's *Humorous Phases of Funny Faces* (1906) or Émile Cohl's *Fantasmagorie* (1908). And of course, some argue that cinema is animation and that the terms are mutually constitutive. None of these articulations, and at times lines in the sand, are incorrect. But they have led to struggles with the term and searches for how to use it, often resulting in etymological lessons of animation's Latin roots and the association of anima with a technologically motivated breath of life. Though this counters limitations wrought by pairing animation with a popular genre, it also requires continual restatement to clarify the term's generic or technological usage. Depending on the context, even the definition moves.

Each of these movements and arguments will be explored in more detail. But sometimes lost in the shuffle over defining animation and its territories is the wonder that it generates, an enchantment with its technological abstractions and syntheses rendered in time. As Alan Cholodenko

emphasizes, the apparatus through which such motion is generated maintains a certain kind of magic, what he characterizes as "a fascination with the way in which an apparatus animates."[1] Even when its technical relations are fully explained, its actions, modulations, and effects are charged with senses of astonishment, generating questions of aesthetic genesis and action across its history of use. This is the point that animator Pierre Hébert makes when self-reflexively asking "what do I really do when I animate?" Like scholars and critics, Hébert struggles with what animation is, working through his thoughts about it in his own artistic practice. And like others, he argues that animation is intertwined with cinema's invention in the late nineteenth century out of a cultural and technological mix of photography and optical toys. But he emphasizes that this common point of origin takes on a different significance for various practices and communities of filmmaking. While the mechanical synthesis of photographic action in cinema stabilized into an almost taken-for-granted black box over its history of use, a similarly secure technical foundation did not emerge for animation. In fact, Hébert explains:

> On the contrary, animation is constantly reopening the technical black box. Some of its key elements, such as the very idea of reconstructing motion frame by frame, are contained in that black box. So every time an animator animates, he is potentially reactivating the memory of the moment in which the elements of cinema got together to form the tightly-knotted entity that is live-action cinema. Animation is based on a dissociative, disjunctive action inflicted upon the very structure of cinema. Animation sends cinema back to the moment just prior to cinema's very existence.[2]

In this formulation, animation and cinema are not clearly separated, nor is one a subset of the other. Instead, they depend on one another through their mechanisms of articulated action and historical modulations, an operation of perpetual re-creation and redefinition best understood not through a center-and-periphery model, but instead through one more recursive, such as an ouroboros. The technological and aesthetic experiments found in animation are not limited to itself; they wind their way through cinema in a variety of contexts at different historical moments. This sometimes

generates perceived crises in the terms themselves, to the point that some contemporary critics question whether cinema is a special case of animation or whether cinema is being subsumed by forms of digital animation.

In many ways such concerns take too much for granted to begin with, thinking that either animation or cinema, or even digital technology, has a stable historical and ontological makeup. Instead, Hébert's articulation of the return reveals the multiplicity and braided histories of these forms, highlighting the role of technics in each. If animators and animation continually follow this vector by questioning the technical means through which movement can be abstracted and synthesized, then the black box that Hébert describes is not stable, but instead changes with the media landscape from which those animators are working at the time. It morphs to include celluloid, Technicolor, oscilloscopes, color organs, scratching, optical printing, raster graphics, and Flash animation programs. Animation does not generate an eternal return of the same form. Instead, it moves with different media ecologies and indexes technological and epistemic changes through its experiments.

Situating animation in this way embraces it as a relational form rather than a static construct that can be pinned down. Through a variety of technical and material instantiations, animation's images pulse through its fusion of static compositions that, without projection, would be discontinuous in their juxtaposition. But its history functions in a similar fashion, pulsing in fits and starts with the creation, distribution, and experimentation of new technologies, thus requiring a simultaneous engagement with these forms, which in turn fold themselves into cinema's shifting braid of media. This relational network is in a constant state of redefinition and is bound to forms of knowledge production as well as material experimentation. *Pulses of Abstraction* explores this model of animation as an epistemic practice, focusing on how the trajectory of animation's continual return to the technical exploration of movement is always modulated by the media ecologies from which the inquiries begin. This book will focus on a period of rapid technological development from the 1950s to the 1970s, taking up key moments of experimentation from this time to show that they can offer the material out of which this more inclusive, flexible, and dynamic account of both animation and cinema can be built. Importantly, this is

not an inclusive study that catalogs a type or subgenre of animation, but instead deeply interrogates select films or works as especially privileged sites for the investigation of technology, form, and aesthetic experience in this historical framework. Animation accrues its identity and cultural power through embedded social and technical actions, leading this study of it to focus on the ways in which such actions manifest through one of its many moving histories.

THE TIME OF MOVEMENT

One of the key technologies that Hébert describes in the opened black box of animation is frame-by-frame movement, an aesthetic and mechanical action familiar to seasoned animators, since they are always thinking through the technological development of movement in time. Norman McLaren makes this factor well-known in his definition of animation as "the art of manipulating the invisible interstices that lie between frames."[3] McLaren emphasizes the connections of intervals that lie between frames of film with perceptual syntheses enabled through technologies of projection, placing the viewer's body at the center of his formulation. Others have followed suit. As many theorists like Cholodenko, Keith Broadfoot, Rex Butler, Suzanne Buchan, Tom Gunning, and Thomas Lamarre have pointed out, animation is a relation between our own perceptual operations and the technology of cinema, an intertwining that encompasses all cinematic experience, but that animation exposes or pronounces more fully.[4] This type of claim links animation's illusions to knowledge about the materials behind their production, charging animation's realm of metamorphosis with a technological sophistication.

That this phenomenological intertwining is bound up with mechanisms of time is precisely the point of McLaren and the other authors listed above. But this assertion is also grounded in nineteenth-century epistemological shifts in which, as scholars like Jonathan Crary note, sensory perception was recognized as operating in duration and without "any necessary link with an external referent."[5] In the wake of such changes, or perhaps helping to spark their genesis, a proliferation of optical toys emerged that synthesized motion across discrete units of the image to create a per-

ceptual illusion, or as the phenakistoscope makes clear in its appellation, deception. As stated above, the relationship between these technologies and the idea of animation has received a lot of critical attention, especially after Lev Manovich's pronouncement that digital filmmaking and animation recall this moment of technological and perceptual play: "The history of the moving image thus makes a full circle. *Born from animation, cinema pushed animation to its periphery, only in the end to become one particular case of animation.*"[6] This argument about the primacy of nonphotographic over photographic technologies in the history of moving images has been scrutinized in various ways, with scholars like Kristin Thompson and Donald Crafton pointing out that the distinction now held between animation and other types of film did not exist for the first couple decades of cinema.[7] Crafton moves through a semantic history of the verb "animated" from the late nineteenth century relative to the later adoption of "animation" as a generic category, showing how Frederick Talbot, in his 1912 book *Moving Pictures: How They Are Made and Worked,* describes live-action films as "animated photography" to connote film's lack of realistic movement and projection, what would have been a true "animation" of nature. Tacking along a different course, Gunning challenges Manovich's claim by showing how animation devices from the mid- and late-nineteenth century share with contemporaneous photography an exploration of the limits of human perception and mechanical instantaneity. Just as devices with revolving shutters synthesized images in motion to create continuity from discontinuity, so too did instantaneous photography "fix the image of an instant," thereby also participating in a process "to manipulate the temporal aspect of vision and create new temporal regimes of imagery through the manufacture of the instant."[8] In this way, animation and instantaneous photography are not opposed to one another, but simply operate in a dialectical synthesis and abstraction of time at a cultural moment when, as Jimena Canales notes, a new understanding of temporality was revealed through technologies of mechanical precision. This augmented sense of time and its relation to vision dominated the moment and revealed a temporality understood or experienced by mechanisms that could capture, or trace, experience below the threshold of human perceptual limits, below one-tenth of a second.[9]

This focus on epistemologies of temporal experience breaks the historiographic circularity that Manovich and others have associated with the popularization of digital animation. But it also clarifies the extent to which animation is entwined with the mutually constituting histories of technology and sensory experience. If animation develops from a new regime of time bound up in mechanical precision and the capturing of the instant, then as technologies and cultural understandings of temporal presence change, animation surely does so along with them. Just as Gunning's well-known articulation about the cinema of attractions emphasizes not only the historical context of early cinema's focus on the presentation of illusory and spectacular views but also the avant-garde's continual return to this cultural and aesthetic moment as "an unexhausted resource—a Coney Island of the avant-garde," so too does animation mine this technological assemblage while tinkering with its gears and new parts.[10] With the rise of computational technologies and the Information Age after World War II, just partway through Manovich's historical markers but after the nineteenth-century "time of the machine" that Canales, Crary, and Gunning, among others, demarcate, commentators in North America and Europe began to articulate how technologies and perceptions of time were changing. This occurred with such regularity and frequency that, by 1968, the Museum of Modern Art acknowledged the shift through its acclaimed exhibit *The Machine as Seen at the End of the Mechanical Age.*

At this moment of transition between cultural understandings of different types of mechanisms—one whose operational aesthetic was visible, and the other whose electronic machinations exist below the threshold of human sensory experience—many artworks and cultural products indexed how people wrestled with these changes through different conceptions of time. Pamela Lee's study of artists like Bridget Riley, Jean Tinguely, and Andy Warhol, among others from the 1960s, describes this cultural anxiety during that decade as chronopobia, "an almost obsessional uneasiness with time and its measure."[11] The simultaneous displacement of one understanding of technology and rise of informational data processing through mainframe computational technologies created a cultural vertigo through what was seen as an abrupt shift. This is what Alvin Toffler identifies as the key problem with this moment in his best-selling 1970 book *Future Shock,*

where he coins the eponymous expression in the title to argue that society had witnessed too much technological change too quickly in the past decade, resulting in a psychological condition of stress and disorientation due to "information overload."[12] In 1972 Alex Grasshoff produced a documentary based on the book with Orson Welles as the narrator. As Welles explains, the sickness of future shock comes from "the premature arrival of the future. For those who are unprepared, its effects . . . can be pretty devastating." Senses of untimely change that information and computational technologies bring with them has not waned, with Crary recently arguing that contemporary culture can best be characterized through an impossible temporality of 24/7: "A time without time, a time extracted from any material or identifiable demarcations, a time without sequence or recurrence."[13] He claims that this shared temporality that assaults the senses and rhythms of life comes into being because, "for the vast majority of people, our perceptual and cognitive relationship to communication and information technology will continue to be estranged and disempowered because of the velocity at which new products emerge and at which arbitrary reconfigurations of entire systems take place."[14] Speed, velocity, and an explosion of information that circulates through transistors and computational processing are the same causes of the social homogenization and disaffection that Toffler describes.

The cultural perception that the era was shaped by new technologies demarcating time through logics of simultaneity and information feedback, rather than through mechanisms that arranged temporal units, became more fully established over the course of the 1950s through the 1970s.[15] Scholars like Ben Kafka and Lisa Gitelman have traced how print and document technologies since the nineteenth century have changed forms of knowledge and the circulation of information, with the 1960s inaugurating a massive proliferation of documents through the development of xerography and word processing.[16] This change is put on dramatic display in 1967 by animator Jim Henson in his advertisement for IBM called *The Paperwork Explosion*, promoting their new Magnetic Tape Selectric Typewriter (MT/ST), a word processing technology, by first presenting a fast-paced teleological narrative of technological progress that results in chaos, a literalized explosion of information and material. Later, the commercial

speaks to crises of confidence in the ability of individuals to manage the perceptual and economic demands brought on by the contemporary media and technological landscape. Henson's ad portrays a fear of diminishing resources and perceptual capacities, especially in regard to an erosion of time explained by a montage of talking heads in a repeated, punctuated rhythm: "In the past, there always seemed to be enough time and people to do the paperwork, . . . but today there isn't." Kafka reads Henson's film as belying the techno-utopianism that IBM was promoting to solve the cultural shift through changes in emphasis articulated in the voice-over at the end of the film, "from '*machines* should *work, people* should *think*' to 'machines *should* work, people *should* think.'"[17] Regardless of the ability of the MT/ST to manage the changes, the film speaks to the cultural anxieties related to time and information and the shifts computational technologies have induced in the experience of time. Lee shows how this became a later focus for Norbert Wiener, one of the founders of cybernetic theory, since "self-regulating systems internalized a notion of time far removed from its commonplace understanding as lived experience or 'clock time.'" Moreover, Wiener marks the importance of shifts in experiences of temporality in his 1948 book *Cybernetics: Or Control and Communication in the Animal and the Machine,* in which a first chapter entitled "Newtonian and Bergsonian Time" explains each version of time through cinematic metaphors.[18]

That said, animation from this period did not simply draw its inspiration or technical processes from the new temporal registers of simultaneity and feedback. In the midst of technological changes during this time, animation witnessed a heightened investigation of materiality more generally, including new computational media, layers of celluloid in filmstrips, mechanisms of color projection, and the interval between frames of film. Often lost in analyses of shifts from this moment is that, while the new computational technologies in the 1960s had the ability to manage forms of information according to the new logics of time that they helped introduce, they had difficulty visualizing them. Even digital animations were created through hybrid processes of photography and computation, an activity that helps show how the development of computer-generated imagery (CGI) did not happen in isolation, but in relation to the moving image context from which it emerged. As in other historical moments, registrations of change

were not immediate or born through ruptures, but instead often operated in conflict, tandem, or hybridity. For animation in the mid-twentieth century, articulations of temporal synthesis coexisted through two models: one indebted to the optical registration of the instant, the other to the algorithmic calculations of information processing. Straddling two registers of temporal experience, this period took on a Janus face as artists, engineers, and programmers made sense of the various media technologies and aesthetic practices that were defining the contemporary landscape.

TECHNICALLY, A GENRE

This landscape's contours were often explored through aesthetics of abstraction. When experimenting with materiality, animators frequently elided figuration to consider the means through which graphic registrations, movements, and syntheses could manifest in different technological contexts. And these films many times centered on one form of abstraction, working through the aesthetic force of color, line, or intervals of time through an experimental technique or technology. But, for critics and historians, this body of work has often escaped analysis and classification because of the ways in which it cuts across genre boundaries and canons of the avant-garde and animation, resulting in tensions both within discourses about animation and within filmmaking communities, a feeling articulated by experimental filmmaker Lewis Klahr:

> What's at stake here is how wide one wants to throw the net of definition around animation. Are all films created frame by frame animation? Maybe. But are all films created frame by frame considered animation? Within the experimental film tradition, pixillated, time lapse, and optically printed films are all constructed frame by frame and are not considered animations or normally included in animation history.[19]

The neglect Klahr references is created through an emphasis on certain techniques to determine the nature both of animation and of avant-garde film, with their intersection containing discursive gaps in historic and stylistic analyses like the ones Klahr falls into. And as stated above, such aporias extend into film theory more generally concerning attempts to

ontologically define the nature of cinema through a limited technological lens.[20] Scholars have been scrutinizing this marginalization, especially in the wake of studies that interrogate digital media, special effects, and experimental film practices.

But, for animation, such examinations often circuitously wind back to the question of specificity and the scope that Klahr wonders about. Gunning's recent definitions of animation are a good example of this operation. Attempting to reconcile debates about cinema's relationship to animation by focusing on how each manipulates time, he widens Klahr's net to claim both as animation, with subtle shifts in emphasis:

> It might be useful to bisect our term animation into two related but separable meanings. The first I call animation[1]; it refers to the technical production of motion from the rapid succession of discontinuous frames, shared by all cinematic moving images. I define animation[2] more narrowly, referring to the genre of animation as commonly understood: moving images that have been artificially made to move, rather than movement automatically captured through continuous-motion picture photography.[21]

Gunning's argument is compelling, but his distinction between types of animation is still reliant on a stable understanding of techniques and technologies for each practice and can be limited to technological assemblages involving celluloid or film frames. Though Gunning is attendant to the history of special effects and CGI hybrids in other contexts, it is not clear how such works fit into the definitions articulated above, since these digital images defy the common boundaries of animation that he invokes.[22] In part, this is because of the scope of history in his definition, which focuses on the wonder animation produces through an articulation of single frames of film or optical devices as they generate syntheses of motion, a temporality born of singular instants.

Perhaps, instead of clearly defining animation as containing a particular technical assemblage, we should embrace its protean nature and describe the logics that govern its moving meanings. Doing so maintains the constitutive wonder of animation's action relative to its mechanical operations but recognizes how each of these can change depending on the

social and technological field in which they exist. If, as Crafton shows, there are shifts in how both "animate" and "animation" are deployed across the late nineteenth and early twentieth centuries, revealing a diversity of traditions for moving image technologies from the time, then such attention to the historic and technical particularities are necessary for later periods as well.[23] This emphasizes not just the relation of moving images to an embodied observer, but the field of social and technical action to which this dynamic belongs in history.

Carolyn Miller defines this as a genre. Within rhetorical theory, her well-known essay "Genre as Social Action" reconceptualizes the term to dissociate it from semantic form or substance and instead shows how it emerges through social actions in recurrent situations. Framing the production of meaning as a social action, she emphasizes that genres come into being through conventions of practice: "The understanding of rhetorical genre that I am advocating is based in rhetorical practice, in the conventions of discourse that a society establishes as ways of 'acting together.' It does not lend itself to taxonomy, for genres change, evolve, and decay; the number of genres current in any society is indeterminate and depends upon the complexity and diversity of the society."[24] Through recurrent moments where meaning is motivated by social exigencies, or "a set of particular social patterns and expectations that provides a socially objectified motive for addressing," genres come into being through typified actions within that field.[25] Thus, they are dependent upon the historical, social, and material instantiations of such actions and index cultural patterns, both within communities and more broadly. This is because the actions employed by individuals within the context of recurrent situations can change, once again emphasizing the cultural embeddedness and dynamism of any genre over time.

Rather than locating a specific technique or apparatus that defines animation, even if there is a common understanding of it at one time, I am suggesting that we view it as a technical genre through the lens Miller provides. This frames animation through the forms of action it makes within a specific cultural field. Miller's rhetorical definition of genre moves away from fixed aesthetic categories and works structurally to help identify and understand strategies of address within a discursive terrain. Rhetoricians

have used this model in a variety of ways to study media and how practices of expression and reception intersect with technologies to create historically inflected genres, such as eulogies, memes, e-mail correspondence, and blogs. And others in media studies have also been influenced by this approach, such as Gitelman, whose history of documents uses this formulation of genre to trace their actions across historic and material changes.[26] In a similar manner, through this optics, animation exists as an epistemic practice whose actions index changing perceptions of moving image technologies.

This practice or action is not directed just toward a social field but a technical one as well. Miller argues that a key aspect within her model is the recurrence of rhetorical situations that enable the deployment or emergence of a genre. These situations must be identified, since, "before we can act, we must interpret the indeterminate material environment; we define, or 'determine,' a situation."[27] For media scholars, this latter formulation contrasts with Friedrich Kittler's well-known, though later-written, postulation that "media determine our situation."[28] Though they occur in different contexts, the contrast between the two claims to agency is very clear: Miller emphasizes the means through which humans employ rhetorical genres in modes of making meaning and of persuasion, while Kittler stresses the ways in which social and cultural choices are bound by the technologies that enable action and structure knowledge production within a given episteme. Miller later clarifies her position in her essay "What Can Automation Tell Us about Agency?" to explain that agency operates as a *"kinetic energy* of rhetorical performance" that requires "two entities who will attribute agency to each other."[29] While not discounting the role or agency of nonhumans in such situations, she claims that humans often hesitate to grant agency to nonhuman actors in the construction of persuasive discourse. Others like Thomas Rickert emphasize the role of things in the development of a rhetorical event to trace the "collectivity of interacting elements, energies, and forces, human and nonhuman" that make up action within this context.[30]

For animation, the constitutive roles of human and nonhuman technical actors is key, since, as Crafton shows, animation's contours as a genre can change within a discourse while the mechanisms remain the same.

If the context of animation changes over time, with animators working to generate an aesthetic and discursive action through the black box of movement's synthesis, then this act also happens within a technical register. Animation appears to us through manipulations of sensory thresholds. And this technical synthesis requires not only an embodied viewer, but often a number of mechanisms working together to generate projections and movements not normally available to the eye, a view that Walter Benjamin calls the optical unconscious and that Joel Snyder describes as a nonhuman vision.[31] As pointed out above, though these mechanisms are visible for some technologies, and even marveled at through what Neil Harris calls an operational aesthetic, others are not and exist below the threshold of sensory experience.[32] Vector, Flash, Source engine, and many other animations exist as configurations that are reliant on several domains of technical action working through the black box of animated movement, though these actions are often directed toward nonhuman entities. This is an alien domain whose landscape and relation to humans have generated substantial debate about questions of agency, phenomenology, and epistemology, among other topics.

But questions of primacy or correlationism, of reliance on a theoretical or explanatory construct that investigates the ontological nature of things or their phenomenological field (sometimes called speculative realism, object-oriented ontology), or alien phenomenology, can often move away from the interrelations of aesthetics and epistemologies in questions swirling around animation. In part, this is because of the philosophical inquiry into the nature of experience and being that drives much of the discussion, a polemical flattening of anthropocentric views that places things at the center of analysis. This has yielded productive and influential theoretical moves, and I believe a focus on nonhuman agents within a study of animation is important. But it must come through a methodological orientation that works through the relations between various actors within a social and technological field. Even when animation directs its actions toward nonhuman objects, humans are not removed from this operational terrain, even if unaware of its machinations. Humans and nonhumans are suffused or intertwined in each other's activities, even when seemingly separate from a distance.

This is the point of Bruno Latour's playful statement in the epigraph to this introduction, where mechanisms often work, and cope, outside of the immediate purview or reasoning of humans, but are never divorced from them. Even when mechanisms take on a seemingly alien independence, there are relations through histories of creation, maintenance, management, or even delegation that Latour, John Law, and others emphasize in actor-network theory. In *The Paperwork Explosion,* with its defensive *"machines* should *work, people* should *think,"* a network of human and nonhuman agents still operate together to generate forms of knowledge and economic productivity. Importantly, and as is often restated, actor-network theory is less a theory than an approach or method that aims to trace connections across hybrids of human and nonhuman actors in social and material constellations.[33] As Latour explains, it "is simply to extend the list and modify the shapes and figures of those assembled as participants and to design a way to make them act as a durable whole."[34] This heterogeneity within the construction of social and technical fields emphasizes the malleability of their constitution through shifting networks of development, or the rise and fall of actors as well as events within the framework. Actor-network theory embraces this dynamism, since, as Law details, "the most interesting places lie on the boundaries between order and disorder, or where different orders rub up against one another."[35] While Ian Bogost and others criticize this focus on malleability for its lack of utility in ontological studies, since it stresses how "things remain in motion far more than they do at rest," what it does enable is a greater emphasis on the action such things generate within social and technical landscapes.[36] This is Jane Bennett's focus in her analysis of the "vital materialism" of things, which have a "positive, productive power of their own" that can operate in political, ethical, and aesthetic regimes.[37] Echoing Latour, she discusses how things can become *actants* and be granted an agency by others that "implies no special motivation of human individual actors, nor of humans in general," but, "by virtue of its particular location in an assemblage and the fortuity of being in the right place at the right time, makes the difference, makes things happen, becomes the decisive force catalyzing an event."[38] Whether a specific articulation of intentionality is granted to a thing by a human actor in this assemblage matters less than the question

Latour poses about agents: "Does it make a difference in the course of some other agent's action or not?"[39] If there is an impact through force or consideration, then that object has agency and is an actor. Such attentiveness eschews artificial distinctions between humans and things while emphasizing the relational construction of socialities, technologies, and forms of knowledge; actor-network theory explores the dynamics of agency to better understand social and material worlds while, as Latour emphasizes, calling into question hierarchies to "redistribute the whole assemblage from top to bottom and beginning to end."[40]

For Bennett, understandings of life or vitality should be centered around these questions of agency, with their parameters explored through inquiries into forms that "capture the pulsing, conative dimension of agency . . . [and] must be engaged in a system of pulses, in an assemblage that links them and forms circuits of intensities."[41] Animation's technical assemblages pulse in this fashion, changing with epistemological landscapes by acting both within and on them. The life of animation is not simply bound to its moving images, but also to its technical changes, which contain a vitality that produces actions. This is part of the point that Bernard Stiegler makes in defining technics as epiphylogenesis, "the pursuit of life by means other than life."[42] Technics here is a "process of exteriorization," or organization of nonhuman things outside the body that act in some manner, a process that, for Stiegler, defines humanity and never ends.

LINE OF PURSUIT

Studying the recurrent practices of assemblages acting together to situate animation's constitution as a technical genre requires engaging with the mechanical and aesthetic actions of its network. This means moving carefully through the machines that contribute to the actions of animation and understanding both the ways they are put together and how they operate independently. Wolfgang Ernst says that this is the project of media archaeology, an "epistemological reverse engineering, and an awareness of moments when media themselves, not exclusively human any more, become active 'archaeologists' of knowledge."[43] This is a media criticism that is not designed simply to provide technical details, but to show how technologies

map discursive terrains while structuring forms of knowledge production and subjectivities. Working within actor-network theory's framework described above, in which technologies are dynamic actors in epistemological formations, media archaeology emphasizes the historical situation for these actions. This does not leave social articulations within the network behind. Scholars such as Gitelman, Alison Griffiths, Erkki Huhtamo, and many others that could be grouped into this field triangulate social and technical actions in their work.[44]

That said, sometimes questions of aesthetics in such relations can get lost in the shuffle, since these are investigations of the functional operations of media forms in social fields. For animation, such actions are always aesthetic, whether directed at viewers or not. To showcase this quality, Lamarre locates a specificity of animation in his study of Japanese anime, arguing that doing so helps avoid "displacing the question of material specificity onto modernity" or allowing technical and aesthetic relations to be subsumed or explained by macrohistorical social flows and developments.[45] Instead, he stresses how material and perceptual syntheses of anime dialectically work with historical paradigms to generate a particular quality he defines as "the 'force' of the moving image (mechanical succession of images) prior to the apparatus, such as the movie camera or animation stand."[46] Placing animation in part of what Félix Guattari calls the abstract machine, which encompasses modes of social, economic, bodily, technical, and aesthetic operations that frame emergent structures of meaning and action, this force incorporates historical and social circumstances that give rise to specific apparatuses that make images move.[47] It enables sociohistorical articulations to press on animation's technical development, and the rise of technics to press back on cultural formations. This is why he argues that the anime machine thinks through technology, for through Guattari's theoretical lens, this machine includes more than the machinations of an apparatus. It produces a way of being and expressing in the world that becomes specific to a historical moment and cultural environment.

In many ways, the present book follows Lamarre's generative framing within a different context while working through the ways alternative assemblages think through animation's technics. I am also interested not just in how the machine or network of actors think through animation's

mechanisms, but in how those technical forms think as well. Here, Steven Shaviro's recuperative project of aesthetics within the framework of speculative realism bears significant fruit. Moving through speculative realism's discourse as well as close readings of Immanuel Kant's *Critique of Judgment* (1790), he explains that aesthetic feeling is part and parcel of the experiential relations and actions between all things and exists in "the realm of immanent, noncognitive contact."[48] Opening the framework of aesthetics beyond phenomenological analysis does not neglect sensual engagements with embodied perception, but rather allows the work between nonhuman actors within the creation of a technical genre to take on an aesthetic dimension in their interactions. Again, in order to understand the impact of animation, an examination of both the technological assemblage and the formal operations of its manifestations is required. These cannot be separated. Gilbert Simondon calls this a "transductive relation," where two forms are mutually constitutive, such as his "technological objects" and "technological ensembles," which include human engagements with them. Simondon describes how a sense of autonomy is projected onto technology, since it can appear to operate with its own volition and in its own time as it introduces a delay between cause and effect while the operations of the machine perform their work. But, like Latour, Simondon explains that technology is never divorced from human experience and interactions with it, suggesting that a history of technological forms cannot be separated from a history of embodied encounters with them.[49] Thus, the graphic manipulations of formal values such as line, shape, space, and color that abstract animators develop cannot be separated from neither their phenomenological impact nor the technology deployed to generate them. Each of these elements must be addressed in order to fully understand the force of these images and the history that they share.

Aesthetic questions surrounding abstract animation, when it is mentioned, often slip into art-historical narratives through their complicated association with the avant-garde. For example, in her 1966 appraisal of contemporary film, Annette Michelson describes what she sees as the political and formal aspirations of avant-garde filmmakers at the time and traces the precedents from which these artists were working to the 1920s and 1930s. Unlike those in that that earlier era, Michelson argues, filmmakers

of the 1950s and 1960s suffered from a conceptual dissociation of formalism and politics, resulting in works that either were invested in elaborating discursive analyses of ideological structures or produced a formal radicalism that explored and manipulated the materials of the medium.[50] Others such as Peter Wollen noted a similar divide, and this bolstered taxonomy of avant-garde film eventually found its way into a subsequent generation of film criticism and scholarship.[51] Within this dichotomy, only the former of the two channels has received sustained attention, in part because its own reflexive political and representational strategies appeared to be allied with semiotic critiques in the vein of political modernism.[52] Additionally, the latter strain is seen as simply rearticulating ideas of formal abstraction found in the 1920s from artists such as Fernand Léger, László Moholy-Nagy, and Theo van Doesburg, thus marking them as aesthetically redundant.

I believe that such a polemical distinction between these two types of avant-garde filmmaking is misleading, one pointing to an antiformalism and the other to a supposedly shuttered embrace and investigation into pure cinematic values. Approaching abstraction formally, I want to emphasize its situatedness in a context that is charged through with history and ideology, much in the way Sergei Eisenstein argues that "form is *always ideological.*"[53] Yves-Alain Bois uses Eisenstein's defense of formalism alongside Roland Barthes's discussion of how forms are always immersed within a historical flux to articulate an approach that he describes as "*materialist* formalism, for which the specificity of the object involves not just the general conditions of its medium, but also its means of production in the slightest detail."[54] This attention to not only the aesthetic articulations of a work but also the technologies of production negotiates abstract articulations about media and claims about its effects with descriptions of specific aesthetic forms. Bois provides Clement Greenberg as a counterexample to this type of formalism: "Although he speaks about the medium of any art as its principal horizon, he seldom discusses the actual stuff of any work of art. . . . Form became an a priori for Greenberg, an idea preexisting its actual 'projection,' its actual descent into the realm of matter."[55] Again, actual aesthetic objects often become lost in a discussion of mediums, materiality, and arguments surrounding their specificity. Balancing such attention requires an engagement with the aesthetic impact of a specific

artwork and how it operates within a medium or how it pushes beyond static conceptualizations of that medium. Twinned with an attention to technics, this approach that Bois lays out is one that *Pulses of Abstraction* employs. Emphasizing the material and technological history of aesthetic forms opens an awareness that media and materiality are hardly ever self-evident and that they include not only the stuff out of which an object is made but also both the social technologies that lie behind its formation and the embodied, phenomenological engagement with that thing. This produces what Johanna Drucker calls a "sustained dialectic" in the analysis of aesthetic materiality, a dialectic between contingent social ideologies and economic modes of production, on one side, and experiential, phenomenological encounters with actual forms, on the other.[56]

This dialectic has continually made itself apparent in abstract animation's history (and film history generally), with artists not only working through the phenomenological impact of the animated motion they produce but also coping with the economic and material constraints of accessing or maintaining film. For example, Léopold Survage in the 1910s could not develop the abstract films that he had storyboarded because of not being able to attain film stock, while the films that the brothers Arnaldo Ginna and Bruno Corra made in the same decade broke down because of the fragility of the stock used. Other artists in the 1920s and 1930s dramatically struggled to procure film equipment and exhibition venues for their work, a battle that continued but changed shape after World War II, especially in the United States.[57] But this materialist orientation also calls for a more nuanced analysis of the abstractions that are still extant and requires a reexamination of this aesthetic in the postwar films that, as described above, were thought to be repetitions of earlier ones and subsequently marked as aesthetically redundant. Abstraction does not operate as a singular distillation of figure or form. Instead, as Kirk Varnedoe points out in his 2003 A. W. Mellon lectures:

> Stressing abstract art's position within an evolving social system of knowledge directly belies the old notion that abstraction is what we call an Adamic language, a bedrock form of expression at a timeless point prior to the accretion of conventions. If anything, the development of

abstraction in the last fifty years suggests something more Alexandrian than Adamic, that is, a tradition of invention and interpretation that has become exceptionally refined and intricate, encompassing a mind-boggling range of drips, stains, blobs, blocks, bricks, and blank canvases. . . . Abstraction is a remarkable system of productive reductions and destructions that expands our potential for expression and communication.[58]

By neglecting the diversity of abstraction and the historical contingencies through which it is created, expression through abstract animation can become whittled down to a symbolic articulation, as if a particular meaning always resided within the work and could be uncovered through hermeneutic analysis. Instead, this book approaches these animations as sensual works and is attendant to their engagement with the diversity of expression Varnedoe describes. In the vein of Susan Sontag's argument in "Against Interpretation," *Pulses of Abstraction* seeks to work through the mutually imbricated roles of technics and aesthetics in the works I analyze and to "show *how it is what it is, even that it is what it is.*"[59]

SHAPE OF INQUIRY

In order to understand the epistemic practices of abstract animation, this book follows the ways in which a few artists began exploring specific mechanical and aesthetic actions in the midst of changing media landscapes due to the rise of information technologies. I argue that, while working through formal experiments, these filmmakers shaped understandings of moving images and technics more generally at the time. But again, this is not at all a fully comprehensive or catalogued history, nor is it a history of first experiments, first discoveries, or first technologies. Instead, one of the primary goals is to trace the mechanical and aesthetic actions that are most prevalent within abstract animation from the time. Focusing on particular practices, both formal and technical, within this historically bound constellation of animation facilitates an understanding of how these actions remain unfinished and relational. They help generate what Karin Knorr Cetina calls "objects of knowledge [that] appear to have the capacity

to unfold indefinitely . . . like open drawers filled with folders extending indefinitely," since their technical constitution is unfixed and in a perpetual state of redefinition.[60] Rather than being static across the history of moving images, animation's protean images match its nature, so that its constitutive assemblage morphs as knowledge practices, technologies, and media ecologies change or act differently in historical and cultural circumstances.

A second and interrelated goal is to provide both a critical vocabulary for abstract animation's formal structures and a conceptual understanding of its modes of expression. The films, machines, and artists discussed in *Pulses of Abstraction* do not stand alone. But I do argue that those examined provide paradigmatic or typified actions within the aesthetic and technical landscape of the time. Within that terrain, these responses are pulses of the discourse that constitute the genre. Accordingly, I have isolated these actions and organized each chapter around one specific element of art or moving image technology in order to fully explore its contours of articulation. This is not intended to be a complete history or to deny the importance and power of other works, but instead to investigate key lines of technical and aesthetic action within the fabric of this historical juncture. Abstract animation punctuates the history of animation and film generally, often not developing continuously, but rather with stops and starts as new media enter into the *dispositif* of the moving image. This book pulses alongside it, aware of its own gaps but reveling in the technical and aesthetic forms discovered.

The first chapter, "Line: Signatures of Motion," focuses on Len Lye's scratch animations from the late 1950s and through the 1960s, such as *Free Radicals* (1958, revised 1979) and *Particles in Space* (1960s, revised 1979). These films were created through a direct animation technique in which Lye scratched into the black leader of 16mm film using a needle. I place Lye's films in the context of questions surrounding abstraction in the mid-1950s and afterward, showing how he was engaging with similar aesthetic questions posed by abstract expressionism but developing different conclusions. After exploring theories of abstraction in relation to the line, I describe the stakes of using this form for Lye, both in his discussions of claims made about the nature of cinema and in those about the power of

abstraction. Because of the small scale in which Lye was working, minute gestures of his body created marks on the filmstrip so that the resulting movements of the line are registrations of his own kinesis. Lye describes this as an energy of movement that reorients senses of bodily action and generates an economy of affect through vectors of empathy, but one that is also oriented toward a technical realm. I argue that Lye's moving abstractions operate through a paradoxical reduction of form and explosion of vitality. When in motion, his lines' permutations take on an animism that no longer simply bares the afterlife of Lye's kinesis, or the action become visible, but become a source of their own vitality and transmission of movement in viewers.

Chapter 2, "Color: The Prometheans," examines Thomas Wilfred's lumia, an aesthetic that uses color and projection experiments built through a machine called a Clavilux that combined aspects from a number of moving image technologies, such as film projectors and color organs. Wilfred began producing this technology in the late 1910s and gained greater critical recognition in the 1950s through his exposure alongside artists such as Jackson Pollock at the Museum of Modern Art's *15 Americans* exhibition in 1952. Influenced by theories of color perception, as well as by aesthetic discourses from Romanticism, I show how Wilfred intended the kinetic dance of color in lumia to propel viewers into what he describes as infinite space, a concept associated with the fourth dimension and expanded or cosmic consciousness. I argue that Wilfred's innovative animation apparatus and abstractions are intended to provide a technologically mediated vision that transcends the world and provides mystical illuminations. The color intensities in Wilfred's aesthetic reveal how the body's relation to the world intertwines with the structure of sensation as articulated in both Romantic and scientific discourses. But its brilliance of color also holds a utopian potentiality to stretch sensation into new ecstatic realms.

In chapter 3, "Interval: Don't Blink," I work through Robert Breer's collage films and optical toys that he began producing in the 1950s and 1960s to explore the relationships among the illusion of animation, the technologies of projection, and the intervals between images in succession. Rather than working with spatial reorganizations of objects to generate new unities, his collages produce juxtapositions in time as noncontinuous images

flicker through barrages of formal plays and combinations at breakneck speeds. Previously a painter influenced by neoplasticism, Breer's practice was influenced by his relationship to neo-avant-garde movements in Paris and New York in the 1950s and 1960s, and I contextualize how these helped him develop his aesthetic use of the chance space or gap between forms and frames in his collages. Specifically, I argue that his formal manipulation of the interval between film frames allows viewers to inhabit new technical modes of time. Novel experiences of temporality open through the push and pull of transformations and contrasts he reveals out of a material assemblage that routinely conceals the gaps that make such ecstasies possible.

Chapter 4, "Projection: Algorithms of Light," investigates Mary Ellen Bute's abstract films from the 1950s and her use of a cathode ray tube oscilloscope at Bell Labs. Since the 1920s, Bute had been researching correspondences between aural and visual perceptual effects, and she began plotting their ratios of correlation with mathematicians beginning in the 1930s. I argue that Bute, like others, turned to oscilloscopes and similar technologies that could perform some of these operations and interface with the rise of cybernetics during the mid-twentieth century in order to model and abstract patterns of sensory information outside the body. Unlike others advocating for a synaesthesia born between perceptual registrations of an image or sound, Bute focused on distilling sense data into common signals that could be measured through hand-rendered calculations or visual technologies of translation and projection. Her technique and use of this technology are thus emblematic of how analog computing from this moment operated, and her filmmaking practice set precedents for the "expanded cinema" to follow, a term that she coined but whose historical contours often marginalize her.

The fifth chapter, "Code: Models of Time!" traces the development of real-time digital filmmaking and animation technologies in the 1960s and 1970s. John Whitney, for example, created a number of early digital films while an artist in residence at IBM from 1966 to 1969, but he and others like Charles Csuri, Lillian Schwartz, and Larry Cuba worked with photographic and a variety of other technologies besides digital computers to generate movement in their works. Through a close examination of the

materials, such as the hardware, programming languages, and projection systems used by each to construct their films and establish aesthetic effects that characterize the possibilities of these systems, like precisely patterned geometries that liquefy or move in harmonic relations, I show how this period of digital animation provides a window into the ways in which digital technology was interwoven into a larger technological landscape. At its beginnings, digital animation was braided with several other types of technologies, like photography and printed paper, and the development of animated time within this new media mix produced experiments in artwork, interdisciplinary laboratory spaces, and a sense of the ways in which these technological folds would be changing broader cultural mediations of time and knowledge formations.

My conclusion, "Re-animating the Past," examines the work of Klahr and the ways in which his aesthetic of re-animation puts into motion disparate materials from the 1950s through the 1970s in an effort to show the effects of that period on the present. Klahr's films are suffused with that past in a way that marks them as being from that era while showing their contemporary relevance through the lingering genre formulations and recognizable cultural dreams and nightmares that populate their landscapes. Casting viewers into a historical vertigo, Klahr also showcases the technologies that make such mediations possible, and I argue that his films similarly work through the history of animation explored in this book. Playing with abstraction and the techniques and media covered here, Klahr's films remind us of the contemporary power in the iconic images from the mid-twentieth century and the ways in which animation from that time indexes epistemic practices and changes in broader technological assemblages that we continue to grapple with.

1 LINE

SIGNATURES OF MOTION

> *Line, no matter how supple, light or uncertain,*
> *always implies a force, a direction. It is energon*
> *work, and it displays the traces of its pulsation and*
> *self-consumption. Line is action become visible.*
>
> Roland Barthes
> "Non Multa Sed Multum"

AFTER A DECADE-LONG HIATUS IN WHICH HE MOSTLY PRODUCED WAR-time documentaries and military training films, Len Lye once again in the 1950s began using the technique of direct animation that he had helped pioneer more than twenty years earlier. Previous films such as *Colour Box* (1935), *Colour Flight* (1938), and *Swinging the Lambeth Walk* (1939) had developed what Lye calls a "sensory-ballet" in which abstract forms and music are knit together with color to produce sensations of motion.[1] The point was to create a sensual experience of pleasure generated through colors whose abstract and direct appeal avoided narrative forms and the kinds of associations that Lye believed plagued realistic imagery. In the early 1940s, Lye stopped producing these films, in part because of the war and an increasing scarcity of financial supporters and in part because of his growing interest in politics and a desire to counter Nazi propaganda films.[2] However, when invited by his friend Alberto Cavalcanti to submit a film to the 1958 International Experimental Film Competition in Brussels, Lye produced a direct animation, but moved away from painting the bold colors he had done previously. Instead, he scratched into black 16mm film stock to produce lines, points, strokes, and zigzags that frenetically move across the screen and play not only with two-dimensional space but also with depth perspective, as some forms twist and rotate on the z axis. The

resulting film, *Free Radicals* (1958, revised 1979), is an ecstatic celebration of energy that elides any kind of figuration and instead embraces a profoundly chaotic abstraction.

Producing these direct animations was no simple task. Lye experimented with a variety of film stocks and application techniques for his color animations, finally deciding on lacquer paints that would not crack or peel off 35mm clear celluloid, while using brushes, combs, and stencils to create striations and other geometric patterns and adding spray paint for particular stencil designs. To ensure that these early abstractions moved to a particular rhythm, he worked with Jack Ellitt, a friend and occasional collaborator, who helped synchronize his films to music. For Lye, this was an early phase of production in these direct animations. After learning how to match the frames on a filmstrip with the lengths of musical phrases, he would then paint visual accents to correspond with those of the jazz or swing music he selected. The scratch films posed their own challenges. As he explains in his writings, because of the small scale in which Lye was making etchings into the 16mm films, he had to keep the needle very still while affecting its direction by moving other parts of his body so that the resulting movements of the line are registrations of his own kinesis. It is the energy and sensation associated with movement that he conveys through these films, generating formally innovative works that also open spectators to a new understanding of motion and how it is sensed by the body.

Such activity is achieved through a misleadingly simple form whose expressive power has been the subject of numerous investigations into modernist aesthetics and the power of abstraction: the line. Little criticism exists on Lye's scratch works, but what does often places them within a tradition of abstract expressionism that was popular in the artistic circles that Lye circulated through in 1950s New York. Wystan Curnow, for instance, argues that Lye's interest in atavistic thought and ideas about a possible link between the unconscious and proprioception indicates an indebtedness to the aesthetic argued over and defined by critics such as Clement Greenberg, Harold Rosenberg, and Louis Finkelstein.[3] To various degrees, each of these critics claims that the gestural abstractions of Jackson Pollock and others bare the afterlife of the artist's unconscious

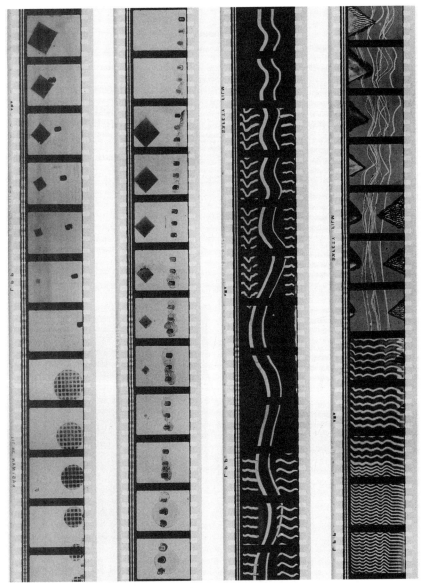

FIGURE 1.1. Filmstrip from Len Lye, *Swinging the Lambath Walk,* 1939. 35mm, color, sound, 4 minutes. Courtesy of the Len Lye Foundation and Ngā Taonga Sound & Vision.

subjectivity. Associating a gestural mark or inscription with the articulation of this form of subjectivity, however, is reductive of both Lye's work and, as other scholars and critics point out, the work of other artists who traditionally fall into the canon of abstract expressionism or action painting. T. J. Clark points out that, though the space of Pollock's canvases reveal an autonomous, subjective realm produced outside the force of market operations, "the marks in these paintings . . . are not meant to be read as consistent trace of a making subject, but rather as a texture of interruptions, gaps, zigzags, a-rhythms and incorrectnesses: all of which signify a making, no doubt, but at the same time the absence of a singular maker—if by that we mean a central, continuous psyche persisting from start to finish."[4] If we sever the associations of Lye's gestural lines, or what he calls "figures in motion," from the divestiture of his unconscious, what do we make of these raw, abstract lines that spin or wiggle frenetically across the screen? Why does Lye turn to this form of abstraction in contrast to his earlier direct animations? What is the relationship between animation and the dynamism or force of movement that Lye wishes to generate in viewers through these abstractions? Furthermore, how do these animations situate the technology of film at this historic juncture?

Lye posed these same questions to himself and was, throughout his career, very deliberate about the aesthetic, formal, and technological choices that he made in a variety of media. In his article "Why I Scratch, or How I Got to Particles," he explains that the lines in *Free Radicals, Particles in Space* (1960s, revised 1979) and *Tal Farlow* (1980) are meant to be formal expressions of a vitalistic energy that swirls around individuals, or "the stuff out of which we came, and of which we are." Such forces are felt by the body, according to Lye, and are stored in what he calls the "old brain of our primal organs," a localization of the body's capacity to sense movement that has been suppressed by human evolution, and further by contemporary culture, he says, until movement exists as a diffused and unintelligible sensation in the body.[5] For Lye, this energy is more connected to the senses and the body than to the unconscious and repressed elements of the psyche. He explains that this energy comes from outside the body in nature but is also responsible for the composition of the body. Associations or communions

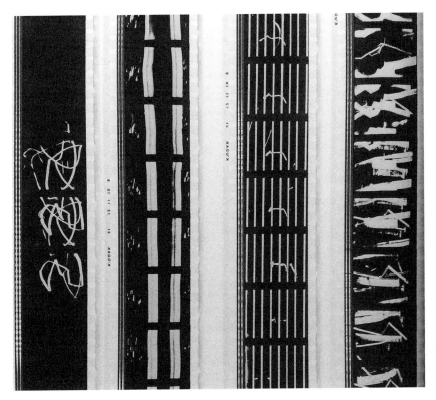

FIGURE 1.2. Filmstrip from Len Lye, *Free Radicals*, 1958, revised 1979. 16mm, black and white, sound, 4 minutes. Courtesy of the Len Lye Foundation and Ngā Taonga Sound & Vision.

with this energy are what transpire unconsciously, or to be more exact, outside analytic thought. This formulation is similar in orientation to the cosmological analysis put forward by Alfred North Whitehead, especially in *Process and Reality* (1929), where he claims that all matter, both animate and inanimate, is constantly reemerging and forming, usually outside of consciousness. The process takes place through what Whitehead calls feeling, arguing that all forms of matter and life are generated out of affect and perceptual vectors, "pulses of emotion" or invisible energy that produce

forms of relative unity. Objects such as rocks, people, and atomic particles affect and are affected by others and thus exist as subjects in a matrix of experience.[6]

Lye believed that certain types of abstraction tapped into a similar sensual energy that structures the inner identity of both the body and nature. Thus, the deep drumbeats on the soundtrack of *Free Radicals* represent, for Lye, an expression of energy in the same way as the mechanistic, whirling sounds produced by his metal kinetic sculptures. For this reason, he incorporated both kinds of sounds on the audio track of *Particles in Space*. The marks and lines in his scratch films visually operate in the same manner and are oriented as modulations of energy made visible through direct contact with the filmstrip. These have a deliberate force that is often structured and precise, rather than generated through techniques of spontaneity that aim to perpetually hold the sense of presence and articulation of subjectivity bound up, as some argue, in Pollock's drips. For instance, in *Particles in Space*, dots congregate and sway to the sounds of one of Lye's metal kinetic sculptures, providing an animated visual projection of its oscillations. In *Free Radicals,* vertical lines many times run down the frame to create a grid that other forms move within. Other marks in the film maintain a consistency of shape as they spin on the z axis, indicating a stronger connection to Alexander Calder's mobiles than to Pollock's drip paintings.

These marks and lines reveal a play not only with dimensionality and figure–ground relations but also with the material base through which these forms are generated. Though Lye was indebted to a tradition of painterly gesture and abstraction, his primary interests were in the aesthetics of motion and cinema's privileged role as a medium in portraying motion. Emphasizing cinema as a technological and aesthetic form best suited for conveying and playing with senses of movement strays from the notion that film is defined through a photochemical material base whose indexicality aligns it with certain aesthetic modes of realism. Lye's frustration with this formulation that guided both film practice and the arguments made within what is often considered classical film theory influenced the construction of his films and theoretical writings on cinema and points to an alternative conceptualization of cinema rooted in graphic manipulations and sensations of movement. His focus on the body of the spectator in his

films and writings and the empathetic relation between the senses and moving forms in cinema led him to produce increasingly extreme abstractions to both distill this connection's elements and analyze their relations. In this light, Lye's animation of graphic forms functions as a site for working through and exploring how the body sensually engages with different materials, a workshop and playground of materialist phenomenology.

Accordingly, for Lye, each type of animation contained its own specific aesthetic potentials, and scratching rather than painting lines was a key distinction between the types of direct animations he produced. The force applied to the celluloid through a technique of negation in which parts of the emulsion are removed produces a work with a kinetic energy whose specificity intrigued Lye immensely. From such a seemingly anarchistic technique and reduction of form came a paradoxical explosion of vitality that Lye believed better conveyed the energy of motion relative to other cinematic expressions. Rooted in an alternative conceptualization of cinema outside the bonds of photography that focuses on sensations of movement and plays on perceptual states, Lye's films explore animation's technical nature. That such an engagement takes place through the abstractions and movements of the line exposes this form's own contradictory simplicity and expressiveness. In motion, these scratch lines move wildly while simultaneously isolating a sense of force in the perceptual encounter with the viewer, multiplying the kind of dynamism that Roland Barthes describes in the epigraph to this chapter. I argue that, when in motion, the permutations of Lye's lines take on an animism that no longer simply bares the afterlife of his kinesis—the "action become visible"—but becomes a source of the lines' own vitality and transmission of movement in viewers. Lye exposes the technicity of the line in animation. And the movements of the line become, according to Lye, the line's own "life-manifestations."[7]

CELLULOID AND RESIDUE, MATERIALITY AND OPTICS

Lye was not alone when thinking through the qualities of different media during and after the Second World War. Questions of medium specificity and materiality were on the minds of a number of critics and artists, especially within the arena of modern painting. Perhaps the most well-known,

as well as belabored, formulation of medium specificity and the role of different aesthetic forms in modernity came from Greenberg, whose criticism has generated both admiration and ire to the point of being so controversial that, as Caroline A. Jones explains, his name alone sparks debates and stands in for a number of ideas about aesthetics in a many times reductive fashion.[8] Jones calls this "the Greenberg effect," and at the risk of provoking similar reactions that exist in such a polemicized discourse, it is necessary to grapple with some of his arguments in order to fully understand both Lye's new abstractions and the context in which they were produced. This is not done to reiterate or recapitulate Greenberg's arguments, but instead to better understand this moment of artistic production and the convergence of modernist and aesthetic claims that this period, and Lye, are caught up in.

One of Greenberg's later and most often cited essays, "Modernist Painting" (1961), concisely articulates his positions on both the distinctions between the arts and how these different forms elicit types of sensual engagements. Greenberg begins the essay by claiming that modernism's essence can be found in a self-critical attitude and position that stems from Enlightenment thought as extended to the arts, whereby each aesthetic examined "the effect exclusive to itself" born from its medium, here defined as the material support.[9] This search for purity "became one of self-definition with a vengeance," and modernist painting turned what were traditionally conceived of as the limitations of the medium into that which defined it and subsequently emphasized these features, such as flatness, color pigmentation of paint, and the shape of the support.[10] These priorities focused attention on the pictorial surface over any illusion of depth or sense of three-dimensionality, which, as Greenberg claims, "is the province of sculpture."[11] This lack of illusionary depth and concentration on the materiality of painterly compositions highlights what many critics call its "literalness," its existence as a two-dimensional artistic form.

In "Art and Objecthood," Michael Fried describes how many artists in the wake of such ontological reductions emphasize the sense of the artwork as a literal object to the point of evacuating pictorial aesthetics and focusing on the beholder's interaction in what he describes as a "theatrical" arrangement. This equally fraught polemic argues that the source of this

subsequent divide between competing aesthetic forms in contemporary art is the same problematic:

> Literalist sensibility is, therefore, a response to the *same* developments that have largely compelled modernist painting to undo its objecthood— more precisely, the same developments *seen differently*, that is, in the theatrical terms, by a sensibility already theatrical, *already* (to say the worst) corrupted or perverted by theater.[12]

According to Fried, modernist painting continues to confront the issue of its own pictorial construction and engagement with visual sensuality, rather than shying away from such issues and accepting, as the literalists had, that modernist painting established a telos toward the eventual uncovering of an art form's objecthood.[13] In this literalist version of modernism, the subjective experience of an artwork gradually stood in for the work itself, a gross perversion, according to Fried, of the engagements with perspective in art undertaken since the impressionists. This ultimately produced an aesthetic practice whose focus was objectless, as Fried puts it, since the sensual encounter with the form's objecthood became the artwork.

This now widely known division between literalness (associated predominantly with minimalism) and pictorial aesthetics had not fully solidified when Lye was creating his scratch animations, and as Achim Hochdörfer explains, it constructs a simplistic rift within both art criticism and artistic practice that also overshadows a "hidden reserve" of works between 1958 and 1965. Looking to Leo Steinberg's criticism in the late 1950s and the writings of Fried before "Art and Objecthood," Hochdörfer identifies this moment when, according to Steinberg, the dialectic in painting and criticism between literalness and aesthetic transcendence was always in tension, with neither limit dominating. Steinberg writes in 1957 about this relation: "We are invited to stare into the gap and to experience the tension of irreconcilable poles."[14] Thus, any aesthetic pleasure was always bound up in a recognition of the material conditions through which it was generated, highlighting the interaction of literalness and visual sensuality. Even Fried's criticism had previously emphasized that the two were not simply overlapping, but dependent on one another. In his essay "Shape as Form: Frank Stella's Irregular Polygons," he explains that, in the work

of Morris Louis, Kenneth Noland, and Jules Olitski, the flatness of the picture's support was occluded by optical illusionism, though "the literalness of the picture surface is not denied . . . on the contrary, one somehow constitutes the other. And in fact, there is no distinction one can make between attending to the surface of the painting and to the illusion it generates: to be gripped by one is to be held, and moved, by the other."[15] This aesthetic balance could tip the other way, an inversion which Fried identifies in some of Stella's works. Yet the dialectical tension nonetheless continued to exist, with each element intensifying the relation to the other until, as Hochdörfer shows, a year later in "Art and Objecthood," Fried abandoned the dialectic for Greenberg's focus on optical illusionism.

However, though Greenberg prescribes a focus on the materiality of a medium in modernist aesthetic practice, he also explains that such purity of form is impossible and that, in modernist painting, "the first mark made on a canvas destroys its literal and utter flatness . . . and suggests a kind of third dimension."[16] This may not generate an illusion of spatial depth, but it will create a sensual encounter directed toward the eye, an "optical illusion." This phenomenological address to "eyesight alone," as Fried coins it,[17] actually sowed the seeds of the later debate and division that Fried articulates. Rosalind Krauss explains:

> No sooner had Greenberg seemed to isolate the essence of painting in flatness than he swung the axis of the field 90 degrees to the actual picture surface to place all the import of painting on the vector that connects viewer and object. In this he seemed to shift from the first norm (flatness) to the second (the delimitation of flatness), and to give this latter a reading that was not that of the bounding edge of the physical object but rather the projective resonance of the optical field itself.[18]

The implications of such a move include not only the positing of a phenomenological mode of address as the primary means through which the conventions and norms of artworks would be generated, but also "that opticality was not simply a *feature* of art, but had become a *medium* of art."[19] Though Greenberg and Fried still emphasized particular physical conditions under which a work was produced, Krauss claims that optical-

ity emphasizes a phenomenological vector that moves the definition of a medium away from singular material supports, exposing a heterogeneity of both form and convention.

In many ways, Krauss returns to the dialectic that Hochdörfer identifies as being lost in the previous generation's debate, but complicates it by denying the existence of particular a priori material foundations of a medium. Here, a medium resists ontological closure and is open to improvisation in a constantly changing "recursive structure—a structure, that is, some of the elements of which will produce the rules that generate the structure itself."[20] In the dialectic between literalness and aesthetic transcendence, each limit morphs such that transcendence implies a play of phenomenological presences and absences, while literalness encompasses not only the physicality of the work but also the artistic and aesthetic strategies that produce an aesthetic event. Such practices exist in a matrix of conventions and challenges that help determine how mediums take form, especially when one set of practices addresses itself to the idea of the medium in the recursive fashion described above and accordingly stakes a claim about the necessity of its own operations.

It is this dialectical play between different conventions and sensual addresses that Lye operated within throughout his career, emphasizing the perceptual address of his films and the variations in experience that different formal manipulations could produce. Like Krauss's analysis of a medium, Lye viewed cinema as a form that participates in the construction of an aesthetic event, but a form that is in flux historically. Though Lye provided an alternative conceptualization of film that emphasized its ability to project movement, his formulation was not reductive, and he saw elements of the energy of movement that he wished to highlight both in moments of Hollywood films and in other forms of art. That said, any rapport that he felt with artistic movements such as abstract expressionism, futurism, or Dada was in their embracing of kinetic work that, like his films, addressed the body along the vector of sensation that runs through Greenberg and Krauss's criticism. This emphasis is apparent in the opening of his first published essay, where he inverts the primacy given to form over movement in perception:

> The result of movement is form. . . . When we look at something and see the particular shape of it we are only looking at its after-life. Its real life is the movement by which it got to be that shape. The danger of thinking of physical things in terms of form rather than of movement is that shape can easily seem more harmonious, more sympathetic with other shapes than its historical individuality justifies.[21]

Such a shift results in Lye positing "movement as a medium" whose formal instantiations are more the residue of movement rather than that which conditions its possibility. In such a framework, marks in Paleolithic cave paintings speak to the contact of movement and also project in viewers a sense of motion through an intuitive force. Movement exists as vitalistic energy in this formulation and can be transferred through a "kinetic kind of osmosis" between different forms and materials, or between a body and an object, the traces of which are always visibly apparent.[22] Thus, for Lye, "to extricate movement from the static finalities or shapes which the mind imposes on living experience is to translate the memory of time back into time again—to relive experience instead of merely remembering it."[23] Shapes and forms are not static in this formulation; instead, they contain traces of action and duration constitutive of their making. The movement of the hand of the artist can become embedded within objects, and aesthetic experience is guided through a subsequent tracing of that movement, recreating the arcs, peregrinations, and pressures of the artist's hand. This aesthetic and intuitive force described by Lye operates through recognition and kinesthetic empathy along tactile and optical vectors.

In this light, the scratches in *Free Radicals* exist not only as the residue or signatures of Lye's bodily motion but also as lines along which the energy of motion exists. The title of the film came from a *New York Times* article Lye had read about the existence of highly reactive and unstable molecules called free radicals, and Lye felt that his aesthetic shared the density of energy and eruptive potential of these forms.[24] He also believed that the title was appropriate given his own orientation to filmmaking and persona as an artist. Throughout Lye's career, he felt a frustration with the emphasis on photographic realism in film and the continuities of space and time constructed through what he describes as "the Griffith technique."

Film, like kinetic sculpture, has a privileged ability to work with the aesthetics of motion because of the way it internalizes time. But Lye found instead that film was increasingly becoming an adjunct to illustrations of literature, and in a lecture to the Film-Makers' Cinematheque, he proposed ways of "get[ting] out of the Griffith technique."[25] One possibility he suggested was to use techniques taken from cartoon animation in live-action filmmaking so that a hybrid aesthetic would be generated that creatively explains how everyday movement is composed through time in cinema, rather than papering over the construction.

GESTURAL MARKS

This hybridity can be seen in Lye's 1936 *Rainbow Dance,* in which colors play off one another in counterpoint as shapes and silhouettes of bodies moving about the screen dance to the Cuban jazz musical accompaniment (Plate 1). His later complete abandonment of figuration was not a denial of the possibilities of this combination. Instead, this departure came about because of an increasing interest in how cinema engenders kinesthesia in viewers through the channels of empathy described above. While *Rainbow Dance* also aimed its address at sensual intensities, it did so through color patterns and an identification with the body on screen hiking, dancing, and playing tennis. Figures move to the music in the film and join sport with choreography that simultaneously highlights color relations. By working with colors inside and around the figures, each of which changes with the melodic patterns of the music, the film produces movements of color that work as "counterpoints to the movement of the object carrying the colour."[26] This produces a different aesthetic formation with its own specific "vibration-pattern," as Lye put it, which here played with the differences between static and kinetic forms and the sense of movement still attributed to a body frozen in action.[27] In contrast, the jerky, intermittently rigid, and chaotic scratches in *Free Radicals* attempt to make present a gestural articulation without a body.

This alternative vision of cinema in these scratch films, where the force of motion is accentuated through types of nonphotographic abstractions, lies at the edge of normative ideas surrounding the medium's identity. But

the divestiture of a representational body does not foreclose the presence of gesture. Just as Akira Lippit asks in his analysis of Martin Arnold's films whether "gesture [can] take place without a body," so too Lye explores not only the possibility of this articulation but also its aesthetic consequences.[28] Ridding the screen of photographic representation reorients the paths of empathy, mimesis, and ontological differentiation that so many have used to explain cinematic form and technology. While André Bazin's essays are frequently invoked—most often "The Ontology of the Photographic Image"—as the theoretical framework around which the threads of time and space that can be represented through photographic means become an ontological foundation for cinema, this characterization often glosses over the nuanced stylistic, technological, and aesthetic arguments that Bazin makes about not only photography, but the mixed medium of film more generally.[29]

A more entrenched relationship between definitions of cinema and photography can be found in Stanley Cavell's *The World Viewed*. One of the chief arguments that Cavell makes there about film is that it provides a response to Cartesian doubt and modernist skepticism, or our inability to have knowledge of the world outside of our senses. By presenting what Cavell describes as a "succession of automatic world projections," film projects the world to unseen spectators:[30] "The world of a moving picture is screened What does the silver screen screen? It screens me from the world it holds—that is, makes me invisible. And it screens that world from me—that is, screens its existence from me. That the projected world does not exist (now) is its only difference from reality."[31] Here, cinema produces a sense of presence through the camera's ability to record and project images of the material world. The automatic nature of this operation is important for Cavell. For the photograph to generate a sense of presence, it must be manufactured by the mechanism of the camera and not be handmade.[32] It is the power of this automatism that is the foundation from which cinema is born and that defines its parameters:

> I said also that what enables moving pictures to satisfy the wish to view the world is the automatism of photography. I have not claimed that film which is not used photographically, to reproduce the world, can-

not be used for the purposes of art. I remark only that film which is not used photographically, in the sense intended, is not being used in its power of automatism. Reproducing the world is the only thing film does automatically. *I do not say that art cannot be made without this power, merely that movies cannot so be made.* Of course we may have to forgo this power; it may lose its power for us. *That just means that the movie will have lost its power.* For what has made the movie a candidate for art is its natural relation to its traditions of automatism.[33]

Such boundaries pose a cinematic essence structured around the medium's ability to project a presence of the world through photographic technology. The most direct source for such a demarcation comes from Cavell when writing about animation in the second edition of *The World Viewed.* Responding to a parody and rebuffing of his argument when applied to animation, Cavell admits that animation is generally considered to be film, but that cartoons or any handmade film is not a movie in the way he defines it, since they do not provide an answer to Cartesian doubt by projecting the world automatically, at least (Cavell admits) not the world as we know it. Instead, he explains, animation projects a primitive, childlike world that is "governed by physical laws or satisfies metaphysical limits which are just different from those which condition us."[34] A key example of this for Cavell is animation's capacity for metamorphosis and a fluid nature of corporeality that does not graph onto our own bodies. Animation, for Cavell, is a threatening realm because it is filled with "beasts which are pure spirits, they avoid, or deny *the* metaphysical fact of human beings, that they are condemned to both souls and bodies"; and this metaphysical separation between different types of bodies on screen extends into a separation of animation from film as a different medium that, like cinema, will develop its own conventions and project "moods and subjects in its own way."[35]

The recent focus on claims such as this, which are bound up in polemics that move toward or away from such articulations, often turns to a phenomenological approach that stresses the ways cinema functions as means through which impressions of reality are manufactured, or as a vehicle for projecting and feeling movement in the viewer.[36] Like the optical vector in modernist criticism, the focus on perceived movement opens

the medium to greater differentiation and becomes, for Tom Gunning, the point of moving away from a focus on photographic indexicality or, for Giorgio Agamben, a means to displace the image in favor of gesture as the foundational element of the medium.[37] For Agamben, cinematic images technologically animate gesture through abstraction and syntheses of action. He explains that "every image, in fact, is animated by an antinomic polarity: on the one hand, images are the reification and obliteration of a gesture (it is the imago as death mask or as symbol); on the other hand, they preserve the *dynamis* intact (as in Muybridge's snapshots or in any sports photograph)."[38] This orientation of cinema as a means to project gestures, rather than reproduce the world, frames the medium around the force of action and the ways in which images within it serve as double-headed arrows, simultaneously both pointing to a full articulation of movement and freezing its constitutive fragments. While Cavell explains that photographs segment part of a world for projection, and is thus "*of* the world,"[39] the images of action in Agamben's reading of Gilles Deleuze's work on cinema continually index the vectors of time and force bound in cinema's technological movements.

That animation presents an otherworldly realm ruled by a sensual, alogical order was precisely the point for artists like Lye who believe that film's power to produce metamorphoses in time added to the "beauty [that] lies in her 'kinesthesia.'"[40] But the question of a gesture's link to a body on screen nonetheless works its way through the history of animation and establishes its most iconic and foundational trope. As Donald Crafton explains in his oft-cited essay "Animation Iconography: The 'Hand of the Artist,'" beginning with lightning-sketch films and early animations of Winsor McCay or Émile Cohl and making its way through Max and Dave Fleischer films, Chuck Jones animations, and contemporary works, animations would often employ the iconography of the "hand of the artist," which would breathe life into its drawings through gestural marks. This not only granted the animator ontological privilege but also linked the world of animated drawings with a corporeal body onscreen. Crafton notes that, though this trope was employed routinely at first, the animator gradually lost the casting as the magician, eclipsed by cinematic technology itself for the role. But the iconic action never faded away, and its ideological signifi-

cance also remained present, allowing the gesture of the hand to bear the weight of life transposed from one corporeal world to another.

For Lippit, cinematic technology presents gestures without bodies on a regular basis, especially in the context of experimental films in which mechanical articulations of actions break from naturalistic depictions of movement, even when projecting photographic images of recognizable figures. Lippit uses Arnold's films like *Alone: Life Wastes Andy Hardy* (1998) as exemplary cases and likens their aesthetic operations to those described by Deleuze in his criticism on Francis Bacon's paintings, explaining that both depict "invisible forces become visible."[41] For Deleuze, Bacon's paintings render the rhythmic operations of sensation that provide the foundation for aesthetic comprehension and bodily action. Bacon's portraits arrest levels of sensation within a temporal flow, creating "snapshots of motion" that are recomposed synthetically like Étienne-Jules Marey's chronophotographs.[42] It is in this projection of gesture and action that the contour of a form can be displaced through figures seemingly caught in abstraction with grotesque breakdowns and syntheses of motion, or "movement 'in-place,' a spasm, which reveals a completely different problem characteristic of Bacon: *the action of invisible forces on the body*."[43] Ultimately, Deleuze identifies Bacon's paintings as functioning in ways similar to Paul Cézanne's in that they project the diastolic and systolic forces in the world and the body, showing how the two press on and open to one another.

The role of the line in this operation is often lost in readings of Deleuze's criticism on Bacon. While dividing Bacon's work into different periods, Deleuze notes how the contour in Bacon's aesthetic practice indexes his pictorial and intellectual investments as formal vehicles in his portraits for isolation, deterritorialization, deformation, and prosthesis. Deleuze describes it as the membrane that enables the coexistence of the rhythmic forces of contraction and dissipation within one composition.[44] In this way, the forces present in gestures and movements become bound to the aesthetic contours of the line. And, in this context, gesture does not bear meaning, but instead loses it entirely through its association with force down the line. As Barthes defines the term, gesture points to the atmosphere of a moment but is constructed through an "indetermined and inexhaustible sum of motives, pulsations and lassitudes . . . [that] abolishes

the distinction between cause and effect, motivation and target."[45] Like the snapshots of motion in Bacon or isolated images of gesture in Agamben's theorization of cinema, these gestures mark indeterminate force to articulate a vector of action.

When animation foregoes the iconographic and ideological power of the artist's hand in films like Lye's *Free Radicals,* a form of gestural force is still present, if only recognized through an atmosphere of corporeal pressure in the lines' moving undulations. For Lye, the actions of his lines isolate a gestural force and indefiniteness that he calls "the ultimate look of energy."[46] But this is not generated from a gestural articulation of a body alone, but also from its coordination with particular technologies of inscription. Lye's experiments with how different tools produce those registrations index this, showing how gesture in this context is bound not only in indetermination, as Barthes suggests, but also in technology, working more firmly in André Leroi-Gourhan's definition of gesture as "instruments of material action."[47] Leroi-Gourhan explains how gestures of the hand developed in relation to technical instruments through an anthropology of technics, focusing on the mutual constitution of human and technical evolution, or what Bernard Stiegler calls "epiphylogenesis."[48] For Leroi-Gourhan, tools develop in tandem with human bodies so that

> we perceive our intelligence as being a single entity and our tools as the noble fruit of our thought, whereas the Australanthropians, by contrast, seem to have possessed their tools in much the same way as an animal has claws. They appear to have acquired them, not through some flash of genius which, one fine day, led them to pick up a sharp-edged pebble and use it as an extension of their fist . . . but as if their brains and their bodies had gradually exuded them.[49]

This process of technical exteriorization and mutually constitutive evolution continues, according to Leroi-Gourhan, and though his historical analysis is fascinated with Paleoanthropians because "we witness the first upsurge of new aptitudes of the brain that both counterbalance and stimulate technicity," this same operation exists in contemporary technical culture.[50]

In this context, the gestural marks Lye produces on the filmstrip in *Free Radicals* project the force of technical movement, not just a bodily

action. Generated in concert with tools of inscription and cinematic projection, the process of exteriorization is one of memory, as Leroi-Gourhan and Stiegler later emphasize, but oriented toward the invisible forces of action instead of a discursive record. This is the thrust of Lye's arguments about sketching, a point that he emphasizes when explaining his attraction to doodling and the "endless ways that energy can be depicted" through this technique.[51] Doodling and scratching function almost as automatic writing processes, providing a way for the muscles of the body to exert greater control over the marks produced than a planned and executed abstraction, thus transferring a bodily energy onto the material through a writing tool.[52] Lye explains that "the 'particle' films *Free Radicals* and *Particles in Space* are transpositions of such information, or at least give the viewer a feeling of mysterioso about such eternal magic."[53] Projections of energy that move between different materials through the impression of the artist's hand generate an image that is both tactile and optical in orientation. This is not exactly a haptic space, but is instead an image that simultaneously targets multiple perceptual registers, a coenaesthesia that heightens and reduces sensual intensities. Thus, while the physical movement of a body may not be present, the gestural mark cascades through technical forms and impressions, producing physiological sensations for viewers through effects of abstract patterns or fantastical metamorphoses instead of realistic worlds.

CONTOURS OF MOTION

Several writers have examined the pathways through which the line produces aesthetic effects, and in animation Sergei Eisenstein's writings on Disney and the line are the most cited. For Eisenstein, animation can offer a spectacular liberation from social and physical laws by projecting a world whose fluidity of shape plays with the relations between subject and object when bodies, objects, and the environment constantly shift through a "plasmaticness" that destabilizes forms and mesmerizes spectators in the same manner as fire. Just as Lye argues, this nonrealistic motion can still produce physiological sensations, and Eisenstein similarly links animated action with a sensual address to the body. While the animated form of

Mickey Mouse or other figures in Disney films continually morphs, the contour of such a transformation was always the line, which was responsible for viewers sensing that these figures were alive and for producing any kinesthetic empathy. Eisenstein explains that the movement and combination of abstract elements in animation is a manipulation of "heartless geometrizing and metaphysics [that] here give rise to a kind of antithesis, an unexpected rebirth of universal animism."[54] The source of such animism is not only the projected movement of these figures, so that one believes, "*if* it moves, *then* it's alive," but also the observer, who endows life to these forms with both the eye and the body.[55]

Traditionally, the line functions as a contour or boundary, a two-dimensional abstraction that demarcates the visible and establishes figure–ground relations in a separation that usually focuses attention on the content it delimits. That said, it hardly disappears, a point that William Hogarth makes in *The Analysis of Beauty* (1753). He explains that the line "leads the eye" around forms in a game of chase, suggesting that an imaginary ray emanating from the eye traces the contours and movements of forms, imbuing the object, as well as the subject, with motion.[56] In this model, Hogarth claims that the "serpentine line" or abstract line that does not generate shapes or function as a contour can produce the most aesthetic pleasure because of the way it sets the eye in motion. Eisenstein, possibly following Hogarth's lead, makes a similar argument about the ways the line affects viewers sensually, with the eye's movement sparking an empathetic relation that cascades throughout the rest of the body as well. Such a sensual mimesis both moves the viewer and imbues the object with an animus through the eye's outlining of its form. This intimacy between subjects and objects strangely makes contours "take on an independent life, independent of the figures themselves, the objects themselves."[57]

This story of the line's revolt and independence from figuration has been thematized by a number of filmmakers, most notably by Émile Cohl in *Fantasmagorie* (1908) and Robert Breer in *A Man and His Dog Out for Air* (1957).[58] In these films, the dialectic between figuration and abstraction through the line is put in motion and cinematically represents Paul Klee's famous formulation of the line's own sense of deliberateness, which "the

principle and active line develops freely. It goes out for a walk so to speak, aimlessly, for the sake of a walk."[59] The lines in these films never cease to oscillate, split, intersect, and take new directions, creating a geometry of peregrinations no longer solely in the service of representation. That said, their vectors still coalesce into figures whose own disintegration keeps the oscillation between abstraction and figuration moving and generates a play with expectations and form. Lye's lines in *Free Radicals,* on the other hand, are forceful graphic marks lacking any kind of figuration. These lines are insubstantial, in that they delimit nothing and serve as ends in themselves. Instead, they focus on the elements and processes through which form is generated, something that Klee's line emphasizes. In his lectures and writings, Klee explains that figuration and the projection of objects and form should not be the goal of aesthetic production. Rather, the approach to how form is constructed should be emphasized, revealing "genesis, essence, growth . . . [and] form as movement, action, active form."[60] Lye's scratch lines focus on this kind of action and take on a similarly vitalistic tenor as they dance across the dark space of the filmstrip while never operating as figurative contours. These independent abstractions instead attempt to give expression to incoherent forms of energy, reveling in a figurative void.

That these lines are constructed through Lye's bodily gestures emphasizes this point. Rather than signifying some form of unconscious subjectivity, these gestural lines articulate a play with indeterminacy and structure through an assemblage of marks that is at times controlled and other times chaotic. Yet the body was not the only source of energy that could generate a force on materials. Lye locates this same power in many places throughout the natural world, describing how the abstractions seen in the cracks of rocks or in the cross sections of trees also bear witness to this force of energy in nature.[61] His drawings and studies for his scratch animations were analyses of moving shapes affected by this energy manifested in the natural world, such as flames, waves, or flapping pieces of cloth. But he explains that, "instead of sketching lines and accents described by things in motion, I now tried to tie and plait their particular motion characteristics into my sinews—to attach an inner echo of them to my bones."[62]

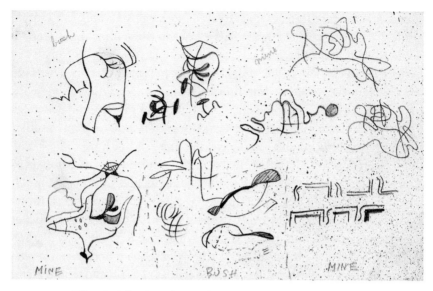

FIGURE 1.3. Len Lye, *Abstractions and Rock Paintings ("Bush-Mine")*, 1933.
Ink and pencil on paper, 113 × 178 mm. Courtesy of the Len Lye Foundation
Collection, Govett-Brewster Art Gallery / Len Lye Centre.

Accordingly, he worked from these transcriptions only to generate ideas of
how this force manifests and how motion operates, attempting to project
abstractions of movement rather than the contours of specific forms.

Using abstract lines to explore this form of mimetic power distinguishes
Lye's direct animations from those of other artists that, at first glance, appear
to share a similar aesthetic. For instance, the scratches found in Norman
McLaren's films *Begone Dull Care* (1949), or even *Fiddle-De-Dee* (1947), are
structured differently because of an emphasis on giving rhythmic visual
expressions to the accompanying music in these films. This synaesthetic
focus that McLaren explored through much of his career, perhaps most
notably in *Synchromy* (1971), is in many ways more similar to Lye's earlier
work.[63] In fact, the two began producing direct animations at the same time
in the 1930s, each pioneering the aesthetic on their own.[64] McLaren, how-
ever, uses the abstract line because of the limitations and narrowness of the
filmstrip when producing direct animations.[65] Its aesthetic operations were

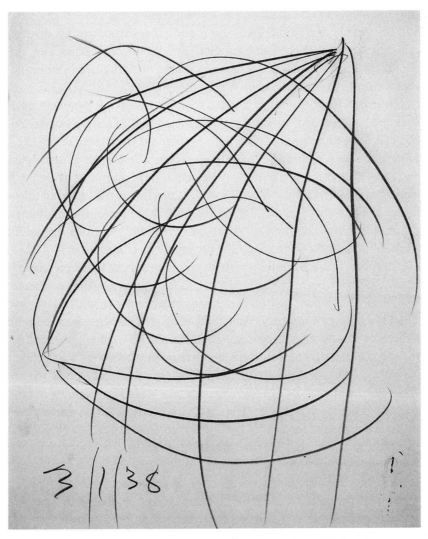

FIGURE 1.4. Len Lye, *Sketch for Motion Composition,* 1938. Pencil on paper, 183 × 225 mm. Courtesy of the Len Lye Foundation Collection, Govett-Brewster Art Gallery / Len Lye Centre.

conceptualized as a bit of hindrance for McLaren, though the effects could still be spectacular. Additionally, he many times structures his abstractions through a relation with figuration. Lye, on the other hand, employs the abstract line's expressive power as a way of breaking free from limitations through the line's seemingly simplistic reduction, allowing his work to reveal this form's ability to possess and convey energy. Similarly, Stan Brakhage's direct animations are not oriented toward kinesthetic action, but instead, as he explains, they seek to "demand a distance or try to arrange a situation of distance" in order to explore other forms of perception and consciousness, a hypnagogic movement inward prompted by a poetics of cinema.[66] Many of these films follow the trajectory of the lines and colors found in *The Dante Quartet* (1987), which Brakhage explains came from a vision of hell brought about by "closing my eyes" and searching inward for a formal expression that exceeds the potentialities of language.[67]

In contrast, Lye's intimacy with abstract lines seeks to bear witness to an aesthetic power similar in kind to the Gothic lines Wilhelm Worringer describes, lines whose "matter lives solely on its own mechanical laws; but these laws, despite their fundamentally abstract character, have become living, i.e. they have acquired expression."[68] Such lines contain a force that, though nonorganic in form, can nonetheless launch viewers into a "blissful vertigo." Following Hogarth and Eisenstein's analyses of how the abstract line animates the eye and the body, the sensual operations behind such ecstasies become more clear. Maurice Merleau-Ponty rearticulates much of this line of thought in his phenomenological analysis of painting and the visual arts. In "Eye and Mind," he explains that, in modern art, Klee freed the line from its traditional role of articulating visible forms, of being "the apparition of an entity upon a vacant background," allowing it now to function as a "modulation of a pre-given spatiality" to structure aesthetic experience in a different way from that of, for instance, Baroque painting.[69] The differences tracked and articulated in the essay emphasize the historical nature of aesthetic encounters for Merleau-Ponty, since they take shape through different techniques. As his other work emphasizes, these techniques are always oriented toward the body: "Every technique is a 'technique of the body.' A technique outlines and amplifies the metaphysical structure of our flesh."[70] This is a powerful argument and explanatory

framework for the sensual engagement with visual aesthetic forms at the moment of encountering or interacting with them, offering a particularly lucid summary and analysis of the line and how it resituates a perceptual encounter under a new aesthetic regime of abstraction and figuration in modern art.

For Merleau-Ponty, the line produces an aesthetic relation through its articulation in space, something that both Klee, as described above, and Henri Matisse emphasized in modern art. While Klee showed the line's ability to reveal visibility's constitutive elements and its ever-constant process of becoming, Matisse used the line to show a form's fundamental abstract characteristics that lead to a gestalt. Matisse creates figures through single lines to mark out their existence and to also signal "the hidden [sourde] operation which composes in it such softness or inertia and such force as are required to constitute it as *nude*, as *face*, as *flower*."[71] Both artists accentuate an element of the line that has always been in existence but that is brought to the foreground in modern art: the line's impression on material and movement through space. Merleau-Ponty explains: "Figurative or not, the line is no longer a thing or an imitation of a thing. It is a certain disequilibrium kept up within the difference of the white paper; it is a certain process of gouging within the in-itself, a certain constitutive emptiness—an emptiness which . . . upholds the pretended possibilities of things."[72] What Merleau-Ponty punctuates in this description is the line's power as a marker of space, its power to produce a field of possible experience for an encounter and to hold out the potential promise for an articulation or representation of a form within that field. To a certain extent, this privileges the possibility of figuration even within abstraction, which Merleau-Ponty still finds in Klee's work, believing that the titles of abstract art like Klee's bear the burden of defining the entity represented or expressed in the work. Regardless, for Merleau-Ponty, a line that runs along the canvas or white paper creates a space for an aesthetic encounter and contains within it the motion of the body that once made it. This is traced through the movement of the viewer's eye, just as Hogarth and Eisenstein describe. Throughout the essay, Merleau-Ponty attempts to explain painting's power, arguing that it functions as a vehicle for the transmission of energy, or "the body's animation," between different bodies. Arguing that a

"blending of some sort takes place" between the body and the phenomenal world that produces sensation, Merleau-Ponty explains that painting does not produce an imaginary field of contemplation for the mind, but rather a sensual one directed toward the eye:

> The imaginary is much farther away from the actual because the painting is an analogue or likeness only according to the body; because it does not present the mind with an occasion to rethink the constitutive relations of things; because, rather it offers to our *sight [regard]*, so that it might join with them, the inward traces of vision, and because it offers to vision its inward tapestries, the imaginary texture of the real.[73]

Merleau-Ponty explains that, in painting, the agile hand of the artist restores to the visible field that which was once sensed by the eye. Painting exists as a place for the exchange of sensations, where an initial impact of the world on vision is then rearticulated by the artist's hand, only to then exist as a form that impacts another's eye. The line and painting more generally become technical repositories and motors of sensation, carving plays of space and time in an economy of empathy.

In fact, what Merleau-Ponty attempts to explain in his phenomenological account of modern painting others describe in a similar fashion as the mechanics of empathy as it operates through visual aesthetic forms. German philosopher Theodor Lipps's application of Robert Vischer's term *Einfühlung* (later translated into English as empathy) in psychological and aesthetic discourses is one of the more well-known analyses of this operation. Over the course of several writings, Lipps explains how aesthetic pleasure functions and how we relate to aesthetic forms. As in Merleau-Ponty's explanation, the boundaries between subject and object evaporate so that, in an encounter, "the contrast between myself and the object disappears,"[74] or as he puts it in another essay: "I must be finding myself in this sensuous object. I experience or feel myself in it."[75] As Robin Curtis shows, objects in this formation become sources of potential vitality, producing, as Lipps explains, "a multifaceted kind of activity is exuded by the object and as such a unified self is felt to be within that object."[76] Objects thus become mirrors for the self in the world while taking agency in a perceptual encounter that also produces an activity on the part of the perceiver, which grasps or iden-

tifies the object, synthesizing its features as something distinct to produce an imagined relation with it.[77] Thus, the phenomenal world as experienced by the subject exists as process: "[It] is permeated by my activity. Activity is life." Empathy, in this formulation, is a mechanism through which the sensual world is organized perceptually:

> Everything, therefore, which exists as some particular thing—and other objects simply do not exist for me—is necessarily and self-evidently permeated by my life. This then is the commonest signification of "empathy." It means that when I grasp an object, as it exists and indeed must exist for me, I experience an activity or a kind of self-activity as an attribute of the object.[78]

In describing how this functions when encountering aesthetic works, Lipps first turns to one of the most basic forms: the line. Like any other object, the line evokes an activity by the perceiving subject, and Lipps identifies pure linear forms that are "the vehicle of concentration and discharge, of tension and release of tension, of initiation, continuation, and cessation, and above all of self-extension and self-confinement."[79] Furthermore, the rhythms and actions of lines seen are "all my own activity, my own vital, internal movement, but one that has been objectified."[80] Importantly, for Lipps, such abstractions are not in a closed perceptual field; they exist in space and in relation to objects in that space. In short, even when abstract lines exist as independent sense impressions distinct from other objects, they are part of a perceptual arrangement that is ordered by the mind. This can be done erroneously, as in the case of optical illusions, but this arrangement still leads the perceiver to locate abstractions within a phenomenal world, to situate them in space and impose a possible figurative order on that abstraction or make figurative sense of the abstraction through a *perceived* gestalt (actual or not).[81]

It is this focus on the phenomenal world and figuration, as well as Lipps' detailed attention to the aesthetic engagement with the human form in his writings on *Einfühlung,* that led Worringer to criticize the idea of empathy and divorce it from abstraction. For Worringer, Lipps concentrates too heavily on the body of the perceiver and on the projection of the self into abstract or figurative forms. He argues that, for Lipps, "the value of a line,

of a form consists for us in the value of the life that it holds for us. It holds its beauty only through our own vital feeling, which, in some mysterious manner, we project into it."[82] Worringer's reading of the perceiving body in Lipps's work grows a bit distorted, in part, as Juliet Koss shows, because of his reliance on how Lipps was interpreted by psychological discourses at the turn of the twentieth century.[83] Worringer argues that a desire to project oneself into outside forms results in an urge that leads to figuration and classical values of mimetic reproduction, where the human figure reigns as the central representational motif. Countercritiques of Worringer have recently attempted to explain Lipps's theories of *Einfühlung* and their applicability to abstract art, critiques whose value is clear in an analysis of Lye's abstract lines, since he believed that their kinesthetic power affects viewers through an operation that he described as empathetic, though he was unfamiliar with Lipps's theories.[84] As Koss also points out, what is lost in the shuffle over analyses of Worringer's reading of Lipps's perceptual theories is the orientation of each of their analyses. While Lipps is principally interested in the perceptual capacities of the body and the ways in which individuals orient themselves and make intelligible not only works of art, but space and form generally, Worringer limits his analysis to the borders of the work of art itself, to the representational field of the canvas or stone block. Lipps is primarily interested in understanding an artwork's place in the world, its embeddedness in a perceptual field. Worringer is less interested in Lipps's phenomenology than he is in whether a phenomenal world is reproduced and projected onto a work of art, specifically in the frame of the artwork. In some ways, Lipps's theories become unfortunate placeholders for what Worringer describes as the desire for figuration and anthropocentrism in art. His conflation is most apparent in an essay entitled "Transcendence and Immanence in Art," which summarizes his arguments in *Abstraction and Empathy*. He claims that "the process of anthropomorphisation here becomes a process of empathy, i.e. a transference of man's own organic vitality onto all objects of the phenomenal world."[85]

The extent to which Worringer was aware that Lipps does not claim that all art and the world are anthropomorphized through channels of empathy and the extent to which he deploys this accusation in order to produce an argument against which his description of abstraction is sensible

remains to be seen. Regardless, the two share a belief that abstract forms attempt to generate a marked separation from the world. Worringer quotes Lipps's explanation of the abstract line in *Aesthetik: Psychologie des Schönen und der Kunst* (1903–1906):

> The geometric line is distinguished from the natural object precisely by the fact that it does not stand in any natural context. That which constitutes its essence does, of course, pertain to nature. Mechanical forces are natural forces. In the geometric line, however, and in geometrical forms as a whole, they have been taken out of the natural context and the ceaseless flux of the forces of nature, and have become visible on their own.[86]

For Lipps, abstraction produces difference and generates attention through contrast. The same perceptual processes are still animated, but abstraction causes a new perceptual relation with the world. It requires reorienting the object in space. Similarly, for Worringer, abstraction creates a differential, though he argues it is more extreme. Abstraction pulls objects out of space and time in order to purify them from the contingencies of nature, or from what he describes as the arbitrariness, entropy, decay, and imperfections that suffuse everyday life, an "emancipation from all the contingency and temporality of the world-picture."[87] This is fundamentally a desire for a retreat from the world and a desire for transcendence both from it and from the body's relation to this space. Instead of providing relief to Cartesian doubt and modernist skepticism by presenting the world, as Cavell explains photographic moving images do, abstraction moves beyond questions surrounding our ability to have faith in the world's existence and attempts to exist outside of a dependence on nature generally. Thus, Worringer claims that there is an evisceration of organic life in abstraction, a separation from natural forces produced through a negative relation.[88]

The pleasure of abstraction in this argument is generated out of witnessing a form break away from the world and become absolute or self-contained and self-perpetuating, inorganic and mechanical. As described above, Gothic lines have this kind of energy. But they are not pure abstract forms in the way that Worringer sees older Egyptian art as being a more exemplary articulation of the desire for abstraction. Instead, the Gothic

line contains traces of both empathy and abstraction, such that a vitality remains within this line that is not a hard geometrical figure, but one that is labyrinthine and endless, that is jagged with stops and starts in interruptions and pulsations that also distinguish it from the smooth, curved line found in classical art. Worringer explains that this type of line contains its *own* vitality, but one that is inorganic, "of a mechanism" outside of nature. Nongeometrical and nonfigurative, it is formless and exhibits a play with energy itself, containing a strange energy that is independent and free from the world. No longer bound to the urge for a figurative representation or for an absolute abstraction from the world, the Gothic line exhibits an independent will to form, so to speak, with its own mechanical laws and values; it has an *"expression of its own,* which is stronger than our life."[89]

Again, this formless abstraction has a similar aesthetic force to the one that Lye generates in his scratch animations. But, as Vivian Sobchack has argued, the aesthetic force of the animated line is doubled in comparison to that in still works. While drawn lines have a movement embedded within them that is translated to the viewer, as I have described above, the "animated line doubles—and qualifies—its 'essential' ontological necessity with (and as) a sufficient and visible different: that is, without negating it, movement transforms the *quantitatively abstract and geometric* essence of the line into its provisional existence as *qualitatively particular and lived."*[90] Sobchack argues that the animated line has a vitality regardless of its shape, simply because it is set in motion. Actually conveying motion attaches an animus and perception of the line's flows rather than a static representation of its past or potential actions, an argument indebted to Henri Bergson's claim that one can truly perceive motion only through an actual experience of it.[91] Though Sobchack's argument applies to several types of animation, this doubled expression of force is put on dramatic display by Lye's films. By avoiding figuration entirely, but not producing a pure geometric form, his frenetic lines operate in the same aesthetic mode that Worringer associates with the Gothic line, producing an abstraction that seems to contain its own animus. They still induce an empathetic kinesthesia, or what Lye describes as an echoing movement in one's bones, but their movement across the screen exponentially increases the aesthetic pleasure born from sensing that they have their own self-contained vitalism. Lye emphasizes

this at the beginning of the 1958 version of *Free Radicals* by including this comment: "Brancusi said: 'Do not look for obscure formulae or mystery, it is pure joy that I bring you.' I say: 'Film is advanced art, not science, education, nor box office . . . but utopia.'" Film's promise lies in providing not only a symbolic form of motion that is traced by the viewer's eye, but motion itself, which appears to be immanent to the projected lines, a spectacular autopoiesis.

The mimetic vectors of this action travel through not just the bones, but the eyes and hands of viewers, a point Worringer succinctly describes. When tracing the movement of a line in visual space, "we feel with a certain pleasant sensation how the line as it were grows out of the spontaneous play of the wrist" and feel as though we had drawn the line ourselves. Importantly, this aesthetic feeling is independent of the initial contact with the artist's tool. While a mimetic action of the hand may be felt, the source for this experience is born from the line itself. Viewers sense the movement of the hand and the expression that "compels the wrist movement," but the line has an independence as well that, though created from the expression of a sensation for the artist, now "appears to impose its expression upon us, [and] we perceive it as something absolute, independent of us."[92]

The eventual separation between body and form is important. Other theorists like Henri Focillon identify form through an ever-present relation to the movement of the body, or through what he describes as the constant spiritual presence of the hand of the artist whose "full weight of the human being is here [in the artwork] in all its impulsive vivacity."[93] But, for Worringer, the body functions primarily as the genesis for the energy of the line, which then becomes its own independent form. Similarly, Lye believes that his lines produce a kinesthetic effect through an empathetic relation, where the energy of movement that he is attempting to convey is transferred from his body to the filmstrip and then to viewers along a phenomenological vector emanating from the film, the strange osmosis he mentions in his writings. But he additionally argues that this energy resides outside the body as a "rhythm-vibration." *Free Radicals* and *Particles in Space* not only attempt to produce kinesthetic responses in spectators but also aim to render visible the sources of sensation that suffuse all matter, the literal free radicals described above and the particles in space usually invisible to the eye.

THE FORCE OF VIBRATION

Lye's visualization of these forces became a central focus while producing his scratch films and the kinetic sculptures that he began working on in the late 1950s and into the 1960s. In his article "The Art that Moves," he addresses this issue directly, explaining that the energy of his sculptures, such as *Rotating Harmonic* (1959) or *Fountain* (1963–76), operates and exists independently of his body. Such a conclusion did not come without its reservations:

> Like most people, I don't get much emotional satisfaction from parallels made between human and mechanical principles and processes, such as the way our thought processes may be similar to those of a brain machine, or our feedback workings to those of kinetic sculpture. But there's one thing I do like to ask myself; does the marked vibration and oscillation, rhythm and spinning, undulation and orbiting, which goes on in my work serve to isolate an image which portrays the fundamental force of nature—energy?[94]

Though fearing that "we will find ourselves in metaphysical debate," Lye nonetheless acknowledges that his focus is on generating an aesthetic image of energy that houses the possibility of a kinesthetic experience for viewers.[95] For Lye, the body exists as one site among many where this rhythm-vibration of energy resides; he finds it as well in formal or mechanical elements such as the line and metallic kinetic sculptures and recognizes, like Worringer, that these forms have taken on their own independent life.

Again, this decentering of the body as the privileged site for sources of sensation is the same operation that Deleuze performs in his analysis of Bacon's paintings. To reiterate, while Deleuze does not deny the existence of sensation in the body, he argues that its conditions of possibility stem from the force of a rhythm external to it. This takes the form of "a wave with a variable amplitude [that] flows through the body without organs; it traces zones and levels on this body according to the variations of its amplitude. When the wave encounters external forces at a particular level, a sensation appears."[96] According to Deleuze, the force of these rhythms and

intensities that operate as the building blocks of sensation also exists in nonorganic matter, which "include[s] mechanisms of perspective,"[97] and generates in the body a form of becoming created solely through forces outside itself.[98] Deleuze's movement away from phenomenology thus occurs through a belief in universal animism, since the indeterminate intensities of rhythm permeate all form, composing "the non-organic life of things": "It is not the mechanical which is opposed to the organic: it is the vital as potent pre-organic germinality, common to the animate and the inanimate, to a matter which rises itself to the point of life, and to a life which spreads itself through all matter."[99] This commonality of forces, implicating the human and nonhuman, permeates all matter, seen in places like the cracks in the rocks that fascinated Lye, or the floating particles of energy and dust in space that the Apollo 14 astronauts discussed in a *New York Times* article that influenced Lye while making *Particles in Space*.[100] For Deleuze, the task of painting is the same one that Lye identifies for his films and kinetic sculptures: the visualization of a rhythm-vibration that produces sensation.

At a moment in modernism when a reexamination of ontological claims about mediums pressed into aesthetic practice, Lye's films that seem to technologically strip cinema down to its most basic elements were paradoxically an attempt to open the medium up and reveal potentialities skipped over by others. Lye's focus on the force of energy that could be conveyed through film by scratching out kinetic movement in its surface was not for the sole purpose of reducing film's materiality to its zero point. Instead, this aesthetic reveals what can be done without principal photography in film and that the medium of film is more than a projection of moving images of the world. His scratch animations exemplify what Krauss argues about the specificity of mediums, that "even modernist ones, must be understood as differential, self-differing, and thus as a layering of conventions never simply collapsed into the physicality of their support."[101] Though there is a play with the material of film in Lye's scratch works, he uses scratches in the black celluloid to generate senses of movement, a vitalistic activity that "is the uncritical expression of life," which, as described above, he argues is the medium he works in.[102]

FIGURE 1.5. Len Lye, *Fountain III*, 1976. Stainless steel on motorized base, 5000 × 5000 × 5000 mm. Photograph by Bryan James. Courtesy of the Collection Govett-Brewster Art Gallery / Len Lye Centre.

FIGURE 1.6. Len Lye, *Blade*, 1959–76. Stainless steel and cork on motorized base, 2856 × 1225 × 1225 mm. Photograph by Bryan James. Courtesy of the Collection Govett-Brewster Art Gallery / Len Lye Centre.

FIGURE 1.7. Len Lye, *Trilogy (A Flip and Two Twisters)*, 1977. Stainless steel, motors, 7000 × 9000 × 1000 mm. Photograph by Bryan James. Courtesy of the Collection Govett-Brewster Art Gallery.

This is why, after many years of unsuccessfully supporting himself as a filmmaker, he turned to kinetic sculpture, since he could more easily find financial support through museums and galleries and because he believed he was performing the same kind of aesthetic operation: "imparting vibration to materials."[103] These works, such as *Blade* (1959–76), *Fountain* (1963–76), *Grass* (1965), and *Trilogy (Flip and Two Twisters)* (1977), are composed of polished steel rods and sheets that move through concealed motors or by the force of the wind. In gallery spaces, lights sparkle across the outstretched rods of *Fountain* as they slowly move and slightly skate across one another to mimic the sound of rain. The metallic sounds produced by these sculptures are just as important as their shining visual undulations, generating an audio-visual projection of energy that articulates movement in the same way as *Free Radicals* and *Particles in Space*.[104] *Trilogy*, for instance, contains one loop of metal and two other straight pieces on either side of it, all suspended from the ceiling. These are twisted and

attached to motors that produce a violent thrashing and swishing to accompany the flailing metal arcs made of the flexible steel. Once again, the expression of energy through the manipulation of material, by natural or mechanical forces, is the focus of Lye's aesthetic that cuts across traditional definitions of media. The articulation of force through a work becomes the focus instead. Like his sculptures, Lye's graphic films release or become an expression of energy, much in the same way Walter Benjamin describes the function of the mark as emerging from material to delimit its own manifestation. Rather than being impressed on an object like a graphic line, the mark rises out of it, operating as a medium for Benjamin, since it does not provide a meaning, a sign, but rather the space for one to be created, an initial "state of neutrality."[105] It is this state of initial rendering, where the force behind the generation of the mark is made visible, that Lye attempts to work through in his scratches and that sets this aesthetic of negative force applied to black film stock apart from his earlier colored lines painted on clear celluloid. Putting these scratches in motion through the technology of film only increases a sense of their power, as they seem to take on a living energy of their own that, outside the hand, has become independent and sovereign.

2 COLOR

THE PROMETHEANS

Perception has a destiny.
Ralph Waldo Emerson

IN 1952 THE MUSEUM OF MODERN ART (MoMA) PRESENTED *15 AMERICANS*, an exhibit curated by Dorothy C. Miller and designed to highlight the institution's commitment to current explorations of modernist abstraction and a new generation of American artists. Existing in a series of exhibitions dating to MoMA's founding in 1929, it was meant, like the others, to showcase contemporary American artists while promoting a sense of nationalist aesthetic achievement.[1] The 1952 exhibit capitalized on the recent popularity of artists like Jackson Pollock, whose feature spread in *Life* magazine three years earlier had catapulted him into artistic and popular culture spotlights, as well as the reputations of Mark Rothko and Clyfford Still.[2] Though only one of the previous exhibitions in the series claimed to focus on a particular style that united the artists, the featuring of these prominent abstract expressionists in the 1952 show, along with the work of the remaining artists, signaled the ways the exhibition was positioning senses of what constituted American abstraction. Found among these now canonized paintings and sculptures were the moving abstractions of Thomas Wilfred, an artist whom MoMA had supported through the purchase and display of his work since 1942 and whose popularity with patrons was recognized by the museum on several occasions.[3] That said, in 1980 the museum stopped exhibiting his moving images and Wilfred's work suffered neglect from others as well, to the point that, sometime after a 1971 retrospective at the Corcoran Gallery of Art, the institution lost *Orientale, Op. 155* (1962), one of his pieces that had been donated to its

63

permanent collection, a large machine whose projections were featured on the cover of the exhibit's catalog.

Though Wilfred fell into relative obscurity in the late twentieth century compared with many of his contemporaries also displayed in *15 Americans,* these artists were drawn to Wilfred's work, as were a number of artists and filmmakers from midcentury and earlier, dating back to the development of his aesthetic practice over thirty years before *15 Americans.*[4] In September 1919, Wilfred joined Van Dearing Perrine and Claude Bragdon to form a communal artists society called the Prometheans, dedicated to exploring patterns of abstract light as a "medium of emotional expression."[5] Soon after setting up a laboratory on the estate of William Kirkpatrick Brice, a mutual friend of the group in Huntington on Long Island, Wilfred was given financial support by Brice so that he could dedicate all of his time and energy to producing a keyboard instrument for light projection performances. Wilfred soon dominated the group, to the point of denying the admission of others who were nominated for membership by Bragdon and Perrine, and precipitated its premature end through the influence of his clear and singular vision. In his memoir, Bragdon explains how he and Perrine were reduced to mere spectators of the speed and technical facility Wilfred displayed in constructing devices that realized the aesthetic ambitions they had earlier conjured.[6] The success of Wilfred's first public performance of one of these devices, which he called a Clavilux, on January 10, 1922, at New York's Neighborhood Playhouse opened up other performance opportunities and indicated that he was free to examine his "fourteen-year-old dream: a silent and independent art of light," which he later called lumia (Plate 2).[7]

The allusion to a long-held fantasy that Wilfred includes in his description of lumia is a reference to his precocious childhood studies of color music and the works of prominent color organists and theorists of the eighteenth and nineteenth centuries, such as Father Louis Bertrand Castel, Bainbridge Bishop, and Alexander Wallace Rimington. Although fascinated with synaesthesia and the possibility of translating music into light and color, Wilfred rejected their direct correspondences at a young age and later summarized their histories to explain how color organs and "the repeated failures of 'color music' demonstrations" obscured the pos-

sibility of cultivating the use of light as an independent medium.[8] He says that "lumia may never be played in the manner of music . . . and I see no reason at all for striving toward this goal."[9] Nonetheless, the devices that Wilfred dismisses greatly influenced his work, partially evident in numbering his compositions as opuses, and he repeatedly positions himself as a figure who realizes what he sees as the obscured aesthetic goal buried in color music: motion.

The Protheans were short-lived, but the influence of Bragdon and his ideas of the fourth dimension, along with other mystical and Romantic thinkers, are vital to understanding lumia's aesthetic forms and relationships with other media. Lumia developed out of an aesthetic and philosophical idealism combined with a technological amalgamation of film projectors, color organs, and early television technologies. What resulted was not a detour in cinema's history. Instead, it shaped the trajectory of abstract animation, special effects sequences, and understandings of visual music. By the 1950s, Wilfred's lumia received increasing attention, in part through museums and other institutions acquiring his works. Though Wilfred initially performed his lumia live, he later created Clavilux devices that could mechanically project an opus without an operator present, allowing his work to circulate a little more. He also received more acclaim because other artists acknowledged their debt to his aesthetic or emulated aspects of it in their own practice. Mary Ellen Bute, Oskar Fischinger, and Jordan Belson all have direct ties to Wilfred, with Belson's films and Vortex Concerts at the Morrison Planetarium in San Francisco between 1957 and 1959 bearing traces of Wilfred's influence.[10] As Gregory Zinman has shown, the influence of lumia is often brought up by intermedial and counterculture mid-century light-show artists such as Joshua White, W. Christian Sidenius, and Stephen Beck.[11] Additionally, lumia were also employed in special effects sequences or served as the inspiration for a number of effects artists, like Douglas Trumbull.

What unites these artists around Wilfred is his play of color in time. Reviewing *15 Americans* for the *New York Times,* Howard Devree notes, "Wilfred's lumia compositions reveal how much they have influenced the abstract use of color."[12] In the mid-twentieth century, color aesthetics were increasingly explored by artists like Wilfred, as well as by a critical

discourse on color perception that, like his work, pulled discussions and experiments with phenomenologies of color from the nineteenth and early twentieth centuries into contemporary contexts through considerations of the animation of color in time. These vectors of temporality and metamorphosis were bound to the technological affordances of animation, changes that have been discussed in the context of early cinematic color practices, Technicolor, and cinematography, among others.[13] But scant attention has been paid to the role of color abstraction and its effect on moving image and animation aesthetics from this time and afterward, with Wilfred often caught in this historical undertow.

Though often obscured, Wilfred's enduring influence stems from his weave of media that project abstract motion and color to propel viewers into what the Theosophists, and the Prometheans, described as "infinite space," a concept associated with the fourth dimension and Romantic senses of a "cosmic consciousness."[14] In such a realm, sense perception is stretched or even transcended in a moment of mystical illumination that is ecstatic. This aesthetic communion had very particular technological requirements, and though Wilfred admired film's ability to project motion and color, he also recognized its imperfections. Film, known for its flicker and unstable celluloid base, could not provide the clarity and fluidity of motion necessary, and because of these perceived deficiencies, lumia does not use celluloid filmstrips to generate motion, but instead a number of different techniques and mechanisms, such as rotational discs, filters, and moving light filaments. What resulted was a type of animation constructed not out of frames of film and time separated by intervals that are perceptually effaced during projection, but instead by a seamless flow of projected light whose movements are controlled through the varied intensity of its source in addition to filters and glass that determine its color. Like other types of animation, this one is generated through the inscription and projection of light, regardless of the particular material foundations and storage technology that records its traces. Yet the technological changes produce a marked aesthetic differentiation, the sources of which can be traced to Wilfred's engagement with ideas of perception, aesthetics, and technology. Lumia emerged out of a framework and idea of cinema, but was also shaped by the legacy of a constellation of discourses that were circulating among art-

ists examining and experimenting with color aesthetics and technologies of projection. This chapter argues that lumia's abstract colors put into motion an aesthetic experience that Wilfred aimed simultaneously both at the senses and at a transcendent experience that was beyond comprehension, or outside analytic categories and perceptual schemas. In coupling color and movement, Wilfred attempted to bring to the verge of sensation aspects of temporality and color that philosophers and scientists had shown exist beyond perceptual borders, aspects that Wilfred believed could be accessed only through forms of sensual intuition. By understanding these forces, Wilfred claimed that one also felt the "majestic rhythm of heavenly bodies moving in their orbits . . . cosmic harmony . . . the music of the spheres," a Romantic coupling of knowledge of the self with the world and beyond.[15]

Wilfred's rhetoric and ideas of accessing a dematerialized "astral body" through aesthetic forms are indebted to Romanticism and Theosophy, and his emphasis on motion, in coordination with color, as generating the most important compound or element in producing mystical liberations closely aligns him with the exploration of color's relationship with rhythm found in the cinematic avant-garde of the 1910s and 1920s. In many ways, he fulfills the aesthetic ambitions of Léopold Survage, an early twentieth-century artist whose dream of producing colored abstract animations failed to develop because of material constraints. Survage describes the "form-energy within our environment" that abstract color can express, thus producing a perceptual reverie that takes on a transcendent power. But, for Survage, so much abstraction exists as "a simple graphic notation," eliding the possibilities for formal elements such as color to be "at one and the same time, the cosmos, the material world, and the energy-field of our light-sensitive apparatus—the eye."[16] The technical question for him was how to make such connections between spiritual and material realities apparent. What aesthetic practices could project viewers into a state of transcendence while avoiding the production of what Survage warned of as "confused sensation" at the sight of abstraction?

Wilfred continually wrestled with these questions, as did other artists like Wassily Kandinsky, whose responses are the best known and the most influential. In his essays, Kandinsky repeatedly describes the cosmic or

spiritual reality buried in forms and explains that we constantly perceive this nonmaterial state of things through sensation, which is composed of vibrations of energy.[17] Other writers, like Theosophists Annie Besant and C. W. Leadbeater, turned to particular graphic elements such as rings of concentric circles or mandalas and argued not only that these structures were more directly linked to the spiritual world, but that each of them also had a particular symbolic correspondence that viewers could deduce.[18] Although Wilfred rarely employed such "sacred geometry" in his lumia, he did study n-dimensional geometric theory and believed that the spiritual realm existed on a fourth-dimensional plane that is normally imperceptible. N-dimensional and especially fourth-dimensional geometry had been a topic of research in mathematics and physics throughout the nineteenth century, later growing in the popular imagination around the turn of the century. Though it shed many of its scientific roots, it became increasingly associated with idealist philosophy and a realm of existence beyond three dimensions. This shift prompted an analogous explanation of the existence of dimensions beyond those perceived in Edwin A. Abbott's popular *Flatland: A Romance of Many Dimensions* (1884), which is written from the perspective of a square in the second dimension who briefly visits the third. Although there were divergent theories addressing the aesthetic means necessary to access the fourth dimension, most agreed on its spiritual qualities. As P. D. Ouspensky explains in one of the first descriptions of the fourth dimension, it was perceived as a "sensation of infinity" that could not be rationally understood but only accessed in ecstasy through "the liberation of your mind from its finite consciousness."[19] Linda Dalrymple Henderson shows how Ouspensky's writings on the fourth dimension, along with those of Bragdon, Max Weber, and Guillaume Apollinaire, couple it with a type of cosmic consciousness that is experienced in moments of ecstatic liberation that usually stem from aesthetic experience or contemplation.[20]

Here, the influence of the Private becomes important, since Bragdon and Wilfred explored the theories and ideas behind lumia at its beginning stages, and Bragdon had published *Four-Dimensional Vistas* in 1916, just three years before the group was formed. In this text, Bragdon describes a dimensional ladder that extends beyond the third in "normal

consciousness," and even the fourth, much of which can be explained through "the Promethean fire of pure mathematics" that provides windows to a clairvoyance in space and time by understanding their relativism, curvatures, and extensions into the cosmos.[21] While still drawing from Kandinsky and Theosophical writings, Wilfred eventually argued that direct symbolic correspondences with the cosmic realm were unreliable and that it was nearly impossible to access this sphere through two-dimensional compositions. Only through a coordination of movement, color, and form could the hidden spirit of matter be revealed while simultaneously having the power to project viewers into other dimensions. In line with Kandinsky, lumia were not simply projections of how the cosmic realm might seem, but visualizations of forces or intensities that serve as the basis for sensations in and around the body. Wilfred argued that his abstractions served as gateways of sorts, perceptual phenomena that began in one world but launched spectators into another, an experience that he characterizes as an "accession to carry you beyond all human sensation."[22] His attraction to cinema developed out of its ability to put images and color in motion, and thus help create a wondrous aesthetic experience where perceptual registers were stretched or even transcended. But his dissatisfaction with celluloid, its decay, and inadequate systems of cinematic color reproduction generated a technological fanaticism in Wilfred, who wished to better lumia's aesthetic and mechanical articulations by borrowing from a variety of sources in the media landscape of the 1920s and 1930s.

MECHANICAL DIMENSIONS

Though initially unsatisfied with his study of visual music, as color organs and experiments in synaesthesia became more popular in the 1910s, Wilfred turned his attention once more to this aesthetic. Settling in New York in 1916 after his service in World War I, he learned of the many experiments in moving color in the area, such as Alexander Scriabin's use of projected color during the performance of *Prometheus: The Poem of Fire* (1910) the previous year, as well as Mary Hallock Greenewalt's color music performances that she called Nourathar and her automated machine, the Sarabet. Scriabin's score contained an instrument called Lutz, or light,

and he utilized a color organ device called a Chromola to project his color scales that moved in time with the symphony. An accomplished pianist, Greenewalt's interest in musical form led to her theoretical and technical experiments, including the development of a rheostat-and-mercury switch and the exploration of color organs and light art. Though she coupled music and color in her performances with the desire that the colored lights would operate in tandem with the music but better express their "vibrations of sound" in a visual mode through channels of synaesthesia,[23] she explains in her 1918 publication "Light: Fine Art the Sixth" that direct correspondences between them are impossible. Furthermore, she argues that "light, in its very nature, is an atmosphere, a suffusion, an enveloping medium," and therefore requires depth and must envelop the spectator, rather than work on flat surfaces in a kaleidoscopic fashion.[24] Wilfred also argued against theories espousing music and color's equivalences, but like Greenewalt, he believed that color could be projected rhythmically in a durational form like music, as his own color-notational compositions indicate.

Greenewalt had patented the notation of light and color in an illustrated score, as well as the intensity of light sequences in conjunction with music for aesthetic effects (Plate 3),[25] and took issue with Wilfred's initial 1922 performances, both in a letter to the editor of *Musical America* in March of 1922 dismissing his work as lacking visual depth and, less publicly, by having her lawyers contact Wilfred's in an effort to have him not show his written notational system while publicly performing lumia.[26] Wilfred's lawyers pointed out that the display of this system was incidental to his aesthetic practice, though they continued to keep tabs on her patent applications, finally letting Wilfred know that, in 1931, the United States Court of Appeals for the Third Circuit had declared her patenting of light or color intensity in relation to musical composition to be invalid.[27] The perceived competition and application for patents on the part of Greenewalt reveals the tensions present in the development of this aesthetic practice and the ways in which the projection of colored light relied both on new technical forms and on a new system of expression for analyzing the relations of their constitutive elements.

Wilfred's earlier compositions did lack the atmospheric quality that Greenewalt believed necessary to fully take advantage of light's properties

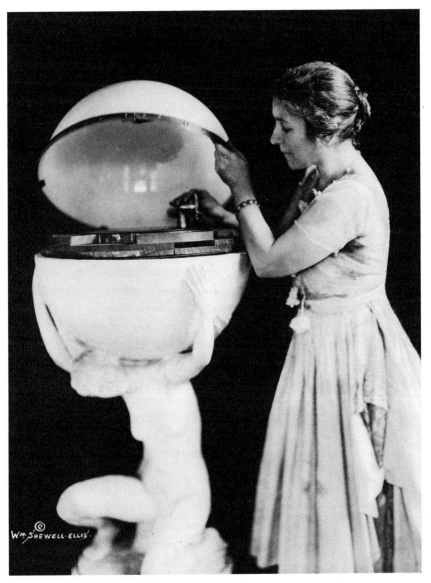

FIGURE 2.1. Mary Elizabeth Hallock Greenewalt with light phonograph, 1920. Photograph by William Shewell Ellis. Mary Elizabeth Hallock Greenewalt Papers (collection 0867), Historical Society of Pennsylvania.

and develop it as a medium, even though some of her own devices could project visual forms only for its performer or a very small audience gathered around the machine.[28] However, Wilfred quickly began to emphasize projected light's immersive qualities and its ability to show continual metamorphoses of color. These were aspects that had been neglected by previous color organists like Rimington, whose strict color–music correspondences produced, according to Wilfred, "no form, only restless flicker, hue after hue, one for each musical note sounded."[29] For Wilfred, such problems exemplify Johann Wolfgang von Goethe's analogy of color and music being two rivers that flow from one mountain source but then "pursue their way under totally different conditions in two totally different regions." In this sense, color and music act "in wholly different provinces, in different modes, on different elementary mediums, for different senses."[30] Wilfred wrote this passage from Goethe down in a notebook along with other theories of color as he tried to understand the aesthetic effects of light.[31] While Wilfred believed that color could be projected rhythmically in a durational form like music, he suggested that, more than the selection of colors used, it was the visual rhythm of the moving forms of his lumia that dictated how they were thematically characterized. In contrast to some Romantic theorists who believed that states of being are associated with certain colors, Wilfred argued for a more intuitive and dynamic model that took into account form and motion. Combinations of these elements could produce certain moods, but with so many variables, a strict correspondence was difficult to deduce.

Engineering such an aesthetic that balanced all these features required extensive effort and was worked out by Wilfred through a process of trial and error. He produced eight different Clavilux devices for public lumia performances in addition to several smaller home units called Clavilux Jr., as well as internally programmed machines for mural-sized compositions. All the instruments operate through the same basic principles and employ high wattage light bulbs, many of whose filaments were custom designed to produce different projected shapes. These could then be rotated within the Clavilux to create abstract patterns in coordination with the moving mirrors and lenses that reflected and passed light through the machine.

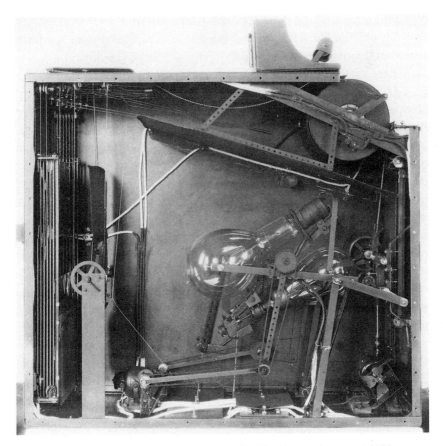

FIGURE 2.2. Clavilux Models C and D with side panel removed, 1924. Thomas Wilfred Papers (MS 1375), Manuscripts and Archives, Yale University Library.

Color gels and filters, as well as three-dimensional form elements and rolls of modifiers, added more options for the manipulation of shapes in lumia compositions. As Wilfred progressed from his original Model A to Model H, the compositional possibilities of each Clavilux also expanded, as did the large keyboards that controlled all these features with sliding keys as- signed to individual elements. The pacing of a composition's performance

was determined by the operator, who worked from a notational system that Wilfred developed for guiding the texture, shape, and color of a form within different cycles of motion.

These cycles were often very precise, as can be seen in his 1948 colored drawing *Sequential Development of Three Form Groups* (Plate 4), where abstract lines of the three primary additive colors red, blue, and green have prescribed rotational directions and placements in the frame to create dynamic operations and figure ground relations in the construction of depth. Additionally, the technical specifications for parts of the Clavilux could affect the ways in which these groups would move together. When experimenting with the number and type of bulbs used in various opuses, Wilfred illustrated in a drawing how the bulbs' shape, filaments, movement, and coordination with a lens would affect abstractions in three examples, with the number of filaments corresponding to the number of curved projections. Two of these examples come from the same work, *Abstract, Op. 59,* and reveal the elaborate correspondences of mechanical and aesthetic form while also gesturing toward the ways in which his compositions could be broken into various parts or movements. Some lumia have undulating strings of color that slowly transform, while others have flames that wrap up the borders of the projection screen, and some have crystal abstractions punctuated by sharp accents of light that twist into shapes until eventually fading to black.

Wilfred's technical research into creating his aesthetic extended in many directions, often collecting patents for other media technologies, like the one for D. W. Griffith's film projector with color effects.[32] Wilfred recognized lumia's similarities with film and was a member of the New York Camera Club from 1919 to 1922, where he became friendly with Alfred Stieglitz while learning the fundamentals of photography in order to try to record his lumia compositions. Additionally, he kept articles and advertisements on abstract animation and was particularly interested in Walter Ruttmann's work, as well as John and James Whitney's *Five Film Exercises* (1943–1944). In a personal volume that contained press articles on his lumia, one of the rare pieces not about Wilfred is from *Shadowland* and explains how Ruttmann uses moving color to produce transcendent forms that function like a visible music. The influence of 1920s avant-garde

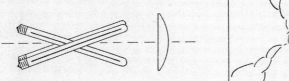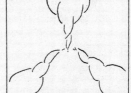

THREE TUBULAR LAMPS WITH RECTILINEAR
FILAMENTS PRODUCE TRIPLE SOLO FORM IN "ABSTRACT, OP. 59"

TWO STANDARD LAMPS WITH SEMI-CIRCULAR
FILAMENTS PRODUCE DOUBLE SECONDARY FORM IN "ABSTRACT, OP. 59"

TWO STANDARD LAMPS, ROTATING AROUND
EACH OTHER ON A TRANSVERSE HORIZONTAL AXIS, PRODUCE A
CONTINUOUS SUCCESSION OF ASCENDING OR DESCENDING FORMS

FIGURE 2.3. Thomas Wilfred, *Light Bulbs for Clavilux Projectors*. Thomas Wilfred Papers (MS 1375), Manuscripts and Archives, Yale University Library.

animations like Ruttmann's is clear in much of Wilfred's aesthetic, especially in the inclusion of plastic rolls of modifiers that project different abstract shapes in succession and that look like the scroll paintings created by artists such as Hans Richter and Viking Eggeling. But, for Wilfred, the key distinction between film and lumia was in the question of how a continuity of motion was generated on their respective screens. Wilfred argued that lumia presented an absolute continuity of motion that could be manipulated without creating any flicker that would call attention to the apparatus through which the spectacle was generated, and thus ruin the intended transcendence of sensation. Though speed was not proscribed in lumia, the freedom to create an "even flow of motion at *any* velocity" distinguishes lumia for Wilfred as a form superior to its closely related medium, film, since 24 frames per second was simply "not nearly fast enough."[33]

While Wilfred had evaluated lumia's relationship with film when constructing some of the first Clavilux machines, this issue became publicly debated in a 1948 issue of *The Journal of Aesthetics and Art Criticism* when a mathematician and fan of Wilfred's lumia, Edwin Blake, wrote to the editor of the journal questioning why Wilfred did not produce abstract films that play with color, form, and rhythm in the same way a lumia does but that could also create a permanent record suited to wider circulation and exhibition. Wilfred's response, quoted above regarding projection speeds, reveals that he was less dogmatic about recording and distributing lumia, since he began such a practice in 1930 through colored discs for his Clavilux Jr. and lumia installations, but was more attendant to the phenomenological distinctions generated through different projection apparatuses.

This is evident in his work with television in the late 1930s. NBC and CBS contacted Wilfred with hopes of finding a way to directly transmit lumia to television rather than simply recording the compositions for possible use between features, as Gilbert Seldes of CBS expressed in a 1939 letter to him.[34] Wilfred stayed true to a prior agreement with NBC and turned the CBS offer down. In 1938 Wilfred had begun construction of a Clavilux made especially for television, which he saw as *the* future exhibition venue for lumia, citing its scanning technology as more suited to representing motion than film. His device was completed and used for a 1939 broadcast, but this was unfortunately a one-time venture, since the NBC executive

FIGURE 2.4. Thomas Wilfred sitting at a Clavilux Jr. Thomas Wilfred Papers (MS 1375), Manuscripts and Archives, Yale University Library.

Clarence Farrier failed to hold up his end of the contract. Farrier not only forgot to contact Wilfred about future work with the studio but also forgot to pay him for that first exhibition. When Farrier was fired in 1941, NBC pursued other interests and Wilfred's new dream of reaching a wider audience ended. But Wilfred was not too disappointed, since this experiment proved that motion was not rendered as properly as he had hoped and the light of lumia was distorted in the medium. Most importantly, as he states in his book-length manuscript on lumia, early television did not have color.[35]

Wilfred nonetheless believed that television would eventually be technologically capable of at least adequately presenting lumia and he desired a larger audience than he was garnering through public exhibitions at various venues, including film theaters. The Clavilux Jr. was one attempt to bring his aesthetic a larger mass appeal, and based on the articles and research he gathered, the device was modeled on technology that could project different patterns of colored light based on the interpretation of sound waves, specifically the Luxatone first demonstrated in 1916 and the Telecolor from 1931. Wilfred's Clavilux Jr. was similar in size to these machines and was intended for the home market, with models that allowed for input through a remote control, similar in orientation to a regular Clavilux. Other Clavilux Jr. models had automated projection technology that read data from recorded compositions on light discs composed of different materials, such as colored glass or records.[36] After World War II, Wilfred also began accepting commissions to do mural-sized installations of programmed lumia, at one point building a Clavilux for the lobby of Clairol's New York business offices.

THE ANIMATION OF FIRE

While this new inscriptive form could generate a different way of engaging with moving images through private use at home, Wilfred was less interested in how the Clavilux could reconfigure social space through spectatorship practices. His targeted address was always the body of the viewer and the production of an ecstatic release through the manipulation of the senses. With the development of his light discs, Wilfred once again interrogated how technologies of motion manipulate the senses and reaffirmed

his commitment to not using filmstrips to project lumia, preferring instead projection apparatuses with motors, mirrors, and counterweights housed in custom made cabinets. This dogmatism can be traced back to his dissatisfaction with the instability of celluloid and any kind of flicker in the image, which was not only an artistic frustration about the quality of materials available for the construction moving images, but also rooted in his young study of perception and aesthetics, a study later guided by Bragdon while the Prometheans were still active. Wilfred primarily sought a high-fidelity method of recording and projecting light that would not deteriorate or cause spectators to become aware of the projection system because of errors or noise within the apparatus. But, while the immersive spectacle of lumia necessitated the inscription of light onto a material support for later automated projections, again, the actual material base did not have to be celluloid in order to draw from the aesthetics of film, and Wilfred viewed the Clavilux as an improvement on contemporary film projection systems. Like celluloid, the Clavilux discs functioned as inscriptive media, a storage technology that operated in coordination with a system of projection to archive sense data. Though still indexical records of color traces, this storage technology did not attempt to capture the contingency of the present through an apparatus that can testify to the experience of presence in the way photography is usually situated. Nor is it built on a model of human perception like the phonograph that, as James Lastra points out, was one of many devices in the nineteenth century that came "to embody a new paradigm of ideal and decidedly inhuman sensory acuity."[37] Instead of fidelity to a world whose traces could later be projected, the Clavilux and its discs recorded traces of abstracted formal elements that, when put in motion, produced ethereal spectacles of color.

In his reconfiguration of the relationship between the projected film image and its material support, Wilfred was also reexamining the interaction between stasis and movement in animation, the aesthetic and technical specificities of which came up in his response letter to Blake. For Wilfred, animation is the "art of painting carried into the time dimension," a characterization that emphasizes the ways in which, he says, animated films are composed first of a book of still images before a transformation of their "dormant motion" occurs through a technical synthesis. He explains

that, though viewers may have expectations of speed in certain contexts, such as Donald Duck or abstract and nonobjective film, "all attempts in this direction have resulted only in flicker and eyestrain," while "in lumia . . . no such problem exists."[38]

By eradicating the interval between frames in animation to better control the articulations of form and motion, Wilfred interrogated and challenged the ways in which moving images operate in time, or as Keith Broadfoot and Rex Butler characterize it, the interrelationship between poses and movement that serves as the foundation for the medium. In their analysis of the illusion of animation they describe two kinds of movement: one that is quantitative, defined through causal relations of stasis and movement, and another that is qualitative, where stasis and movement appear simultaneously. In the latter, "instead of a regular series of fixed poses and movement, which leaves us unable to see how one is transformed into another, there is the irregular and aleatory occurrence of singularities, at once a pose and the movement connecting one pose to another."[39] Qualitative movement always plays with the relationship between movement and stasis, pointing simultaneously to Zeno's paradox of the arrow, which defines quantitative movement, and to the articulation of a form's movement that folds in on itself by trying to both abstract and synthesize its own actions.[40] Broadfoot and Butler explain how certain kinds of animation have this movement, self-reflexively revealing their constitution with forms dependent on the machinations of the apparatus that puts them in motion. This is an aesthetic that focuses on the action of becoming in animation, or that attempts to visually articulate the paradox of being "at once the pose and the movement connecting poses, the pose and the impossibility of the pose."[41] It is an aesthetic that plays with how movement is perceived in the image. Sergei Eisenstein, according to Broadfoot and Butler, describes animations that have this as exhibiting a plasmaticness, or quality of continually metamorphing and folding onto themselves in a constant state of becoming. Quantitative movement, on the other hand, operates through a unidirectional continuity of poses that are united perceptually. This movement functions *through* time, a conjoining that Aristotle explains in *Physics* as happening in *aisethesis* where the process or mechanics of movement is papered over in the process of its own becoming. The rapid succession of

multiple images produces the perceptual effect of seeing only one image in motion, eliding the registration of a multiplicity of images and the gaps separating them.

This registration of movement in space through perceptual operations is precisely what Henri Bergson analyzed in several essays and books to which Wilfred was exposed in a variety of contexts. Wilfred read and took notes on Alexis Carrel's *Man: The Unknown* (1935), a controversial text in many regards, which contains a chapter entitled "Inward Time" that summarizes Bergson's ideas of duration from *Creative Evolution* (1907) by quoting key passages defining the term and considering its relation to objects throughout the universe.[42] He additionally read Adolfo Best-Maugard's *The Simplified Figure: Intuitional Expression* (1936), which does not directly cite Bergson, but does work from his ideas of intuition and sensation in considering the construct of graphic form.[43] Wilfred also may have been exposed to Bergson through his friendship with Stieglitz, whose journal *Camera Work* published a translated excerpt of *Creative Evolution* about aesthetic intuition in relation to forms of perception in October of 1911. It also published a selection of *Laughter: An Essay on the Meaning of the Comic* (1900) entitled "What is the Object of Art?" in January of 1912.[44] But most obviously, Wilfred likely learned of Bergson's ideas through his collaboration with Bragdon, who discusses Bergson's ideas of duration at length in *Four-Dimensional Vistas*, both in his chapter on "Curved Time," which explains the conscious experience of time and the dimension's relativity, and in a section of the book that investigates Bergson's cinematographic metaphor for reason and consciousness. In the latter analysis, Bragdon holds out hope that there are ecstatic states of perception that can access Bergson's notion of *élan vital*, which would be akin to unlocking another dimension of experience, since in our three dimensions, "we may be images in a world of images; our thoughts shadows of archetypal ideas, our acts a shadow-play upon the luminous screen of material existence, revealing there, however imperfectly, the moods and movements of a higher self in a higher space."[45]

Bergson's phenomenology has been the subject of a number of critics and theorists who either utilize his approach to explain perceptual phenomena or critique it for what they characterize as an insufficient reliance on the homogeneity of time.[46] But regardless of the validity of Bergson's

phenomenological and epistemological models, especially the often cited cinematographic metaphor, his ideas had a profound influence on artists like the Prometheans, who worked through these theories in order to understand how to produce an aesthetic that harnessed technologies of movement for the sake of propelling spectators beyond normal forms of perception. Bergson explicitly describes two ways of knowing in *An Introduction to Metaphysics* (1903): analysis and intuition. The first is characterized by a representational or symbolic scheme that defines objects in our surroundings and allows for them to have practical utility as parts of a total impression of the world that contain a determinate interest on the part of the perceiver. Here, perception operates through abstraction because, in order to relate objects and experiences to one another for a purpose, even a routine one such as recognition or identification, they must be expressed in terms other than themselves. As Bergson explains, "all analysis is thus a translation, a development into symbols, a representation taken from successive points of view from which we note as many resemblances as possible between the new object which we are studying and others which we believe we know already."[47] This analytic mode extends into how we perceive movement and time as well. Consciousness can understand and recognize movement only through a simultaneous multiplicity where movements in space are analytically broken into successive states and then synthesized, much in the same way that Aristotle describes, with Bergson similarly declaring that this synthesis is "a mysterious operation which takes place in darkness."[48] This operation that he calls "spatialization" occurs with time as well, where any kind of representative logic or instantiation of time into a medium manifests itself through space.[49] Spatialization, then, is the means through which cognition measures, analyzes, and makes sense of objects and the world. It is the activity of perception and, as Bergson explains in *Time and Free Will* (1889), "spreads into the depths of consciousness."[50]

In Bergson's model, the perception of movement occurs in the mysterious darkness through the unity of abstract states. Akin to Zeno in his paradox of the arrow, Bergson in *An Introduction to Metaphysics* uses the metaphor of a pearl necklace: "We shall have, on the one hand, as great a number of points on the trajectory as we may desire, and, on the other hand, an abstract unity which holds them together as a thread holds together the

pearls of a necklace."[51] In *Creative Evolution,* the metaphor changes shape and Bergson uses the cinematic apparatus as a way of explaining how perception operates analytically. Static photographs represent the isolated pearls, and the thread that unites these abstracted states is here the projection apparatus: "In order that the pictures may be animated, there must be movement somewhere; . . . it is in the apparatus."[52] He explains that our consciousness operates in a way similar to cinema:

> We take snapshots, as it were, of the passing reality, and, as these are characteristic of the reality, we have only to string them on a becoming, abstract, uniform and invisible, situated at the back of the apparatus of knowledge, in order to imitate what there is that is characteristic in this becoming itself. Perception, intellection, language so proceed in general. Whether we would think becoming, or express it, or even perceive it, we hardly do anything else than set going a kind of cinematograph inside us. We may therefore sum up what we have been saying in the conclusion that the *mechanism of our ordinary knowledge is of a cinematographical kind.*[53]

Bergson points out that this is an operation of perception and a *method* of knowing the world, of operating "practically" within it and utilizing knowledge and consciousness for action. Many critics point to the above passage and claim that Bergson has a dissatisfaction with cinema generally. But Bergson's critique is more specifically focused only on utilizing this method, and he reveals that another way of knowing also exists: intuition.

Rather than develop a representation of an object in order to derive its significance in relation to other objects for consciousness, intuition moves into and through the object. While analysis implies that we "move around the object," intuition implies that we "enter into it."[54] In this epistemological scheme, a continuity of the world with temporality exists that cannot be broken down into isolated fragments or blocks. Bergson argues that this is how the world truly exists and that the mysterious links between spatialized instants, or the intervals always present regardless of how small the increments between blocks of time, point to the existence of a "continuous flux" of time, a duration, that cannot be divided.[55] Because of this

continuity and indivisibility, objects exist in a state of perpetual becoming, of movement and development that is difficult to grasp and impossible to know through consciousness or perception. Only through intuition can this absolute be grasped:

> When I speak of absolute movement, I am attributing to the moving object an interior and, so to speak, states of mind; I also imply that I am in sympathy with those states, and that I insert myself in them by an effort of imagination. Then, according as the object is moving or stationary, according as it adopts one movement or another, what I experience will vary. And what I experience will depend neither on the point of view I may take up in regard to the object, since I am inside the object itself, nor on the symbols by which I may translate the motion, since I have rejected all translations in order to possess the original. In short, I shall no longer grasp the movement from without, remaining where I am, but from where it is, from within, as it is in itself. I shall possess an absolute.[56]

In order to employ this method of intuition, one must engage in an intellectual sympathy with the object, which, as Gilles Deleuze explains, "leads us to go beyond the state of experience toward the conditions of experience."[57] Bergson admits the difficulty of this, conceding that "the mind has to do violence to itself, has to reverse the direction of the operation by which it habitually thinks."[58] Doing so, however, opens up potentialities of experience and knowing that otherwise remain dormant, and intuition leads to a better understanding of not only the world, but also the self.

Many of these tenets about intuition and its relation to intellectual sympathy are discussed in the passage of *Creative Evolution* that was reprinted in *Camera Work*, a section of the book that highlights the two ways of knowing described above while also linking intuition to aesthetic experience. At other moments, Bergson describes both the conditions for the experience of intellectual sympathy with an object and the duration of time. In *Matter and Memory*, for instance, he describes how a continuity of sensation needs to be restored that is usually broken into discontinuous points by perception, and he explains in *Time and Free Will* that this continuity is maintained during sleep, which changes the ways sensations

are organized by the mind: "Here we no longer measure duration, but feel it; from quantity it returns to the state of quality."[59] While Bergson describes technologies or works that function as metaphors for how consciousness breaks sense data into spatialized points, like the operations of the cinematic apparatus, he often leaves open-ended the question of how aesthetic forms can elicit intuition. In one passage from *Laughter* reprinted in *Camera Work*, he provides a more concrete way of engaging with how intuition could be elicited through aesthetic experience.

As Bergson explains in *Creative Evolution,* aesthetic experience can lead to an intellectual sympathy with form and the world while moving past using consciousness solely for utilitarian purposes. Such experience has the power to remove the veil that exists "between nature and ourselves," an estrangement that also makes our own perceptual engagement with the world appear foreign.[60] It generates a "purity of perception" that he characterizes as intuition in *Creative Evolution* and that is set into motion through "rhythmical arrangement[s]" to "become organised and animated with a life of their own."[61] Moving into the aesthetic object in this description of intuition involves recognizing that form is not instrumental, that it not only has utility but also contains its own animus. Accordingly, this acknowledgement and simultaneous movement into the object involves a communion with that form's animus, a melding of subject and object into an absolute continuity. This is why Bergson characterizes this engagement as a kind of sympathy with the object.

This is the conceptualization of intuition that Bragdon employs in *Four-Dimensional Vistas* to explain how the fourth dimension can be experienced. He also contrasts intuition with quantified renderings of experience, citing Bergson in his claim that "reason and intuition are seen to be two modes of one intelligence."[62] For Bragdon, the fourth dimension that could be accessed through intuition was characterized as an indivisible realm similar to the absolute that Bergson describes. For the Prometheans, the cultivation of an aesthetic and technology that caused spectators to inhabit this phenomenological mode was key to experiencing the fourth dimension. They desired to produce an art of the ineffable whose movement, rhythms, and form were not only novel but also challenging to viewers perceptually—an aesthetic that caused an intuitive engagement with

matter. The Prometheans turned to an abstraction that elides cognitive schemas in order to facilitate a desired purity of perception that enables a focus on the relationship between movement and color. As Bragdon explains, this would be "an art of mobile color, not as a moving picture show—a thing of quick-passing concrete images, to shock, startle, or to charm—but as a rich and various language in which light, proverbially the symbol of the spirit, is made to speak, through the senses, some healing message to the soul."[63] The influence of Bergson's condemnation of the cinematic apparatus's employment of movement through the succession of static images shines through in this formulation, but Bergson's description of the ways in which duration can be felt by the body through sensation rather than conscious perception is also at work. Bragdon argued that, through an aesthetic that operated on the senses without figuration or concrete form, one that seemed to make visible the life force that exists in the world but was unknown to rational perception, viewers would have the kind of intuitive engagement with the world that Bergson described. This would subsequently produce an ecstatic experience, the sensation of infinity in the fourth dimension.

In 1918 Bragdon again characterized this aesthetic as "an art of mobile color unconditioned by considerations of mechanical difficulty or of expense: . . . sunsets, solar coronas, star spectra, auroras such as were never seen on sea or land; rainbows, bubbles, rippling water; flaming volcanoes, lava streams of living light."[64] While film could project abstract images, it could not do so as fluidly as Wilfred's Clavilux. These natural abstractions punctuate color and motion, but also manipulate senses of temporality and stasis, an effect Aristotle describes as the waterfall illusion, which is a result of neuron fatigue that applies to color as equally as to time.[65] Indeed, as Sheldon Cheney described in 1924, time grows evasive in lumia as metamorphoses and colors develop distinctive qualities and themes to produce "that feeling of detachment, of ecstasy, which is a response only to the most solemn religious or aesthetic experience," a feeling accentuated by the time loops of many mechanized Claviluxes that run for hundreds of hours before repeating.[66] Cheney recounts what can be best described as a sublime experience that, as Henderson points out, was synonymous with the fourth dimension in the early twentieth century through their shared

interest in an experience of infinity.[67] Wilfred, however, intended to reproduce the pleasure of the sublime without its terror. The transformations of color were key to this project, in contrast to the assaultive power he saw in static color. In a lecture at the Art Institute of Light in New York that Wilfred founded, he explains:

> Form and motion are the two most important factors and they determine to a great extent the effect a given color has on us. Red, for instance, the color of fire and blood is basically exciting if it flashes before the vision in flamelike waves. . . . But if we stop all motion and show a large even area of plain red the effect is provocation and irritation and the subconscious reason is: Flames always flicker, rise and fall, this red does not move, it is unusual.[68]

The legacy of Wilfred's collaboration with Bragdon is clearly apparent in this statement, especially his conceptualization of how colored light takes on a paradoxical immaterial body in the articulation of four-dimensional space, which can be sensed, but not through the apprehension of a static object in space and only in coordination with imaginative faculties. In an effort to create an environment for this activity, Wilfred painstakingly manipulated his performance venues, covering windows with cloth and painting walls black so that the phenomenal world would seem to melt away in the absolute darkness before lumia performances, representing "a transition, . . . the dark before the dawn."[69] Wilfred also explained how the new intervening light can transfix materialized vision into believing that it witnesses "a large window opening on infinity, . . . a radiant drama in deep space," to enact a breakthrough of sensual or physical vision into imaginative seeing, a movement from material embodiment to transcendent illumination that also produces "a balance between the human entity and the great common denominator, the universal rhythmic flow."[70]

Like Bragdon, Wilfred uses fire as a metaphor for describing the seamless and transformative movements in lumia, as have many critics. In 1922, Stark Young used this image as a way to characterize lumia's immaterial motion, explaining that, though it was a new art, there was "no sense of strangeness . . . we realize its closeness to our dreams. This is what was in us when we watched the clouds . . . or when we sat watching the shadows

IMAGINATION — THE ESTHETIC CONCEPT.

THE ARTIST VISUALIZES A LUMIA COMPOSITION IN SPACE. HE AIMS
TO PERFORM IT SO CONVINCINGLY SPATIAL THAT THE SPECTATOR
IMAGINES HE IS SEEING IT THROUGH A LARGE WINDOW IN THE
CABIN OF A MAGIC SPACE-LINER.

REALITY — THE PHYSICAL EQUIPMENT.

THE SPECTATOR IS SEATED IN A RECITAL HALL. THE MAGIC
WINDOW IS A FLAT WHITE SCREEN. THE ILLUSION OF SPACE
IS CREATED WITH A LUMIA PROJECTION INSTRUMENT CON-
TROLLED BY THE ARTIST FROM A KEYBOARD.

FIGURE 2.5. Thomas Wilfred, *Imagination and Reality of Light*. Thomas
Wilfred Papers (MS 1375), Manuscripts and Archives, Yale University Library.

in the fire; in those embers where, as now in this color, the life of the mind went looking for its experience, and found things true to itself in color and form and motion."[71] As Young continues his description, he identifies how Wilfred's aesthetic mechanically replicates the sensual reverie that natural abstract forms produce. Quoting Samuel Taylor Coleridge on the wonder of science and discussing the moments of childhood when one did not attempt to wrestle meaning from such spectacles, Young's essay is pregnant with Romantic terms for creative perception.

The Romantics associated with childhood a freshness of sensation that could overcome habit, custom, and regular engagements with the world, and many modernist writers returned to this theme especially when evaluating the perceptual effects of film. In essays by Eisenstein and Walter Benjamin, animation held a particular power in this regard.[72] Though in different ways, animation existed for each as an attraction whose technological play with the animate and inanimate, with shape and metamorphosis, and with subject–object relations held a redemptive potential. Eisenstein's discussion of animation has a particular affinity with Wilfred's lumia through his explanation of the shared spectacular logic of animation and fire. In his collected writings on Disney, Eisenstein explains that fire is an attraction that is "capable of most fully conveying the dream of a flowing diversity of forms" and that it can hypnotically absorb attention as it propels spectators into the "pure sensation" of ecstasy.[73] This foregrounding of sensuality takes place through fire's continual movement in time, through its "absolute unrest" and nonrepetitive changes that perceptually grip and fascinate viewers, sometimes, as Eisenstein points out, to an obsessive state such as pyromania. The perceptual release of these metamorphoses can be intoxicating, perhaps because of the neural fatigue, and like Young, Eisenstein believes that this ecstasy can be produced by other natural forms like the movement of water, clouds, or music, though he argues that fire has the greatest power to attract and hold viewers through its variability that shows "an image of coming into being, revealed in a process."[74]

The focus for Eisenstein here is on the power of colored light as a natural force that can be technologically replicated through animation. Similarly, Benjamin writes in many essays about the transformative sensual appeal located in animation that he also sees in children's books, as

well as in natural forms like rainbows. In his desire to return to a Romantic freshness of sensation and perception, Benjamin discusses the ways in which color in this state "is fluid, the medium of all changes," and has a shimmering whose abstractions can generate a harmony of aesthetic vision.[75] He quotes Goethe at length about the attraction of transparent colors, explaining that "their magic lies . . . in the colored glow, the colored brilliance, the ray of colored light," which can engender a creative perception and imagination that children have.[76] This is a "pure vision" that color can elicit: "[Color] goes right to the spiritual heart of the object by isolating the sense of light. It cancels out the intellectual cross-references of the soul and creates a pure mood, without thereby sacrificing the world."[77] Benjamin argues that natural forms such as rainbows generate this mood and produce a purity associated with the infinite in contrast to color in painting, which appears through a process of inscription on a material support.[78] At issue for Benjamin, as it was for Wilfred and the other Prometheans, is the projection of colored light and the lack of substance but rendering of form enabled by color contrasts.

TISSUES OF LIGHT THAT TOUCH ARTIFICIAL MOONS

Eisenstein and Benjamin were not alone in believing that colored light had the greatest power to generate this type of aesthetic reverie. Greenewalt made a similar claim when comparing her work to music: "Light is still finer. It is still deeper in its infiltration, within the body's tissues."[79] But, for all these theorists and practitioners, color was an integral aspect of light and working with it would enable the projection of any sense of shape in an immaterial form. Like movement, color was situated as having its own energy that, when put in motion, would create harmonious metamorphoses. In each lumia opus, Wilfred carefully measured the effects of different elements of color, such as the hue, chroma, value, and intensity. But, again, he was clear that color had to operate in conjunction with motion and form to anchor viewers in the spectacle. Otherwise, he warned, the spectator "will quickly seek a visual anchorage elsewhere, an apex for the distance-measuring triangle that has its base between the pupils of his eyes."[80] In his typical autodidactic style, he studied optics and the perception of color

in scrupulous detail, carefully documenting theories of the color spectrum and different color wheels, as well as Goethe's experiments and hypotheses of color effects. He did this while also drafting notes on how to coordinate abstract colored forms in motion and kept careful records of these drafts for later incorporation into a lumia opus, at times making records of color elements using the notation system he developed, as seen below (Figure 2.6) in one of the keys to that notation system with a corresponding chart for the keyboard.

Though the mechanisms of color fascinated Wilfred and he worked through how to register particular types of color through a study of light and optics, the focus was always on the spectator and how these colors affected perception. Emphasizing the process of seeing color not only prompted him to solicit feedback from viewers in the form of questionnaires that he

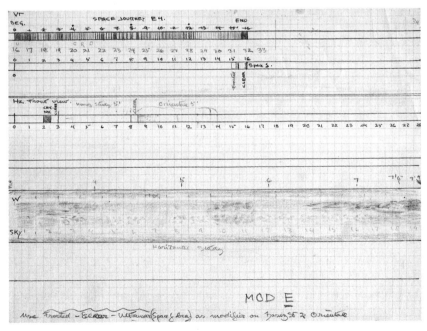

FIGURE 2.6. Thomas Wilfred, Model E notation for composition. Thomas Wilfred Papers (MS 1375), Manuscripts and Archives, Yale University Library.

carefully catalogued and summarized according to different opuses and exhibition spaces, but also made him incredibly sensitive to the activity of the eye and body in sensing these colors. In particular, he used Michel Eugène Chevreul's theories of simultaneous and successive contrast and began utilizing these perceptual effects in the construction of his opuses, illustrating in his notes how the climax of a composition relies on the contrast of complementary colors for an aesthetically pleasing final effect.

Wilfred desired for this to not only affect the eye, but radiate throughout the body as well, projecting perception toward a future that Emerson alludes to in the epigraph of this chapter, which also appears at the beginning of Bragdon's *Four-Dimensional Vistas*. And, as Wilfred and Bragdon make clear, there are several other natural forms that can provide spectators access to this other state of consciousness, but the difficulty, as Wilfred explains, was in the proper rendering of a device of mechanical reproduction that could harness the energy of those natural forms. This recognition that there is an animus or force that permeates nature was articulated by Goethe in his studies of science that Wilfred read, particularly *Theory of Colours*. As Rudolf Steiner explains, Goethe's writings on science, especially his studies of morphology, emphasize how "sensory qualities arise in an organism as the result of something *no longer perceptible to the senses*. They appear as the result of a higher unity hovering over the sense-perceptible process."[81] According to Goethe, natural forms emerge out of a "unifying principle" that exists beyond perception, an animus that keeps organic forms in flux—unfinished, never at rest, and in a constant state of change. Color is a particularly privileged part of the natural world that reveals this animus, but in the preface to *Theory of Colours*, Goethe is quick to point out that light is not the only means through which it is seen and explains how the "infinite vitality" of color can be made visible for even the blind through other means, such as musical harmonies.[82] In fact, Goethe's work on color is as much about embodied perception as it is about color, as seen in the ways he describes afterimage effects and other perceptual operations that, as Jonathan Crary explains, belong solely to the body of the observer who is situated in Goethe's writings as the engine of optical experience.[83] This emphasis on a phenomenological account of color relocates the center of color experience in the corporeal body, shift-

ing it away from an aspect of light that Isaac Newton had emphasized in *Opticks*.[84] Goethe even begins *Theory of Colours* with a description of "dazzling colourless objects" experienced in a room "made as dark as possible," with a small amount of light allowed to enter that then produces a variety of colors through retinal vibrations that actively generate color experience.[85] As Crary shows, Goethe's emphasis on afterimages and other optical experiences was part of a shifting landscape around understandings of the body's involvement in perceptual operations.[86] This transformation located the body as an agent for the synthesis and production of optical and, more generally, sensory illusions.

These ideas about a corporeal, subjective vision influenced a variety of modernist artists, as well as the understandings of optics, though they were debated throughout the nineteenth and twentieth centuries. A younger contemporary of Goethe, Arthur Schopenhauer, worked through Goethe's ideas on color and perception in his book *On Vision and Colors*, which Wilfred also references in his notes.[87] For Schopenhauer, Goethe's emphasis on the body as the primary site of optical experience did not go far enough, since Goethe still located color outside the body and attempted to describe aspects of physical and chemical colors. Rejecting these categories, Schopenhauer's theories of color perception abandoned notions of an objective external world, a rejection that both Crary and Georg Stahl explain as a dissolution of subject–object relations, a collapse articulated through Schopenhauer's definitions of the differences between sensations and representations. Sensation, in this theory, exists as data for which an immediate or "intuitive perception" of the phenomenal world can be rendered, but it is inside the body, which also locates the cause of the stimulus in the external world as a part of reality that can be understood only through a perceptual articulation of space, or representation of it. Thus, the difference between cause and effect, between subject and object, disintegrates, since all of this exists as "a function of our brain."[88] Like Goethe, this focus on the body of the observer helps explain the sensation of color in the dark and the activity of this body in the production of perception more generally. For Schopenhauer, "color is the qualitative divided activity of the retina," or the perception of a variety of colors along the retina brought about through an external referent. These color sensations can appear for us through

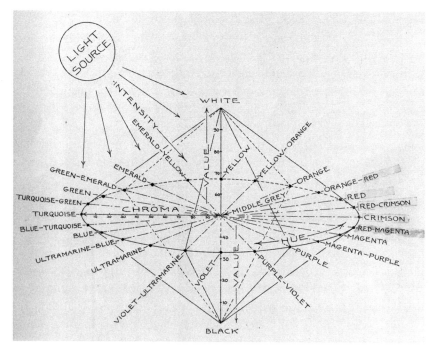

FIGURE 2.7. Thomas Wilfred, *Light Source and Diamond-Shaped Color Spectrum*, circa 1940–50. Thomas Wilfred Papers (MS 1375), Manuscripts and Archives, Yale University Library.

predicted mathematical relations of color energy from the initial stimulus, a mixture and correspondence that he sees in Phillipp Otto Runge's color sphere from the early nineteenth century. Runge's color sphere was intended for artists to use and took into account the relations of hue, value, and chroma whose correspondences bear a resemblance to those in the sphere that Wilfred drew to explain his determination of a color in his work.

This color sphere was designed around creating harmonic balances of color in compositions whose correspondences matched the color energies on the retina that Schopenhauer identified and the relations of light and dark colors that Goethe was working through as well. While many aspects of these theories were contested by the scientific community or over-

shadowed by later models, some of their principles continued to affect ideas about color or the technical projection of color aesthetics and effects. In the 1950s, Edwin Land, founder of Polaroid, developed a colorizing technique for black and white photographs by working from nineteenth-century experiments with colored light and shadows. Publishing a summary of his findings in *Scientific American* in 1959, he began to articulate what would later be called his "retinex theory" of color perception, which challenges beliefs that the eye registers the same vibration of color in the wavelength of light that is found at the corresponding point of the stimulus. Instead, as he shows through a variety of experiments, the perception of color is affected by its boundaries with other objects and sources of illumination.[89] As physicists Neil Ribe and Friedrich Steinle explain, "it recognizes lightness (that is, reflectance) as the fundamental stimulus of color, and it emphasizes the importance of boundaries, which allow the eye to estimate lightness by seeking out singularities in the ratio of energy flux from closely spaced points."[90] Applying these theories, Land was able to colorize black and white images in what appeared as a full spectrum by using only two hues, one long and one short wavelength, relying on our perceptual synthesis and relations to fill in the missing colors. This focus on boundaries and the importance of the observer in color perception was precisely what Goethe also emphasized, with Land investigating these phenomena through analyses of measured wavelengths.

Such theories and experiments reveal how color exists through our sensual relation with the world, which operates through an interweaving that can be so specific as to produce problems in conventions of conceptual logic, a difficulty studied by Ludwig Wittgenstein in *Remarks on Color*, written just before his death in 1950. He recognizes color as a "phenomenological problem,"[91] one that Maurice Merleau-Ponty similarly takes up in *Phenomenology of Perception*. When defining sense experience, Merleau-Ponty turns to color in order to show the ways in which any experience is constituted through a blending of subject and object, or what he calls an intertwining, a mutually constitutive merging of the body and world:

> The sensor and the sensible do not stand in relation to each other as two
> mutually external terms, and sensation is not an invasion of the sensor

by the sensible. It is my gaze which subtends colour, and the movement of my hand which subtends the object's form, or rather my gaze pairs off with colour, and my hand with hardness and softness, and in this transaction between the subject of sensation and the sensible it cannot be held that one acts while the other suffers the action, or that one confers significance on the other. Apart from the probing of my eye or my hand, and before my body synchronizes with it, the sensible is nothing but a vague beckoning. . . . As I contemplate the blue of the sky I am not set over against it as an acosmic subject; I do not possess it in thought, or spread out towards it some idea of blue such as might reveal the secret of it. I abandon myself to it and plunge into this mystery, it 'thinks itself within me,' I am the sky itself as it is drawn together and unified, and as it begins to exist for itself; my consciousness is saturated with this limitless blue.[92]

Color here reveals the structure of sensation itself and the fusion of the body with the universe, a coupling articulated through a denial of the tenets of acosmism that would posit the blue sky or world as illusory. Instead, color is created through an interpenetration of the sensing body and the world: they plunge into one another, producing a saturation of experience and sensation.

In a similar fashion, Wilfred studied how the interaction of colored light affects its perceptual registration and the ways in which color is synthesized by the brain, remarking in his research notes on the "Psychology of Sight" that "every visual object is perceived in dependence, not only upon the sensation of intensity and color which are due to the excitement of the retina, but also upon the sensation of motion."[93] Noting that much of the light spectrum is imperceptible, he explains in other contexts that the eye is not the only part of the body receiving light, since our skin also absorbs it, and more importantly, that the eye is not always able or trained to register parts of the color spectrum:

The human eye receives visual impressions far in excess of anything the brain can record in a useful way and at the entrance gate to the brain from eye and ear we have a sorting room through which only a part of the impressions are permitted to reach the consciousness, and accord-

ing to the quality and efficiency of this sorting room we become wise or ignorant, happy or unhappy. It may well be compared to the tuning dial of a radio receiver.[94]

Remarking on the evolution of human perception, Wilfred gestures toward the ways in which lumia will be able to retune the senses, making spectators aware of their own habitual perceptions and opening them to scales of energy and space beyond normal registers. Just as he suggests that it is "conceivable that each single proton in the nucleus of an atom encloses another universe," he similarly believes that his aesthetic not only makes one aware of these worlds, but can bring them into perceptual consciousness to make contact with the tissues of the body.[95] Here, lumia's technological alchemy both saturates the body in an envelope of sensation and attempts to launch it into another dimensional experience, harnessing colors from the heavens for touching an artificial sky.

3 INTERVAL

*The idea we have of the world would be
overturned if we could succeed in seeing the
intervals between things.*

Maurice Merleau-Ponty
"The Film and the New Psychology"

IN 1954 ROBERT BREER CONDUCTED AN EXPERIMENT WITH FILM IN ORDER
to better understand the tools and methods available to him as an animator
in constructing motion. He exposed six feet of 16mm film one frame at a
time, as he had done in previous animated films, but decided to make each
image "as unlike the preceding one as possible" and then looped the ends
of the film together using rubber cement, so that it could be endlessly pro-
jected. Though he expected that the film would prove monotonous upon
viewing, he found instead that "the eye constantly discovered new images."[1]
After many projections, the film loop eventually wore out, but the experi-
ment spawned an interest in the perception of motion that led him to create
optical toys like thaumatropes, mutoscopes, and flip-books, as well as some
of his most well-known films, such as *Recreation* (1956), *Eyewash* (1959),
Blazes (1961), and *Fist Fight* (1964). The films produced during this phase of
Breer's career are commonly referred to as his collage films, a designation
that Breer embraces in numerous interviews, revealing that, when making
them, he was working from the ideas and aesthetic forms found in Kurt
Schwitters's collages, but making them more "dynamic and rhythmic."[2]

This influence is doubly apparent in *Recreation*. Its soundtrack con-
sists of a nonsense text read in a staccato rhythm by Noël Burch, which
was inspired by the nonsense poetry and audio recordings of Schwitters,
like the poem *An Anna Blume* (1919). Visually, many of the film's frames

99

contain cutout shapes that are juxtaposed with advertisements, newspaper, or drawings in a style reminiscent of Schwitters' *Merz* pieces. But Breer does not limit the visual collage to a static form. By employing a rapid montage in which most shots last for only one, two, or three frames, the film stacks the collage of images through time. It produces juxtapositions that play off one another not only to merge disparate forms but also to create a new kind of perceptual continuity, one that he explains is based "more in counterpoint than in harmony" and that allows for rediscovery,

FIGURE 3.1. Filmstrip from Robert Breer, *Recreation*, 1956. 16mm, color, sound, 2 minutes. Courtesy of Kate Flax and gb agency, Paris.

with new forms, colors, and images endlessly found through multiple viewings.[3] Having earlier explored animators' traditional tools for producing illusions of fluid, continuous motion, Breers now exploits those tools. Along the lines of Norman McLaren's understanding of animation as "the art of manipulating the invisible interstices that lie between frames" (see the introduction of the present book), Breer's work during this period continually explores this interval through mutoscopes or flip-books that allow for the viewer's direct control over the passage of time between successive frames

or through the densely compact montages developed in his discontinuous single frame animations that both perceptually excite and antagonize viewers.[4] Each of these kinds of works develop an aesthetic that I call "disintegrated animation," where the perceptual limits that are usually utilized to generate a fluid image of movement are exposed by ruptures in continuity through either the juxtaposition of discrete images in cinematic temporal progression or a play with technologies of viewing.

Breer recognizes the violence born from the discontinuity he creates in his collage films, noting how often, when screening them, "people stalk out of my films, and are angered."[5] Jonas Mekas writes about observing the same reaction in a 1964 column for *Movie Journal*:

> People have told me, after seeing Robert Breer's film *Blazes* or after Stan Brakhage films, that they have headaches. Which is very possible. Others among us, those who have been watching these films more often, feel that the movements are too slow—we could take so much more. Our eye has expanded, our eye reactions have quickened. We have learned to see a little bit better.[6]

In the 1960s, Mekas many times emphasized the perceptual play occurring in contemporary American independent cinema that he says fostered an "expanded eye" of heightened perceptual acuity. This critique eventually led to the cataloguing of many of these films as being part of the "expanded cinema" of that era, but Mekas is quick to point out that the eye is not physically changing so much as it is being retrained to see differently in these films.[7] For him, it is more a matter of attention, of "removing various psychological blocks than to really changing the eye," which defamiliarizes the world and can lead to a transformation of consciousness and subjectivity.[8] Such an act of estrangement answers Russian formalist Victor Shklovsky's call for art to "make objects 'unfamiliar'" and reorient perceptions of the world, a connection that was clear to P. Adams Sitney in 1969 when writing his first articles about the graphic and structural films of the 1960s.[9] The concomitant pain and feelings of disorientation experienced by some spectators is brought about because its aesthetic catalyst interrupts habitual modes of perception. These normative habits are precisely what Breer is interested in examining, manipulating, and exposing for view-

ers through his disintegrated animations and optical toys. As Breer says, he wishes to "attack the basic material, to tear up film, pick up the pieces and rearrange them."[10] At issue for Breer is the interval of time separating pulses of animation in projection and the perceptual syntheses that work with it to sense motion.

But how does he land this blow? How do his formal manipulations take shape to explore perceptual continuities and discontinuities? Given the duration of cinematic time, how does such an aesthetic stage questions concerning the role of instantaneity within this trajectory of (dis)continuity? Breer's disintegrated animations seemingly revolve around the hope of an unblinking viewer's eye that is open to the force of directness and immediacy flashing images on screen. Through discontinuity, his animations attempt to locate and embellish the singular frame and its perceptual registration while also causing that image to be held in plurality with others that are juxtaposed to it in an unrelenting discordant flow of images. This play on the relation of images to one another in an aesthetic of animated synthesis alternately breaks and perpetuates metamorphoses in an unrelenting stutter, inviting spectators to explore the technological intervals between images more than the fusions of movement. Imploring spectators before a screening to be receptive to this experience, he introduced his films and then requested that the audience members "please do not close your eyes."[11] But there is a certain impossibility of this experience, a slippage built into this aesthetic such that attaining any complete picture is just out of reach as new forms, colors, and images are endlessly found through multiple viewings of the same juxtapositions. By targeting a paradoxical instant of cinematic time, Breer breaks and distorts the intertwining relation between perceptual operations and moving image technology that encompasses all cinematic experience but that this animation pronounces, or exposes, more fully. Seeming to target the eye, these films actually address the interval itself, working through formal relations and dimensions particular to the materiality of celluloid in order to produce gaps of recreation whose opacity is paradoxically articulated through its genesis during projection.

Understanding Breer's aesthetic address helps make sense of the historical lineage and interpretative framework often used for his films. Often labeled Dadaistic because of the assaultive nature of his montages and

because of his invocation of Dada collage aesthetics as described above, his work from this period is often placed within the neo-Dada movement that began to form in the 1950s around figures like John Cage, Jasper Johns, and Robert Rauschenberg. The connections between these artists' works and the earlier forms and practices of the prior Dada movement were immediately recognized by many commentators at the time, prompting exhibitions, articles, and at least one symposium on the topic where both Rauschenberg and Marchel Duchamp were invited to participate and discuss the new aesthetic (re)turn. Most of these critics considered the neo-Dada and neo-avant-garde movements to be pale imitations of what came before and also argued that the aesthetic developed in such works used a shock for its titillating effects that would simply be consumed by the viewer rather than wielding it as a politically efficacious tool.[12] But instead of situating the aggression or shock in Breer's aesthetic within a politically transformative or complacent binary, I believe that his collage films with their rapid montages explore how historically charged materials relate to one another in collage aesthetics and how perceptual thresholds can be exploited through cinematic technology. Breer's films engage in an experimental play that can produce states of apperception, but the recognition of the conditions of perceptual embodiment are not prescribed for viewers, politically or otherwise, and instead are indeterminate. As some recent critics of the neo-avant-garde argue, the critical discourse surrounding these artists is misguided when it projects onto the neo-avant-garde an intentionality of the earlier Dada and avant-garde movements.[13] Focusing instead on the differences in aesthetic strategies between the two and the changes that took place in social, political, and economic climates shows that the critical negativity and institutional critique found in the Dada ballistics during the interwar period changed dramatically in orientation by the time artists in the 1950s returned to such forms and employed them in their own work. Like Breer's disintegrated animations, these function less as attempts to produce a transformative shock for spectators, and more as an aesthetic exploration of phenomenological and technical intertwining.

 The role of technics within the cultural and aesthetic transformations occurring during the 1950s and 1960s was often explored by many of the artists Breer surrounded himself with during this time. On March 17,

1960, as Jean Tinguely finished the construction of his large, mechanical *Homage to New York* outside the Museum of Modern Art that, once completed, would then destroy itself in a fury of anarchic disorder, Breer set up his camera to produce a documentary of the event, which he aptly titled *Homage to Jean Tinguely's Homage to New York*. Breer and Tinguely had been friends and occasional collaborators since they were both affiliated with the Denise René gallery in Paris in the 1950s. There they were included in the 1955 exhibition *Le Mouvement*, one of the first shows dedicated to exploring motion in art, which also featured pieces by Duchamp, Alexander Calder, Raphaël-Jesús Soto, and others, with an accompanying screening at the Cinémathèque Française of abstract animation by artists such as Hans Richter, Viking Eggeling, Oskar Fischinger, and Len Lye. For both Breer and Tinguely, this show was a pivotal moment. Breer exhibited some of his first films at the screening and also had an optical toy in the exhibition gallery, a flip-book entitled *Image par Images* (1955) that explored the relation between stillness and movement in animation, an articulation that was central to his work and that he continued to explore in later works such as *Flix* (1967). Tinguely created and let loose in the gallery his first Meta-Matic machine, which walked around the museum, drew pictures, and bumped into other objects on display. For both artists, there was a fascination with contemporary technologies and their effects on aesthetic production. Though Breer had been working in painting since the 1940s before focusing on moving images, his father was an engineer whom Breer recalls experimenting with the development of a 16mm three-dimensional movie camera and projection system at their home in 1940. The research rubbed off, setting a foundation for Breer's artistic career and development of not just optical toys and celluloid experiments, but mutoscopes, mechanized floats, and a variety of motorized sculptural forms. Breer saw the same mechanical endeavor inside Tinguely, soliciting his help for the construction of mutoscopes in 1958,[14] as well as beginning his *Homage* with a paper cutout image of Tinguely that opens to reveal gears, wires, and spinning motors inside the artist. Like Breer, Tinguely was fascinated with perceptual thresholds exploited through technology and, as he puts it, the way in which "everything transforms itself, everything modifies itself ceaselessly."[15] Breer's film echoes the experience of witnessing Tinguely's

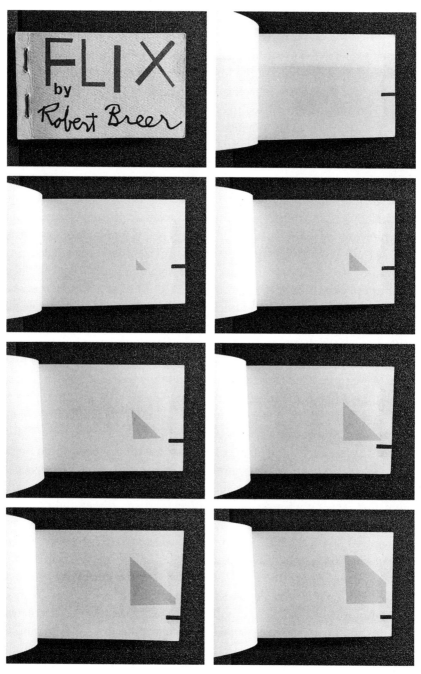

FIGURE 3.2. Robert Breer, *Flix,* 1967. Amherst College Archives and Special Collections. Courtesy of Kate Flax and gb agency, Paris.

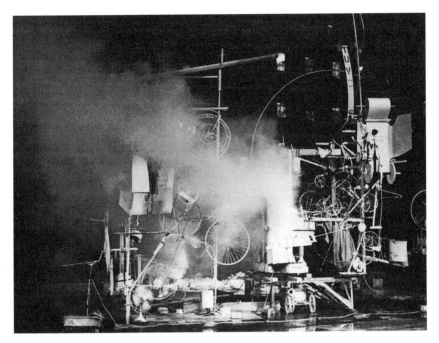

FIGURE 3.3. Film still from Robert Breer, *Homage to Tinguely's Homage to New York*, 1960. 16mm, black and white, sound, 10 minutes. Courtesy of Kate Flax and gb agency, Paris.

Rube Goldberg catastrophe, at times documenting its construction and at other moments accelerating through its operations via his collage aesthetic to create a sense of what Breer calls "anti-continuity," images held separately or, as he further explains, as sensual units moving in time.

To access this sensual articulation, viewers must attune themselves to an experience of time that lies outside habituated norms. Breer's formal and material manipulation of the interval allows viewers to inhabit regimes of time that are constitutive of celluloid projection, regimes often papered over within perceptual syntheses of animation and continuity, and brings forth experiences normally endemic to machines. Through radical juxtapositions of images that are generated at a rapid pace, Breer creates impressionistic flows of motion while simultaneously opening spectators

onto these other regimes of time. In Breer's animated collages, the perceived acceleration of images flashing on the screen challenges viewers aesthetically and perceptually, hoping to precipitate a retraining of sensual engagements with moving images, but forcefully revealing a temporality of metamorphosis and quick change. At the borders of perceptual limits, it holds the possibility of being a euphoric and ecstatic time, pledging a release. Breer's flip-books and optical toys hold out this same promise if the viewer chooses to try to experience it. They also allow for a variety of other kinds of engagements, since they provide the freedom for viewers to choose how rapidly or slowly images alternate. In all these works, Breer further investigates the interval that structurally divides moving images. He utilizes technologies that allow for spectators to be barraged with images at a speed faster than what cinema can keep pace with, or one that is down tempo, providing a more contemplative view of the transformations he creates. Through different registers, the time of moving images contracts or dilates.

A LITTLE BIT TOO FAST

This focus on time and perception does not wholly discount the role of Dada aesthetics in Breer's play with the interval of animation. Duchamp even recognized its importance when seeing Breer's films. In an interview with Yann Beauvais, Breer tells the story of how he became acquainted with Duchamp while still living in Paris in the 1950s and how he invited Duchamp to his apartment to see his films. After the screening, Duchamp commented:"'We used to play around like that.' But he said, confidentially to me in a low voice: 'Don't you think they are a little bit too fast?'"[16] Duchamp's simultaneous identification with and disavowal of Breer's films point not only to differences between the historic and neo-avant-gardes, but also to the ways Breer transforms collage aesthetics by juxtaposing images temporally rather than layering them across one another in a shared space. In many ways, Duchamp properly articulates the overwhelming experience of viewing Breer's collage films from this time, a perceptual inundation that Breer acknowledges through one of his titles, *Eyewash*. In this film, the juxtapositions occur so quickly and with such force that, in one section of the film, Breer does not employ an animated metamorphosis through

the combination of photographed frames but instead uses a time-lapse technique so that the action of the animator is made visible. The resulting blurs of nearly a dozen abstract shapes as they are placed on his animation stand blend into the frantic arm and hand of the artist, creating a frenzy of motion that lasts for two seconds. At other points in the film, radical juxtapositions and their concomitant flicker are emphasized, seen for example in his contrast of solid yellow and black or yellow and red color frames. The impact of the afterimages produced in such frenetic combinations is what Breer is attempting to harness, and he uses not only independent images that are contrasted with one another but also materials such as tightly woven fabrics that he pans over in close-up for a second or two, creating a dizzying optical movement similar to those found in Victor Vasarely's or Bridget Riley's work. What is perceptually registered in the rapid-fire combinations of these various optical manipulations lasts for fractions of a second and changes at each viewing, but across the culmination of these sequences in the film there exists a fascination with the perceptual registration of movement and its illusory production in the cinematic apparatus. As white forms busily dance over a white background and leave white streaks in their wake, or when a cutout head from a photograph rotates on a white surface and grows larger until it is substituted for a black circle that finally encompasses the screen (all over the course of twelve frames), *Eyewash* plays with the perceptual activity that occurs in constructions of cinematic motion and overwhelms the viewer with the artifice that lies at its foundation.

As Rosalind Krauss argues, manipulations of perception lie at the core of Duchamp's *Rotoreliefs* and *Etant donnés,* reminding viewers of the embodied processes of what Krauss calls "carnal vision" through an illusionistic play with depth that provokes aesthetic pleasure.[17] Though also interested in the psychophysiology of perception, Breer's films investigate what he calls "the domain between motion and still pictures" through movement created not by an illusionistic trompe l'oeil, but instead through "time intervals and space changes."[18] As Laura Hoptman points out, such an aesthetic is more akin to Duchamp's later formulation of what he calls the "infra-slim."[19] This is a space of perceptual uncertainty between different registers whose

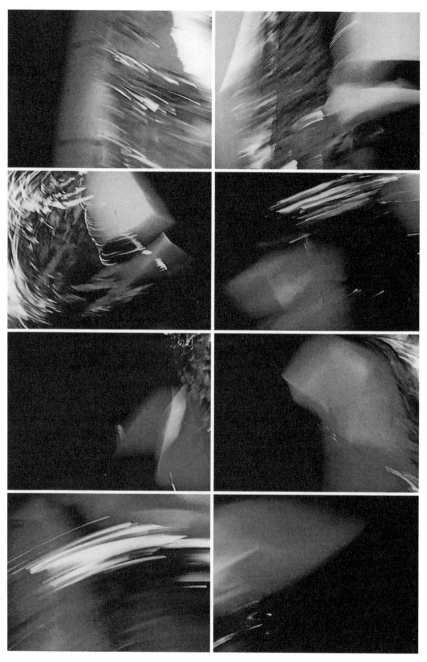

FIGURE 3.4. Film stills from Robert Breer, *Eyewash*, 1959. 16mm, color, sound, 6 minutes.

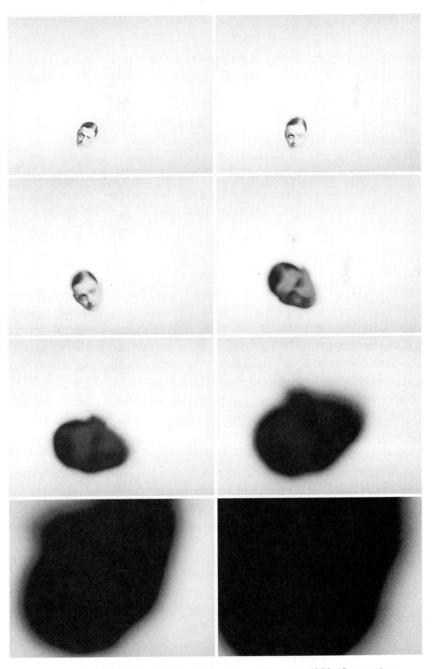

FIGURE 3.5. Film stills from Robert Breer, *Eyewash*, 1959. 16mm, color, sound, 6 minutes.

tipping point is perpetually elusive and that Duchamp believed could not be defined, but only exemplified. In a 1968 interview, he explains:

> [I] chose on purpose the word slim which is a word with human, affec-
> tive, connotations, and is not an exact laboratory measure. The sound or
> the music which corduroy trousers, like these, make when one moves,
> is pertinent to the infra-slim. The hollow in the paper between the front
> and back of a thin sheet of paper To be studied! . . . It is a category
> which has occupied me a great deal over the last ten years. I believe that
> by means of the infra-slim one can pass from the second to the third
> dimension.[20]

This graphic movement between spatial dimensions is analogous to the difference between progressive intervals of time for Duchamp, as he shows in one of his examples of the infra-slim in *Notes:* "In time the same object is not the / same after a 1 second interval."[21] By pointing to such thresholds, Duchamp emphasizes the weight of time on objects, an entropy whose effects are usually registered over longer periods. Such a statement positions objects in a perpetual state of becoming or flux and claims that false continuities are attributed to such forms, where difference is elided in favor of perceptual consistency. His main interest is in playing with these gaps and exploiting sensory experiences for a better understanding of not only how normative perception operates but also how it can be manipulated to become more receptive to aesthetic effects.

Breer's collage films and optical toys similarly call attention to this speculative space between things, simultaneously contracting and expand-ing its limits. In a letter to Mekas in 1970, Breer explains that his work is invested in "revealing the artifices instead of concealing them" and that he attempts to manipulate

> the threshold area that defines the form. Thresholds for my own explo-
> ration have been:
> 1. The fusion of stills into flowing motion and back again (flip cards,
> collage film, sculpture).
> 2. Transition from literary convention to other—i.e. abstraction and
> back again (collage films—Pat's B'day).

3. Transition from subconscious to conscious awareness—i.e. slow motion sculpture, fast paced film.
4. Transition from 2D to 3D and from 3D to 2D—transparent muta-scopes and cut out sculpted mutascopes—rotating bent wires.
And so forth.[22]

The first threshold that he defines is one that he explores in many of his films, but it begins to take shape with his 1954 experiment and with *Recreation*. As described above, in *Recreation* Breer produces a dense visual collage with many kinds of materials, but he also photographs numerous objects in isolation. Some of these he animates in order to produce a play on tradi-tional illusions of motion, such as in a five-frame sequence of a pocketknife opening or a yellow square rotating ninety degrees in front of a black back-ground. At other moments in the film, he punctuates the visual collage with objects moving mechanically without the aid of stop-motion tech-niques, such as the wind-up birds who make their way across the frame and leave a trail of ink, the paper knife grinder at work in the pop-up book, or the wads of paper that decompress.

These sequences function in many ways as breaks from the intense flow of images in the film while also serving as visual jokes on modernist artworks such Piet Mondrian's neoplastic paintings and Kasimir Malevich's *The Knife Grinder* (1912). But, like the quick juxtapositions of forms that produce graphic transformations, these sequences also investigate the phe-nomenon and beauty of movement. This is particularly apparent in the stop-motion sequences, where Breer employs traditional animation tech-niques that take advantage of the perceptual phenomenon related to the stroboscopic effect, a visual limitation that links short pulses of images or light into continuous motion. Ordering frames to produce the illusion of motion is the foundation of cinema, but it can also, as Sergei Eisenstein points out, be manipulated through montage to produce artificial and il-logical images of motion, exemplified in *The Battleship Potemkin* (1925) when, through the juxtaposition of three shots, "a marble lion leaps up, in protest against the bloodshed on the Odessa steps."[23] For Eisenstein, this action is unified through the sequence of images that are abstracted from one another in space and time but formally linked to generate plays

FIGURE 3.6. Filmstrip from Robert Breer, *Recreation,* 1956. 16mm, color, sound, 2 minutes. Courtesy of Kate Flax and gb agency, Paris.

on animated syntheses and narrative motivations. It is a moment of magical defamiliarization as the lion cinematically wakes from its physical and intellectual slumber through an animation whose means of creation are immediately recognized. Edward S. Small and Eugene Levinson point to this sequence as an exemplary case of frame-by-frame filmmaking, arguing for a broad definition of animation to include any such single-frame practice that causes inanimate objects to move and "violate physical law"; Small and Levinson even suggest that montage and animation are equivalent operations.[24]

Eisenstein certainly gestures toward the possibility of such an argument when explaining montage's effects, and Breer uses forms of intellectual montage in sequences of his films while simultaneously creating metamorphoses. Indeed, in *Recreation*, not only does he employ stop-motion effects on objects like the pocketknife to make it appear to move, but he also creates animations reminiscent of Eisenstein's lions, where objects appear to grow and contract through single-frame exposures of similarly shaped but nonidentical forms. At one moment in the film, circular objects expand and are replaced by rectangular ones that similarly change shape quickly, only to be intercut with the original object in the sequence. The two shapes collide and fuse into one another in a series of eighteen images that lasts for less than one second. This metamorphosis in Breer's film more accurately imitates a sequence in Fernand Léger's *Ballet Mécanique* (1924) that consists of two images: a white shoe and a white hat, both on black backgrounds that are intercut with increasing speed. Standish Lawder explains the effect of the sequence in Léger's film:

> Eventually, as the associative values of these images begin to wane, they appear more and more as pure shapes of white on black, calling forth the surprising illusion that they are merely the same form physically pulled and pushed, back and forth, from one shape to another. That is, it is no longer an alternation of shapes that we perceive but a fluid metamorphosis from one to the other at lightning speed. The eye supplies all the intermediary stages of this plastic transformation: we see a long horizontal white form with a black central hole (the shoe) swelling up, redistributing its area of white to become a design of two

concentric white circles (the hat), all realized in a flash, and then instantly reversed, again and again.[25]

Sitney and others have recognized the influence of Léger on Breer, especially when exploring antecedents for Breer's rapid and rhythmic montages. The connection is justified. When writing on *Ballet Mécanique*, Léger explains that "contrasting objects, slow and rapid passages, rest and intensity—the whole film was constructed on *that*,"[26] and Breer's collage films certainly follow a similar pattern that takes advantage of graphic counterpoints to produce new unities.

But some, like Duchamp, believe that Breer goes too far, or rather too fast. Small and Levinson, in their analysis of animation's use of the interval, also point to the moment in Léger's film described above and warn of alternations that are too incongruous to provide any kind of metamorphosis of form, which, for them, is the goal of all animation. Though they agree with Lawder that the movement between the hat and shoe melds the two shapes together, they claim that, if the graphic juxtaposition is too dramatic, the cuts will simply assault, rather than produce a transformation.[27] But, for Breer, the goal of these films is to examine not only how forms mutate or blend into one another but also the constitutive space or gap between them created through the celluloid filmstrip. This becomes the organizing principle behind his collage films, such that they belong, for him, to "a type of cinema built around the art of the non-rational, non-reasonable association of images."[28] This is an explosion of traditional cinematic form that provocatively uses the interval between frames to articulate separations and force relations between images, a generative foundation for Breer's aesthetic of disintegrated animation. Though the images and frames exist in a short instant that can be isolated, normally unseen relations between these images rise up through the cinematic interval as they move in time.

The distinction that Breer makes between an aesthetic based on the investigation and production of new associations and one that intends to foster a critical distance through strategies of shock is a division that lies at the heart of the difference between the historic avant-garde and the neo-avant-garde. In a central work on the history of avant-gardes, *Theory of the Avant-Garde*, Peter Bürger defines the ways in which art movements at the

beginning of the twentieth century attempted to use aesthetic forms as tools in an ideological critique of bourgeois society. Though such attacks had taken place in the past from artistic circles, Dada and other avant-garde movements of the early twentieth century were different because they were critically self-aware of the relatively autonomous institutions of art from which this critique usually comes. One of their aims was to strip the artistic world of this seclusion by incorporating art into the praxis of life while attacking "the means–ends rationality of bourgeois society."[29] For Bürger, the neo-avant-garde neglected this critical turn and embraced the autonomy of art institutions while appropriating the aesthetic forms of the previous movement.[30] Its failure resides in aestheticizing non-sense in a politically unengaged way that does not produce the shock found, for instance, in Dada pieces like Duchamp's *Fountain by R. Mutt* (1917).

One of the key approaches that Bürger identifies for the creation of this shock effect is the historic avant-garde's use of collage and photomontage, which takes objects and forms out of their original context to imbue them with a new meaning amidst an assemblage of other materials. This act of resignification does not treat forms as organic wholes, but instead as gestalts with fragments that simultaneously serve as metonymies and produce a new construction. As others such as Benjamin H. D. Buchloh also point out, this avant-garde practice is essentially an allegorical procedure defined by Walter Benjamin in which objects are ripped out of context and joined with others, and in doing so are invested with a new meaning.[31] These artworks challenge norms of aesthetic contemplation through tactics of distraction that join disparate elements, as Benjamin writes, to turn "the artwork into a missile . . . [which] jolted the viewer, taking on a tactile quality."[32] In both collage and montage aesthetics, the work prevents viewers from following their own patterns of attention by forcing new images on them that dramatically contrast one another. Again, as Buchloh argues, Benjamin situates montage as an allegorical operation, but one that is pivotal in a historical shift of everyday perceptual and social organizations. Through acts of appropriation and plays on signification, Dada aesthetics promotes a critical distance in which the historical and social conditions of a form's composition are emphasized or made apparent. For Bürger, this act is pivotal and revolutionary because the newly composed

work "calls attention to the fact that it is made up of reality fragments; it breaks through the appearance of totality" that defined bourgeois artworks of the past.[33] But, to produce shock effects, avant-garde art can also simply deny the construction of new meaning, as Duchamp's *Fountain* attempts to do. In this situation, an impression of meaning is withheld to induce critical defamiliarizations and awakenings. This shock, however, is fleeting, and Bürger admits that it is a rather singular experience. Additionally, spectators can learn to prepare for it, and such anticipation signals a consumption of the experience that renders it ineffectual. For Bürger, it is here where the neo-avant-garde finds itself. He argues that it appropriates both the formal and the discursive strategies of the prior avant-garde in a later historical moment where the challenges associated with these practices have been institutionalized. Such works are no longer shocking, but instead employ a titillating aesthetic that fashionable audiences can find in traditional art institutions. In this new climate, the neo-avant-garde unknowingly panders to the mechanics of supply and demand that grip such spaces. Their promotion of collage and neo-Dada aesthetics results in withholding meanings, producing "nothing," as Tristen Tzara famously described the project of Dada, but for no social end, thus replicating the irrationality of late capitalism.[34]

This account of the neo-avant-garde has been challenged by many critics, though most agree with Bürger's assessment of the historic avant-garde and its general failure to more fully integrate art into the life praxis of viewers. Buchloh and Hal Foster, for instance, argue that the repetitions of the neo-avant-garde are very self-conscious and not mere replications of past aesthetic forms and discourses, but continuations of a similar project in a different historical and aesthetic register. In this formulation, the neo-avant-garde is conscious of the historic avant-garde's failure and knows that it too can only fail. It recognizes that its attempt to resolve social and political contradictions is impossible. Nonetheless, "if the work of art can register such contradictions, its very failure is recouped."[35] For Buchloh, such self-consciousness about this failure is a guarantor of "historic and aesthetic authenticity," since it registers the overwhelming infusion of rationalized capitalism in all forms of aesthetic production, commercial or otherwise.[36] Foster claims that the self-aware repetitions reveal a "complex

relay of anticipated futures and reconstructed pasts," where the neo-avant-garde exists in a dialectical relationship with the historic avant-garde, reciprocally acting on each other.[37]

Both of these arguments conceptualize the aesthetic strategies of the historic and neo-avant-garde as aiming at politically efficacious results, or at the very least producing a form of critical negativity in viewers. This, in part, is a legacy of Bürger's analysis, which Buchloh acknowledges in later writings while admitting that a "dissolution of power and repression" can take place through a multiplicity of aesthetic forms that are not bound to strategies of critical negativity and shock.[38] The stakes of the allegorical redemption that are tied to Dada aesthetics do not dissolve into neo-avant-garde aesthetic forms that relish play or parody, for instance, but have a complicated relation to both politics and history, where collage is still used to produce aggregates that dispel organic unities but do not produce a new unity through allegorical procedures. Branden Joseph argues that this operation exists in Rauschenberg's Combines, where these collages do not invest allegorical meanings in material fragments to produce a new unity, but instead focus on the contingent relations that exist between fragmented materials. This delays the production of a new unity in an attempt to instead call attention to the differentials that exist between objects in space and time. And the exposure of these gaps is principally how neo-Dada differs from the older movement for Cage. As Joseph shows through an analysis of Cage's article "History of Experimental Music in the United States," which cuts across principles of composition and experimental action through several media, Cage explains that "the space and emptiness" between objects in collage during the postwar period distinguish earlier Dada aesthetics from these works.[39] With a focus on the differentials that exist between forms in collage, the space between them can function as an articulation of difference that calls attention to the contingencies that brought elements in contact with one another. Emphasizing indeterminacy and lack of compositional unity fosters moments of aesthetic pleasure grounded in what Joseph describes as "the immanent, indeterminate force of difference coursing through its interstices."[40] Here, the gaps between forms structure aesthetic experience, though in a hazy manner where difference is indefinite and based on perspective, much like the infra-slim that Duchamp describes.

THE FIST OF THE ANIMATOR

Breer's collage animations accentuate the gap between forms through intense juxtapositions between frames, producing an awareness of the interval of time that exists within one manifestation of cinematic projection. Though it is foundational for Breer's aesthetic, he was not the first to manipulate this gap or exploit its formal possibilities. Dziga Vertov is perhaps one of the more well-known modernist filmmakers to work through, and theorize on, the manipulation of the interval in film. Vertov says he turned to this element in order to organize "movements of objects in space as a rhythmical artistic whole, in harmony with the properties of the material and the internal rhythm of each object."[41] The films that work through this aim, such as his *Kino-Pravdas* (produced between 1922 and 1925) or *Man with a Movie Camera* (1929), were intended to create electric utopian Soviets whose heightened perceptual acuity would allow them to also become more refined political and social subjects. This contrasts with Eisenstein's prescription for the impact of the cut between frames, which focused on the dialectical conflict produced between images in film that could lead to new aesthetic unities and changes in subjectivity.[42] Such graphic collisions and conflicts between shots are meant to produce "dynamizations in space" and physically impact spectators for the eventual experience of ecstasy mingled with pathos, all for an intellectual reawakening of consciousness.[43] In this way, cinema can communicate abstract ideas while simultaneously affecting spectators through its mimetic powers. Eisenstein is clear about the desired impact of this operation, as well as its assaultive nature, explaining that such montage collisions are to act as a "Kino-Fist" that will reconstitute social attitudes and organizations. Calling for an end to aestheticized portrayals of reality that he claims Vertov exemplifies, Eisenstein sees this type of filmmaking as working over the spectator—"a tractor ploughing over the audience's psyche with a class purpose in mind"—molding reality rather than presenting it, and calling for audience members to do the same in their social world.[44]

The correspondence between aesthetic and social revolution that Vertov and Eisenstein locate in montage takes on a different character in the context of Breer's work. Breer's films do not contain or articulate a particular

political project that attempts to restructure social organizations and institutions, and again, Bürger and others have leveled this as a critique of the neo-avant-garde. Instead, as I have illustrated above, his films sensually explore the intertwining of technological and perceptual registers within cinematic assemblages and challenge practices of viewing that have been taken for granted. If animators constantly open the black box of cinematic movement, as Pierre Hébert claims, then Breer smashes it and playfully shows its contents to viewers. For Jacques Rancière, this type of aesthetic is a political operation because of the ways in which it addresses the possibilities for forms of enunciation and action generally. Using Eisenstein's films and writings as illustrations, Rancière explains not only the attempts to produce subjects through montage that are sympathetic to political projects but also the aesthetic that abandons certain mimetic constructions in order to generate "an art where the idea is no longer translated into the construction of a plot dependent on identification, fear, and pity, but is directly impressed onto an adequate sensible form."[45] Such an appeal to sensory effects in order to communicate ideas challenges cinematic codes that are indebted to what Rancière calls the representative regime of art. This type of aesthetic production is bound to a system of imitations through a logic of mimesis; it links the possibilities between what Rancière calls the visible and the invisible in a particular codified relation that is dominated by a type of narration that emphasizes resemblance and portrays emotion. Taking this connection for granted, it also creates "expressive traits whereby the hand of the artist translates the emotion and transposes the tropes."[46] Images in this regime *mean* something. They signify a feeling or thought in a direct manner. Rancière argues Eisenstein, as well as others such as Stéphane Mallarmé, uncouple the image from this logic of signification so that artistic works have an autonomous sensuality that exists within a new aesthetic regime. Here, images have what Rancière describes as a twofold power: "the inscription of the signs of a history and the affective power of sheer presence that is no longer exchanged for anything."[47] This operation is political in orientation because it shapes the conditions under which an articulation of experience is made possible and then put into circulation, or what Rancière calls the "distribution of the sensible." Such actions enable

the generation of a community bound together through shared under-standings of what can be articulated and felt. Thus, aesthetic works take on a political valence by challenging the dominant order through which "the sensible" is produced. As Rancière explains in an interview:

> The passage of pairing "aesthetics and politics" is a way of taking this into account: We no longer think of art as one independent sphere and politics as another, necessitating a privileged mediation between the two—a "critical awakening" or "raised consciousness." Instead, an ar-tistic intervention can be political by modifying the visible, the ways of perceiving it and expressing it, of experiencing it as tolerable or intoler-able. The effect of this modification is consequent on its articulation with other modifications in the fabric of the sensible.[48]

The spheres of politics and aesthetics are united by a shared landscape of articulation, and challenges to this terrain can take the form of political ges-tures in a call for action or aesthetic reorientations of perception that shape how we sensually engage with our environment.

For Rancière, artworks in the aesthetic regime are characterized through play, where experimentation with presentation and form generates new sensual experiences designed to shift horizons of experience across politi-cal and aesthetic registers.[49] Cinema holds such a privileged site of analysis for him because of its contradictory containment of both representative and aesthetic regimes.[50] As he explains in his work on Eisenstein, films many times bolster the mimetic logic of the representative regime, produc-ing works that have expressive codes and well-known narratives, while at other times leveling such codified structures of experience and producing engagements ruled by affective play that characterize the aesthetic regime.

Breer recognizes this dual capacity of cinema to employ both a repre-sentative logic of images and a sensual one. His collage films are specifi-cally targeted at exposing this dynamic while simultaneously pressing for the latter form of aesthetic production. For example, in addition to images of artists and self-portraits, *Fist Fight* begins with several photographs of people who aided in the performance of the Karlheinz Stockhausen com-position *Originale* that accompanied the first screening of *Fist Fight* in 1964, but with a less intense rate of juxtaposition between the frames than that

FIGURE 3.7. Filmstrip from Robert Breer, *Fist Fight*, 1961. 16mm, color, sound, 11 minutes. Courtesy of Kate Flax and gb agency, Paris.

which occurs later.[51] Yet Breer still plays with these images, turning them upside down or animating the activity that was captured in mid-action by moving the photograph on the animation stand. After the title card, the pace quickens and the collage style that is present in his earlier films returns, with images of newspapers, comics, family photos, race cars, drawings, playing cards, and photographs of his paintings at gallery shows in the 1950s all mixed in rapid succession with other ephemera. In many ways, an argument can be made that *Fist Fight* is pregnant with meaning, with each frame performing a role in an onslaught of signification. But this generates a paranoia of signification as vectors of address that could point to meanings anywhere pile up in time. Even if some of these representative lines hold true, their registration is soon scrubbed through formal juxtapositions. Instead of operating through an iconographic framework, Breer's film sensually links images, generating relations through shape, movement, and material. In one series of frames, he plays with the associations between the faces of a baby, a woman, and a female comic character, while in another, Ringo Starr blowing smoke is juxtaposed with an upside-down pipe. Many of these cuts are playful, but they also work through a fundamental distinction between using the interval separating frames to create a continuity of narrative action or argumentation and using the interval as a marker of indeterminacy that makes connections between elements whose differences are nonetheless always present.

While this discontinuity serves as a way to abstract the cohesive flow of representative motion, Breer also uses the cumulative effect of his disintegrated animations to work through the relationship between figuration and abstraction that Maurice Merleau-Ponty writes about when analyzing the line drawings of Henri Matisse, as discussed previously in this book. Breer takes up the issue of the abstract line's relationship with figuration directly in *A Man and His Dog Out for Air* (1957), which he produced in the middle of his collage period. But, as seen in the juxtaposition of forms in Figure 3.7 or in the correspondences between the arms and bodies found in Breer's drawing and the playing card in Figure 3.8, he continued to work through this dynamic in his collages. Here, however, his exploitations of the gap between frames produces metamorphoses of form rather than the continuities and peregrinations of the line. Breer's rapid juxtapositions of

playing cards in *Fist Fight* exemplifies this dynamic. First using a deck of suit cards, Breer exposes in each frame the top or bottom two-thirds of a card, creating a rapid transformation of faces, symbols, and numbers. He then intercuts other types of cards in the shuffle of suit cards, such as one for a comic character named Frogman, and also uses Popeye playing cards. The Popeye cards hold a prominent place in this section of the film and they also appear individually in other places. Although it is not shown in the film, these popular King Features cards include an instruction slip from the manufacturer explaining: "To make 'FLIP-MOVIE' put cards in numerical order and riffle top of deck with thumb." Though the cards placed in numerical succession will not produce a continuity of motion, Breer takes the instructions literally for *Fist Fight,* producing a discontinuous flow that resembles what would be seen if flipping the cards like a flip-book. The resulting animations still produce metamorphoses, but the figures collide in time to produce perspectival distortions and abrupt discontinuities of action. Many of the cards in isolation already play with the perception of action, or what Scott McCloud calls subjective motion, through gestures and motion lines.[52] This is one reason Breer uses these with such frequency in the film, since they abstract the perception of motion in static images, and therefore compound the tension in animation.

Fundamentally, Breer's collage films are extended examinations of the tension between stasis and movement that lies at the foundation of animation, and his disintegrated aesthetic builds upon this relation while interrogating cinematic technologies that bring illusory life to form. The interval that Breer exploits in this exercise highlights both technologically and formally this source of play between the animate and inanimate. While Eisenstein similarly calls attention to the cut so as to break ideological structures with his "Kino-Fist," Breer draws attention to the materiality of film for its own sake. His aesthetic examines how images are related to one another technologically through the medium and exposes not only the space between them as a site of productive difference and generation of new sensual unities, but also the force behind their placement: the hand of the creator. In most of Breer's collage films, his own hands appear, not only through the stop-motion technique described above, where their movements are registered across the animation stand, but also in frames as

FIGURE 3.8. Filmstrip from Robert Breer, *Fist Fight,* 1961. 16mm, color, sound, 11 minutes. Courtesy of Kate Flax and gb agency, Paris.

FIGURE 3.9. Film still from Robert Breer, *Recreation*, 1956. 16mm, color, sound, 2 minutes. Courtesy of Kate Flax and gb agency, Paris.

clenched fists. This is in part influenced by Breer's close friendship with members of the Nouveaux Réalistes while living in Paris, like Tinguely, Jacques Villeglé, and Raymond Hains. Villeglé's and Hains's films *Paris Saint Brieuc* (1950–52) and *Étude aux allures* (1950–54) experimented with techniques such as direct animation at the same moment that Breer was also playing with this method in his first film, *Form Phases I* (1952).[53] But their *décollage*-lacerated posters, which they began producing together in the late 1940s by tearing away bits and scraps of posters layered on top of one another on public billboards in Paris, influenced Breer's own aesthetic of collage (Plate 5). These call attention to spatial and contingent relations between formal elements, as well as to the seemingly magical anonymous hand that revealed these through the subtractive rather than additive method, a legacy of gesture found in the tear.[54] Importantly, Breer's fists are also a play on the recognized tradition in which the hand of the

animator appears in many animated films as the source of vitality and life for the movements of forms and beings in the films, as discussed by Donald Crafton (see chapter 1). These hands are extensions of the artists, who, while many times remaining anonymous, are "god-like" and breathe life into objects while also functioning as a "mediator between the spectator and the drawings, between the world of humans and the world of animations."[55] Thus, the fists present in *Fist Fight* and in the other collage films not only invoke this association and well-worn trope but also call attention to the tension and force of his aesthetic and powerful hands, to how the disintegrated animations work over the form and technology of animation, as well as the senses of the spectator.

THE FLICKER OF THE FIRE

This preoccupation with the speed of perceiving different kinds of graphic impressions led Breer to the quick development of a friendship with Peter Kubelka when the two met and first saw each other's films at the 1958 Experimental Film Festival in Brussels. Like Breer's, Kubelka's work explores the production of illusions of cinematic motion through manipulations of intervals between frames of film. In 1966, when describing three of his metrical films—*Adebar* (1957), *Schwechater* (1958), and *Arnulf Rainer* (1960)—he explains that, for him, "cinema is not movement. Cinema is a projection of stills—which means images which do not move—in a very quick rhythm. And you can give the illusion of movement, of course, but this is a special case, and the film was invented originally for this special case."[56] Like Breer's collage films, his short, meticulously composed metrical films explore the mechanized instant and transition between stillness and motion. Unlike those wary of juxtapositions between successive shots that are too great, Kubelka argues that films should explore such collisions, citing Eisenstein's intellectual montage as a precedent but noting that the conflict Eisenstein emphasizes only manifests *between* frames of film as two shots are juxtaposed with one another.[57] Tired of the malaise in formless cinematic time that continuous motion generates, Kubelka attempts to rectify such states by producing visual ecstasies. Echoing Eisenstein's notion of ecstasy as *ex-stasis,* a movement outside of oneself that takes place

during a transition to a new quality,[58] Kubelka describes the "prison of na-
ture" that one has to "serve time" in and that so much of film attempts to
replicate. Nonetheless, he says, "there is a possibility to get out of all of it,
even if it is just for my interior reality. I want to cease to be the noble beast
obeying the laws of nature. I want out, I want other laws, I want ecstasy."[59]
Following the example of classical music harmonies that also produce such
states, he explains that musically induced euphoria is created through es-
tablished intervals and that he desires to develop a similar visual rhythm.
Film, he says, is already divided into individual units that can be used to
produce harmonic relations. The frame-by-frame succession of images can
be manipulated to generate a new articulation of time, a new "rhythmic
and harmonic being."[60]

Such experiences occur for viewers when they attune their bodies to
technical relations and machine-based temporalities that are actually omni-
present. Devices like Joseph Plateau's phenakistoscope, invented in 1832,
produce the illusions promised in its name by folding the body into its tech-
nical assemblage through the material inclusion of separate images seen
through slits in its rotating discs. Acting like a shutter, these material sepa-
rations were necessary to produce perceptual continuity in moving images.
Though in hand for nineteenth-century viewers, this animation ensemble
is often occluded in contemporary viewing contexts. Like Kubelka, Breer
attempts to generate an awareness of thresholds of temporality through
his disintegrated animations, though his aesthetic is not as indebted to
the structural laws that Kubelka took from his interest in music. While
Kubelka later organized his films according to what he described as a rhyth-
mic logic of editing, seen in *Unsere Afrikareise* (1966), his earlier calculated,
algorithmic style is at odds with Breer's more random shuffling of images
that generates the graphic impression of movement through discontinu-
ity.[61] *Blazes* takes this up explicitly and cuts across images more quickly
than any of Breer's other films (Plate 6). When producing it, Breer painted
one hundred cards in dramatic calligraphic lines, shuffled the cards ran-
domly, and then rearranged orders of images that he did not like. He did
this multiple times during the film's construction and repeated some of
the rhythmic patterns he found before finishing with four thousand im-
ages based on the original one hundred cards.[62] There are also periods of

blackness broken up by one or two frames of flickering images, and at the end of the film he zooms in on several cards very quickly to generate a cycle of vertiginous propulsions forward that culminate in thrusting back to the original vantage point through an abrupt cut onto another image before repeating the process. At this stage in the film, the audio track's monotonous clacking and pops speed up as well, a crescendo that signals *Blazes*'s climax.

Anticipating a criticism focused solely on the assaultive nature of these juxtapositions, which Small and Levinson would level at him, Breer explains his collage films, and *Blazes* in particular, thus:

> [They are] very much concerned with a new kind of continuity; even if it's an anti-continuity, it still has a form. Take *Blazes* for instance. It's a film where notions of continuity are shattered. The succession of abstract pictures follows so quickly and is so different from one to the next that one doesn't accurately see any one picture, but has the impression of thousands. It's a form of visual orgasm. I put the spectator off the track to such a point that he becomes passive and forgets notions of continuity. He can no longer anticipate the images and is too bombarded to remember the past images. He is forced to just sit there and take the thing in as an actuality: the violence is just a by-product.[63]

The rapid speed of the editing across conflicting forms works with the small fragments of time between film's most basic material unit, the frame, so that, as Breer further explains," a new continuity emerges in the form of a very dense and compact texture. When pushed to extremes the resulting vibration brings about an almost static image to the screen."[64] Here, again, Breer emphasizes how he disintegrates animation, and though there is no continuity as it is normally seen in other films, the exploitation of the link made between frames over their interval still causes figures to morph into one another so that impressions of graphic forms and movements are created, though their specific vectors and shapes are indiscernible.

Such an aesthetic is, as Breer says, rooted "more in counterpoint than in harmony,"[65] and though he is clearly interested in ecstasy, describing *Blazes* as a "visual orgasm," this is not created through a reliance on classical harmonic structures, but the sensation of movement and time de-

veloped through fast, unexpected juxtapositions. Although he massages many of these chance conflicts after shuffling the cards of the film together, the development of the rhythm generated through much of *Blazes* is not planned, but created through the dynamics spawned from the accidental collision of forms, as he says in an interview with Mekas and Sitney.[66] This, however, is one reason why Sitney does not include Breer's films in those he labels as structural. Though he recognizes Breer's and Kubelka's use of the flicker form and manipulation of the interval between frames as forerunners to this type of cinema, he argues that they are more interested in exploiting the graphic and material possibilities of film, while structural films are more focused on "apperceptive strategies."[67] To perhaps further differentiate the two filmmakers from those creating structural films, he explains that, in structural film, "the *shape* of the whole film is determined and simplified, and it is that shape that is the primal impression of the film."[68] Structural films have a form that can be discerned by viewers, a clearly recognizable pattern that nonetheless produces perceptual estrangements through distinct, individual aesthetic experiences. Breer's films do not contain an overall logic like Tony Conrad's *The Flicker* (1966), which Sitney claims is "one long crescendo-diminuendo,"[69] and because Kubelka's "films move so fast and are so complex that the viewer perceives their order without being aware of the laws behind them,"[70] they fall short of this form of American avant-garde filmmaking for Sitney.

The particular films and filmmakers included in this category are debated, with George Maciunas and Malcolm Le Grice articulating their own boundaries of inclusion.[71] But all agree that *The Flicker*'s minimal use of form and deep phenomenological play help define this category of film and that it was a watershed for the formation of an avant-garde practice. Here a formal structure could be discerned by audiences that is both assaultive and pleasurable, giving viewers an experience that pushed them into a recognition of the technical environment through which cinematic perception occurs, which they do not control, but also an awareness of how the experience was structured over its duration. Conrad explains: "I viewed this as a situation in which I would mediate the power of the flicker as a tool. . . . I wanted to really give people a chance to pretend that they were in control of the situation, but then make it very painfully and slowly clear—as

though you're slicing them very slowly—that it's the film that is in control of what is going on."[72]

Like Conrad's, Breer's films attune the body to this technical action, forcing an awareness of the mechanism with a similar power. The aesthetic that arises opens viewers to structuring intervals of cinematic form and the relations between objects that can exist within that architecture, even if such connections are lost in a blink. Steven Shaviro, echoing Alfred North Whitehead, describes this type of aesthetic encounter that defamiliarizes the normally unseen operations of objects and their engagements with other forms as a lure. Within this exchange exists both a possible revelation of an object's construction that is immanent only to itself, called an allure, and a metamorphosis, which Shaviro describes as a withdrawal of a thing's articulated qualities actuated through mutability. Shaviro explains: "In the movement of allure, the web of meaning is ruptured as the thing emerges violently from its context; but in the movement of metamorphosis, the web of meaning is multiplied and extended, echoed and distorted, and propagated to infinity as the thing loses itself in the network of its own ramifying traces."[73] Shaviro describes aesthetic encounters between subjects and objects in his elaborations on how we engage with forms by the ways they position us within that moment. But he shows how this vector of feeling can exist between objects as well, a framing that does not neglect human engagements with things in the constellating universe that Shaviro tracks but that does recognize that these objects can have dynamisms independent of our relations with them. Like those of Jane Bennett and Bruno Latour, Shaviro's acknowledgement of the force or vitality of material grants objects forms of agency on us and on other things within assemblages.

To inhabit a space between images in cinematic time involves exploring the agency and power of celluloid's materiality as it moves in projection. Breer's aesthetic reveals the technical means through which this operates while also having images meld in a protean flicker. As he explains in a note from 1960, he seeks "to get back to the fixed image by way of cinema . . . to cross back and forth dragging elements from both worlds."[74] Whiplashing between stillness and movement, films like *Fist Fight* and *Blazes* press viewers into this play with images, causing us to feel both the articulations

of form and the technical pulses of the shutter that constitute them. The action manifests as a continual sensual surprise for Breer, since he explains that he wishes to suspend viewers in a state of perceptual novelty so that they "no longer anticipate the images and [are] too bombarded to remember the past images."[75] This desire for a perception divorced from memory, based solely on sensation and thought in the present, is similar to the one that Henri Bergson describes in *Matter and Memory* when attempting to formulate how images affect perception and bodily action. Recognizing that "there is no perception which is not full of memories," Bergson nonetheless creates a category called "pure perception" in order to explain the workings of perception that react to an external object before explaining the interaction between the material world and past memories in normal perception.[76] He explains that it "exists in theory rather than in fact and would be possessed by a being placed where I am, living as I live, but absorbed in the present and capable, by giving up every form of memory, of obtaining a vision of matter both immediate and instantaneous."[77]

The possibility of this form of perception is what Breer reckons with in his disintegrated animations, putting immediate perceptions into a new tension with the past and straining the senses in an attempt to play with this dialectic of time. Though Bergson does not believe that such moments of purity can ever exist, Gilles Deleuze, like Breer, sees cinema as offering the promise of this form of perception. In his books on cinema, Deleuze projects Bergson's theories of bodily perception onto film, claiming that it emancipates perception from the body's synthesizing predilections, thus creating an eye sensitive only to the immanent plane of matter, and not to transcendental subjectivities.[78] This eye goes "beyond the subjective and objective towards a pure Form which sets itself up as an autonomous vision of the content."[79] He says that the first time this is most clearly apparent is in Vertov's films and his theory of intervals that produces machine assemblages of images based on "the *genetic element* of all possible perception, that is, the point which changes, and which makes perception change, the differential of perception itself."[80] In short, Deleuze recognizes that Vertov's articulations are founded on the most basic of film's elements: individual frames and the intervals between them. In such assemblages, as described above, Vertov goes beyond images of movement and works with

their most material elements in order to generate a perceptual model for a new Soviet subject.

Deleuze finds this same desire to attain a pure perception in post–World War II American avant-garde cinema, footnoting the styles and film-makers he is considering in this group: "flickering in Markopoulos, Conrad, Sharits; speed in Robert Breer; granulation in Gehr, Jacobs, Landow."[81] He cites this cinema's interest in the flicker effect and "hyper-rapid montage" as the inheritance of Vertov's play with the photogramme and interval to exploit perceptual differentials between motion and stasis. Yet he notes how these films lack the explicit political project of Vertov's and that they are instead created as perceptual experiments. They "make one see the molecular intervals" and "release the perception of 'doing,' that is, to substi-tute pure auditory and optical perceptions for motor-sensory perceptions."[82] This substitution he later calls a time-image, which is marked by a virtu-ality that reveals a subjectivity not located in actions oriented toward the material world, but rather in nonchronological time and sensory images.[83] Deleuze explains that one of the key techniques utilized in films that pro-duce these images is the irrational cut, a method of linking divergent forms or images to one another to make visible the space that normally joins cinematic images in continuous motion:

> Cinema and mathematics are the same here: sometimes the cut, so-called rational, forms part of the one of the two sets which it separates (end of one or beginning of the other). This is the case with "classical" cinema. Sometimes, as in modern cinema, the cut has become the interstice, *it is irrational and does not form part of either set, one of which has no more an end than the other has a beginning*: false continuity is such an irrational cut.[84]

For Deleuze, the irrational cut can mimic consciousness by negotiating sen-sations and memories through nonlinear trajectories. But, he also shows how the utilization of this technique can create images of perceptual activ-ity itself: "[When] the cut no longer forms part of either of the two series of images which it determines, there are only relinkages on either sides. And, if it grows larger, if it absorbs all the images, then it becomes the screen, as contact independent of distance."[85] The cut in this style of filmmaking

swallows the film whole and uses images only to maintain its rapid pulses of change. The images in these films, like those in Breer's disintegrated animations, no longer exist autonomously, but instead as part of an irrational flow that perceptually excites viewers while offering them escapes into new thresholds of time and metamorphoses of forms. They expose the space between images and the means through which objects become related to one another. Pure cinematic perception exposes its own technical foundation.

Breer echoes this kind of analysis when he explains that, rather than thinking about his films as continuities, he instead sees them "as blocks of time in which no time takes place," explaining that he attempts to distort viewer's anticipations of continuity and instead generate a type of vision through the possibilities and constraints of cinematic technology.[86] Exploring the dynamics of materiality in this assemblage also led Breer to work with flip-books, kinetic sculptures, and optical toys, such as mutoscopes and thaumatropes, explaining that, in these works and in his films, he is "dealing with thresholds of awareness, of perception if you like."[87] Some of these optical toys are wall-mounted, while others have an independent base, but all of them have a minimal number of abstract elements on each frame, if they have anything at all. *Homage to John Cage* (1963) and *Double Mutoscope* (1964), for instance, contain blank metallic frames and invite the viewer to play with and focus on the flicker fusion threshold by hand cranking the speed at which the blank frames move. The latter mutoscope was a gift to Cage and works through Cagean aesthetic ideas related to chance, indeterminacy, and immanence that Breer learned of through his friendship with Cage and general participation in the avant-garde circles in New York in the late 1950s and early 1960s.

Cage emphasizes in lectures and performances (later published) an artistic practice that extinguishes continuity and structure, opening form and experience onto an indeterminacy that creates phenomenologically rich encounters. He prescribes that, for musical compositions, "the form, the morphology of continuity, is unpredictable. One of the pianists begins the performance: the other, noticing a particular sound or silence which is one of a gamut of cues, responds with an action of his own determination from among given possibilities within a given time bracket."[88] Such

FIGURE 3.10. Robert Breer, *Homage to John Cage*, 1963. Photograph courtesy of Kate Flax and gb agency, Paris.

FIGURE 3.11. Robert Breer, *Double Mutoscope,* 1964. Photograph courtesy of Kate Flax and gb agency, Paris.

aesthetic works become what he describes as "time-objects," a term Breer invokes later, which, as Joseph explains, are not static, but always in flux and constantly changing, depending on the chance encounters and circumstances of their instantiation. They produce "a thoroughgoing disarticulation of any and all abstract or transcendent connections between sounds or between individual components of a sound, such as frequency, amplitude, timbre, duration, or other morphology."[89] Yet, as Cage notes, the embodied experience of the work still emerges from an interaction with material in time, though it is strange and elusive, subject to arbitrary actions and sensual operations. It's an aesthetic action that Breer wrestled with when attempting to incorporate it into cinema. Since the placement of objects in frames on a filmstrip or even the sequencing of blank frames would produce a determined linearity and shape to experience, this form was at odds with Cage's aesthetic ideal, a feature that Sitney later identifies as becoming a tenet in structural film through his analysis of Conrad's *Flicker.* Recognizing the necessity of dealing with linear structure of some kind in

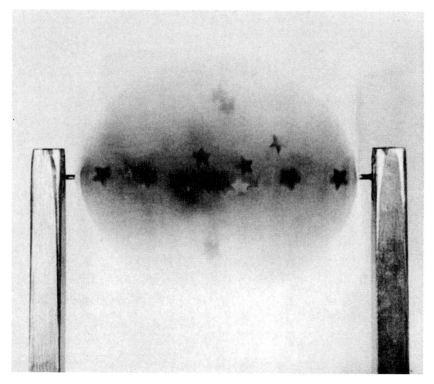

FIGURE 3.12. Robert Breer, *Stars* (thaumatrope), 1964. Photograph courtesy of Kate Flax and gb agency, Paris.

projected films, Breer nonetheless attempted to produce new sensual encounters upon each viewing through his disintegrated aesthetic described above. But the mutoscopes with their endless loops allowed him to produce a work that would engage solely with the flicker and interval between frames in an indeterminate manner. Viewers could control the speed of the mechanism and enter into an engagement with the rate of animation that was variable, creating perceptual unities whose contours could expand and dilate. This use of cinematic technology outside its normal architectural setting allows for an infinite play with the threshold of continuity that Breer continually explored through all his works. Andrew Uroskie argues that this indexes a desire to *"displace* cinema from the theater to the gallery"

and emphasize the relations between perceptual and material operations that produce all cinematic motion.[90] But Breer's fascination with thresholds of (dis)continuity cuts across both spaces, with references to the action of hands in his films or optical toys and the presence of mechanically moving objects or allusions to flip-books peppering films like *Fist Fight*. In his optical toys and in his flip-books, the action of the animator's hand that is so prominent in his collage films simply fluctuates, allowing for reversals and changes of speed through control of the interval between frames. Such abstractions attempt to produce a perceptual encounter with a work that is always defined through novelty and a freshness of visual experience. Stuttering and flickering, they disintegrate continuous movement while simultaneously producing a new flow of images and experiences of a machine time that exists outside of normal registers.

4 PROJECTION

ALGORITHMS OF LIGHT

> In mathematics, everything is algorithm and nothing is meaning.
>
> Ludwig Wittgenstein
> *Philosophical Grammar*

THOUGH USUALLY ASSOCIATED WITH BROADCASTING TRANSMISSIONS from the 1930s, television's history dates back to the late nineteenth century when ideas about the possibility of seeing at a distance took shape around other transmission forms such as telephony and telegraphy. Over the course of several decades of research and experimentation, engineers increasingly turned to visual projection systems that could efficiently abstract information about an image into communication protocols that transmit and synthesize visual forms in another space. The first systems utilized were mechanical, such as Paul Nipkow's *elektrisches Teleskop* composed of a metal disk with perforations that, with a beam of light behind it, would spin and scan parts of an image for broadcasting. But by the 1920s, technicians like Kenjiro Takayanagi and Philo Farnsworth had developed electronic display standards and technologies whose principles remain in use. Their primary area of investigation was the cathode-ray tube (CRT), an electronic display that uses a vacuum tube with an electron gun and phosphor-coated screen. By means of magnetic or electrostatic fields, the gun is directed to fire electron beams on the screen and generate a series of scan lines for images. By the 1930s, this technology had become standardized and available to mass markets, with several companies manufacturing CRT televisions and governments working to produce broadcast infrastructure and standards.[1]

Often lost in the history of television technology is the oscilloscope, a

device that, unlike most CRTs, rarely left laboratory settings in the 1930s. This, in part, is due to what the technology was and is still used for most: scientific and engineering applications. Oscilloscopes visualize frequencies and operate a little differently from their televisual cousins. Specifically, they measure signal voltage inputs on a graph of x and y axes, producing what looks like a wave line. And instead of making this image by having the cathode ray's gun scan the entire screen, from one side to the other, top to bottom, in what is called a raster-scan display, oscilloscopes operate much more efficiently. They simply direct the gun to fire at the display according to the arbitrary inputs the system receives. Thus, the waveform seen on the oscilloscope's screen is the same path that the gun made to draw it on the phosphor coating; this is called a vector-scan display. Such direct, analogous visualizations of electronic input are what made the oscilloscope such a powerful tool for so many different communities, since the time, intensity, and frequency of signals could be seen and measured in new ways.

By the late 1940s, CRTs were more commonplace and, alongside post–World War II surplus caches, manufacturers began producing affordable oscilloscopes for mass markets. But their popularity was not limited to technology enthusiasts. Artists like Mary Ellen Bute also turned to the device as a new means of creating abstract animations that would measure and visualize sound inputs. Bute had been making abstract animations since the early 1930s and worked with ideas of synaesthesia throughout her filmmaking career and before it, befriending Thomas Wilfred and working as his assistant in the 1920s to learn more about the Clavilux prior to working in Leon Theremin's studio. After a brief period as a painter, she chose to work in film so that she could translate the aesthetic action of music through movement. Echoing other artists and theorists of synaesthesia, Bute explains that, though her interest in this phenomenon and visual music more generally was not new, by the mid-twentieth century it had begun a new phase of development. Describing this aesthetic as an "expanding cinema," she relates the new media landscape of this moment to the focus on the interactions between "light, form, and sound [that] are in dynamic balance with kinetic space relations" found in the Absolute Film movement of the 1920s and 1930s.[2] The distinctions she identifies

FIGURE 4.1. Illustration of vector-scan and raster-scan displays. Courtesy of Ian Bogost.

emerge from new technical syntheses that produce the formal actions in these works.

Over the course of Bute's work with Theremin and Wilfred, she met the musician Joseph Schillinger, who had developed a system of musical composition based on mathematical principles and algebraic formulas. Believing that music was an expression of movement, his method created patterns of mathematical action that corresponded to rhythms and

melodies. This also led him to develop ideas about the ways in which this action could be synchronized with visual form, as he explains in his essay "Theory of Synchronization," which provides details about how visual and auditory movements could be rendered from the same algebra. Unlike artists such as Wassily Kandinsky or Alexander Wallace Rimington (discussed in chapter 2), who wished to generate synaesthesia in their works that would then model a perceptual training within viewers, Schillinger developed his correspondences between visual and musical form through a focus on ratios of correlation, which provided the foundational principle to what he calls, in the title of his 1948 book, *The Mathematical Basis of the Arts*.[3] As early as 1934, in "Theory of Synchronization," he clarifies that these ratios "do not necessarily mean one to one correspondence. Different components can be correlated through all the infinite variety of their different powers. . . . This means that the continuum of one or more components can be represented through a system of parabolas, where the location of points expressing different parameters can be determined."[4] Bute's first film, *Synchromy* (1933), was made in collaboration with Schillinger and attempted to put into cinematic form his theories of visual rhythm. Though never finished, a fact that William Moritz speculates was due to the laborious equations and geometric drafts illustrated in the 1934 article, Schillinger's principles of algebraic composition influenced Bute's films, as can be seen in her 1934 film *Rhythm in Light*. The film opens by explaining that it provides "a pictorial accompaniment in abstract forms" but uses mostly three-dimensional animation of objects such as pyramids, ping-pong balls, egg beaters, and cellophane to produce moving abstractions in a less laborious manner than the mathematically drawn animations attempted with Schillinger.[5] The film also recalls her training in stage lighting at Yale University's drama department and her subsequent work with Wilfred and Theremin. Using movement and reflection in a tradition of light art that includes Lázló Moholy-Nagy's *Lichtspiel* (1930), *Rhythm in Light* examines another avenue of correspondence between vision and music. As Bute elaborates in her 1932 presentation with Theremin at the New York Musicological Society entitled "Light as an Art Material and Its Possible Synchronization with Sound," there is more than one way to generate this action.[6]

Bute's immersion in the avant-garde and cosmopolitanism, which led

to her studies of art history at the Sorbonne in Paris, as well as to technical training on lighting equipment in Germany and Austria, exposed her to a variety of filmmakers and artists working through forms of visual and audio synchronization. And her invocation of the Absolute Film movement as a precursor positions her films as sharing similar aesthetic goals that filmmakers like Hans Richter, Walter Ruttmann, and Oskar Fischinger worked through in the 1920s and 1930s. These films developed abstract graphic movements through cadenced rhythms that were in correspondence with sound recordings or were intended to invoke synaesthetic expressions of musical accompaniment. But, over the course of these films and the careers of each filmmaker, they also wrestled with the language of abstraction, or more specifically, the meaning attached to these graphic forms. Richter, along with Viking Eggeling, produced experiments aimed initially at generating a universal language of abstraction as part of a larger political project that emerged from his association with De Stijl and constructivism.[7] On the other hand, Ruttmann's films, such as *Lichtspiel: Opus I* (1921) or *Lichtspiel: Opus III* (1923), attempted to produce vocabularies of sensual form and movement, locating the justification for abstraction in the work itself. As Michael Cowan explains, "what was at stake in Ruttmann's filmic abstractions was no longer an epistemological project but rather an *experiential* one."[8] Ruttmann wished to locate the ways this aesthetic would develop solely from, as he says, "the possibilities and demands of its material."[9] Yet the debate about the meaning of abstraction between the filmmakers points to larger epistemological questions surrounding the relationships between technics and the senses, as each filmmaker explored the means through which film could generate analogous correspondences between vision and music.

Bute's awareness of the technological play that resulted in these experiments helped her to be one of the first to recognize the capacities and potentialities of the "Expanding Cinema," though her term became more associated with 1960s and 1970s psychedelic and abstract film movements that Gene Youngblood features in his 1970 book of the same title.[10] For Bute, the new techniques and technologies that were entering into the mix of cinema were often at the service of exploring the technical means through which synaesthesia could be articulated. Though her phrase and

its associations are well-known and encompass a variety of filmmakers, in the interview where it first appears, she is most immediately referring to mathematicians that she and Ted Nemeth, her husband and cameraman, were working with at Yeshiva University. Members of the editorial board of *Scripta Mathematica*, a journal begun at Yeshiva in 1932 for the study of the philosophy and history of mathematics, helped Bute and Nemeth by creating "equations for the scale of the model and tempo of the visual music" for a film Bute was producing at the time of the 1936 interview. She points out that the mathematicians "aim to construct music from the equation in a sequence of pictures, not pictures from already-written music."[11] As in her earlier collaborations with Theremin and Schillinger, Bute's focus here on mathematics to create visual and musical correspondences stemmed from a model of perception that positioned sensory data as something that could be abstracted from the body and quantified. If epistemological questions plagued the Absolute Film movement as artists struggled to determine whether meaning could be present in their moving abstractions, Bute's project fell in line with Ruttmann's invocation of experiential form but avoided his pedagogical focus on training individuals to understand new types of movement. For Bute, moving image technology offered the means through which the senses could be modeled and analyzed. It stood as a laboratory for examining how perceptual registrations of sound and vision interact, with questions of modeling and operation constantly looming over the process. Her work asks how sensual information registers and transmits both action and effect through perception. Do these signals of information have abstracted principles that both constitute and unify them in the body? Can sensual forms even be constituted as information that exists outside the body and be displayed through isomorphic technologies?

These were the same questions that the mathematicians of *Scripta Mathematica* were asking, as well as a number of scientists and philosophers working in the new area of cybernetics that emerged in the 1940s and 1950s. Bute's regular collaborations emerged out of a shared interest in research surrounding perception and communication, leading Ralph Potter, Director of Transmission Research at Bell Laboratories, to seek out Bute after learning about her films like *Parabola* (1937) and *Synchromy No. 4: Escape* (1938). This led to Potter developing an oscilloscope and transmission

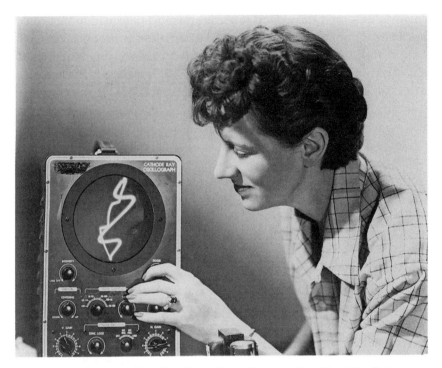

FIGURE 4.2. Mary Ellen Bute with oscilloscope. From Mary Ellen Bute, "Abstronics: An Experimental Filmmaker Photographs the Esthetics of the Oscillograph," *Films in Review* (1954).

circuit for her at Bell Labs, where she made her oscilloscope animations *Abstronic* (1952) and *Mood Contrasts* (1953), the latter winning the "Best Short Film" award at the 1958 International Experimental Film Competition in Brussels, attended by many abstract animators and artists like Len Lye, John Whitney, Robert Breer, and Stan Brakhage. I argue that Bute's oscilloscope animations were not simply illustrations of the device's operations, but instead provide visualizations of cybernetic perceptual models that Bute and her collaborative research scientists studied. Instead of positioning synaesthesia as a means through which forms of Romantic perception could exist, Bute's oscilloscope animations create a visual music in order to abstract sensory information from perceptual registers in the body,

showing how their distillation rendered them as information that could be removed from material contexts and transmitted across CRTs. Though often marginalized within histories of abstract animation or expanded cinema (there is, for instance, no mention of her in Youngblood's book), Bute's success spoke to how this paradigm was embraced and to the ways in which it shaped the potentialities of this new technology's projection of light.

ANALOG CORREPONDENCES

Norbert Wiener's oft-cited definition of cybernetics as the science of "control and communication in the animal and the machine" from his 1948 *Cybernetics* summarizes the core focus of the field by emphasizing how it studies the efficiency of information transmissions within technical systems.[12] But the history of cybernetics reveals divergent ideas about how these systems could or should communicate and also shines light on the ways in which information within these systems was understood and theorized. As often elaborated, cybernetics emerged as a field after the Second World War through a confluence of military technologies, Cold War scientific research programs, and the rise of computational machines. Peter Galison points out that Wiener's model of cybernetic control grew out of his work on antiaircraft gun predictors whose programmed anticipation of ballistics helped produce Wiener's broader model of abstracted "human proprioceptive and electrophysiological feedback systems."[13] The implications of this behaviorist model were far-reaching, including eradicating the distinction between human and mechanical actions within it.[14] Thinking about feedback systems and the establishment of controls, Wiener and others attempted to eliminate variables to establish stable operators within quantifiable communication, including individuals. Wiener famously wrote about human bodies: "Our tissues change as we live: the food we eat and the air we breathe become flesh of our flesh and bone of our bone, and the momentary elements of our flesh and bone pass out of our body every day with our excreta. We are but whirlpools in a river of ever-flowing water. We are not stuff that abides but patterns that endure."[15] How those patterns took shape was contested. Katherine Hayles shows how, within the first wave of cybernetics developed around the Macy Conferences in the 1940s

and 1950s, where research and conversation about topics within the field helped coalesce its identity, two ideas about information emerged within these models: one that focuses on what information is, and the other on what it does.[16] Wiener and Shannon-Weaver were advocates of the former understanding of information, which would allow for it to float free of material constraints and function as a mathematical probability within control systems. In this separation, Wiener claimed that "information is information, not matter or energy. No materialism which does not admit this can survive at the present day."[17] Donald MacKay pressed for the latter conceptualization, which emphasized the actions that information produced within systems, "a process that someone enacts, and thus [that] necessarily implies context and embodiment."[18] Each had different advantages and disadvantages, so that information's alignment with a stable quantity enabled it to help produce homeostatic feedback loops while its action-oriented definition took into account receivers of parts or entire systems. As Hayles points out, the former won out during the first cybernetic wave because of the ideological appeal of creating universal systems and because it was a more manageable endeavor, since considering the materiality and context of information "and measuring this effect sets up the potential for a reflexive spiral through an infinite regress of observers."[19]

The model of communication transmission most associated with this theory of information is Claude Shannon's "Mathematical Theory of Communication," with its diagram of a communications system that tracked how information could be converted into a signal that could move from a source to a receiver through a channel that suppresses noise. Shannon's goal, as Weaver also explains in his introductory note to the theory's book length publication, is to produce a system rooted in abstraction that would be flexible and encompass the transmission of any message, thus disregarding meaning. He points out that "*information* must not be confused with meaning" and that "two messages, one of which is heavily loaded with meaning and the other of which is pure nonsense, can be exactly equivalent, from the present viewpoint, as regards information."[20] Information within this cybernetic model functions as a unit of probabilities, or "the logarithm of the number of available choices,"[21] that could be converted into a signal intelligible to both sender and receiver. As Weaver explains, the system is

"so general that one does not need to say what kinds of symbols are being considered—whether written letters or words, or musical notes, or spoken words, or symphonic music, or pictures. The theory is deep enough so that the relationships it reveals indiscriminately apply to all these and to other forms of communication."[22] As with the abstraction of information from embodied forms of materiality, Weaver similarly uncouples the research context from which the model emerged in order to direct attention to the model's utility and what Shannon describes as "the fundamental problem of communication [which] is that of reproducing at one point either exactly or approximately a message selected at another point."[23] The slip between reproduction and approximation here is important because it points to the ways in which comprehension within this communication theory was not understood as holistic, but instead atomized into discrete elements, parts of which could be left out while still maintaining signal clarities.

Focusing on outcomes of communicative models meant that the context through which these signals were interpreted mattered less than the maintenance of analogous relays that tied the system together. In 1943, this emphasis was made explicit in an essay by Wiener, Julian Bigelow, and Arturo Rosenblueth titled "Behavior, Purpose, and Teleology." The essay opens by explaining how the authors use behaviorist methods in their research rather than functionalist ones, since behaviorism emphasizes the study of inputs and outputs of objects within their environments and "omits the specific structure and the intrinsic organization of the object," which is the domain of functionalism.[24] Conditions of change within a system come to the fore of this method and let objects and their constitution become relatively incidental. The consequence of this, as noted by many, and by the authors, is that the difference between humans and machines in these models no longer mattered, since the approximation of an object's actions drove the operational and analytical focus: "That the gross behavior of some machines should be similar to the reactions of organisms is not surprising, . . . [and] the methods of study for the two groups are at present similar."[25] Because relations of inputs and outputs are measured within a system, the actors encoding and decoding these signals could be interchangeable so long as they efficiently performed the communicative operations, leading to an understanding of the body within this discourse

as a composite of actions and reactions that can exist by analogy within machines. Behaviorist methods of research within cybernetics led to communication models with analogies of all things in abstract equivalence.

As Jonathan Sterne points out, this drive for abstractions within information theory also emerged in psychoacoustics and research in telephony before the establishment of cybernetic theory and greatly impacted that field's development. Shannon's 1937 master of science thesis, "A Symbolic Analysis of Relay and Switching Circuits," worked through the problems of applying Boolean algebra to circuits, and he was later hired at Bell Labs to do the same to their telephone systems.[26] Within Bell, researchers since the 1910s had been analyzing digital signal theories to produce correspondences of pulse transmissions with various symbols or letters that could be used in communication pathways. As Sterne shows, the on–off logic of binary operations was being used at this point in telegraphy, which was then employed in the creation of a more encompassing model for signal transmission systems like telephony, radio, television, and others by Bell Labs scientist R. V. L. Hartley.[27] Hartley produced a theory of information similar to the one Shannon later developed, and is cited by Shannon, where information within a communication system is defined through probabilities in time. As in later cybernetic theories, the key to Hartley's model of transmission was the abstraction of information from material limits so that it could move as a quantitative expression through signal channels. He explains that, in telephony, "the actual physical embodiment of the word consists of an acoustic or electrical disturbance" expressed in time and that it is necessary to "eliminate psychological factors involved and to establish a measure of information in terms of purely physical quantities."[28] Though Shannon's similar definition of information and behaviorist approaches to communication systems is associated with debates within the nascent field of cybernetics in the mid-twentieth century, this model had by this time been embraced by a large number of engineers and scientists studying signal transmissions.

Hearing and other perceptual modalities thus became sites for the sorting and categorizing of information for the body, an operation that could be abstracted and replicated by analogous machines within cybernetic and transmission systems. Though Hartley's examples encompass media

whose machinic homologies extend beyond the ear, Wiener explicitly links the abstraction within information theory to vision. In attempting to understand patterns of attention and perceptual acuity, he argues that there are a series of filters or steps that the eye, retina, and optical nerve engage in to distill omnipresent visual information. Using our ability to perceive outlines as an example of this, he explains that gestalts and associations of the face's contours with a particular subject reveals that, "somewhere in the visual process, outlines are emphasized and some other aspects of an image are minimized in importance."[29] The evidence for this assertion comes from observations about sensitivity to contrast in afterimages and the fact that a majority of optic nerve fibers respond to the flashing of illumination, though this part of his text is filled with equivocations. What he emphasizes before moving on is an isomorphic relation between visual perception and photographic processing. Wiener explains that, "in photography, it is known that certain treatments of a plate increase its contrasts, and such phenomena, which are of non-linearity, are certainly not beyond what the nervous system can do."[30] Like a darkroom technician, visual perception is constantly sorting through information available to it and attempting to highlight what is of interest for comprehension and action. Thus, along with taking in relevant information present, it filters out or shadows what it deems unnecessary as a way to "decrease the total unusable information carried by an image," which he hypothesizes happens more in earlier stages of perception, since this attenuation is "probably correlated with a part of the reduction of the number of transmission fibers found at various stages of the visual cortex."[31]

Modeling visual perception as a sorting mechanism is key for Wiener in this text since he is attempting to explain gestalts and the ways in which mechanisms could be built to replicate this cognitive and perceptual function. As he moves toward the conceptualization of this technology, he continues to pepper his explanations with examples of media that work in ways analogous to different parts of visual perception. Moving from photography to television, he explains that the latter's scanning technology abstracts two dimensional images and samples regions of them for transmission as it creates what will later be taken as a whole image through representational gestalts. The process whereby this selection of samples is taken to maintain

coherence he calls "group scanning," emphasizing that the grid through which it operates contains abstract positions in space that will ensure a legible transformation. Wiener illustrates the utility of this system by showing how it could translate visual images into auditory ones for the blind, and he explains how an optical character system could be used to scan letters and translate them into notes of a chord with "several photo-electric cells placed in vertical sequence, each attached to a sound-making apparatus of a different pitch."[32] Here Wiener begins to work through theories not just of one perceptual faculty, but of how all the senses are related to one another within cybernetic models.[33] Though he and others discussed in general the ways in which information can be abstracted from material contexts and how humans and machines can operate within patterns of communication in analogous ways, it is specifically in his analysis of gestalts that he lays out the corollary that senses can operate in abstract equivalence to one another. As he describes visual scanning devices, it becomes clear how he positions their machinations as functioning in the same way as human perception, arguing that, just like their group scans, "something similar occurs in other senses as well. In the ear, the transposition of music from one pitch to another is nothing but a translation of the logarithm of the frequency, and may consequently be performed by a group-scanning apparatus."[34] The activity of listening, like seeing, works as a sorting mechanism that isolates information to be transmitted and registered in perception, rendering the context of the source as irrelevant, just as the paper, font size, and weight of the book were all obstacles in the scanning of text described above. Scanning and transmitting the world across the senses was possible if sensation was conceptualized as frequency modulations.

ENGINES OF ABSTRACTION

Such explorations of analogous sense perceptions were not new, as the discussion of synaesthesia in chapter 2 details, but the electronic measuring and transmission of frequencies renewed interests in the possibility of cross-translating visual and auditory sensations. Tom Levin shows how the development of optical sound recording technologies in the 1920s that photoelectrically recorded sound waves on part of the filmstrip—the

sound-on-film systems like Tri-Ergon and Movietone—ushered a series of experiments in the relationships between sound and vision through the manipulation of magnified optical soundtracks.[35] Sound engineers in the early 1930s were some of the first to begin working in this way because of the need to add dialogue to various film sequences without the actors on hand to record their lines. As reported by the *New York Times* and other publications, engineers resorted to studying a preexisting soundtrack featuring the actor and then isolating phonemes that could be replicated and mixed into sound patterns to produce the sonic equivalence of the actor's voice saying the lines needed in the shot.[36]

This laborious, synthetic process was replicated in the avant-garde, with artists like Moholy-Nagy emphasizing the ways in which it could articulate sounds not previously heard within an aesthetic of modernist production that explored new sensual relations augmented by machines.[37] Like the sound engineer, he wished to "write acoustic sequences on the sound track without having to record any real sound."[38] The simultaneous projection of these sequences on the visual track would not only reveal the ways in which the senses were related but also generate a new vocabulary and grammatology born from the technical landscape that had so radically transformed the first decades of the twentieth century. One of the most well-known films to illustrate this is Norman McLaren's *Synchromy* (1971), which features blocks of color abstractions on each frame that are also printed on the optical soundtrack (Plate 7). The tones match a playful visual rhythm whose pitches rise and lower with the length, height, and number of the blocks on the visual track. Because of the separation of abstractions and frames, the melody of the song has the quality of being sampled as an 8-bit era pulse-code modulation, which limits the range of frequency captured to create the blocky sound textures and effects that distinguish computers, games, and synthesizers from that time. But the film only mimics this digital aesthetic, simply relying on the discrete blocks of color to generate the pulses of sound. McLaren had experimented in the relationship between sound and vision for decades by the time this film was made, working through and studying a variety of techniques to generate sound in films such as *Loops* (1940), *Neighbors* (1952), and *Blinkety Blank* (1955). In 1950 he wrote a pamphlet for the National Film Board of Canada entitled

"Animated Sound on Film" that explains these and the history of synthetic sound on film, emphasizing that "the only difference from normal cartoon picture shooting is that the drawings are not of scenes from the visible world around us but of sound waves, and they are not done on cards of a screen-shaped proportion but on long narrow cards."[39] McLaren explains that, amongst the techniques reviewed in the article, he uses a system similar to the one Rudolph Pfenninger developed in the 1930s, which employed a "library of cards each bearing the drawing of a single pitch, graded in semitones over a wide pitch range. In these drawings the basic units for sound waves were sine-curves and saw-tooth forms."[40] These would then be photographed on the optical soundtrack and volume could be determined through exposure levels.

Levin also traces the history of this animated sound, showing how Pfenninger and Fischinger created similar techniques in the early 1930s, but with different motivations. Fischinger initially became interested in the analogical relations between images and sound within a synaesthetic framework, examining what Levin characterizes as the "acoustic correlates" of graphic forms whose hand-drawn double exposure on visual and sound tracks of film offered a new tool in aesthetic visions, or as Fischinger says: "Hand made film renders possible pure artistic creation."[41] Pfenninger, on the other hand, drew approximations of sound waves to collect notational fragments that could be deployed within new semiotic contexts. Levin explains that, though the two produced works appear similar, unlike Fischinger, Pfenninger was "eschewing aesthetic discourse entirely" and creating "a new form of acoustic writing, a semio-pragmatic of sound whose function was to liberate composition from the constraints of both the extant musical instrumentarium and reigning notational conventions."[42] Levin argues that this was an effort to mark, transcribe, and represent sound that would break indexical relations of recorded sound within the social and technological landscape, namely that lines of acoustic sine waves were referential in nature. As James Lastra shows, through the nineteenth and early twentieth centuries, phonography became associated with a form of technological recording or inscription rather than a producer of new sounds, which "was a discursively efficient way to crystallize the basic epistemological questions raised by sound recording."[43] Casting the new media

into a representational arena, this not only mollified concerns over its powers of reproduction, but also framed its technological operations, a process that simultaneously occurred with photography, which Henry Fox Talbot famously described as "the pencil of nature."[44] Discursively, the technology seemed to record what was presented before it.

Even with these differences between Fischinger and Pfenninger, the two still shared an understanding of how technology could abstract various sensations and convert them into frequencies for storage and rephenomenalization. Though the source of sound differed, the sensation of sound for both artists was modeled as frequency vibrations that could be projected, stored, and visualized by technologies that were analogous to the body. This isomorphism was at the root of both artists' experiments, as they each wished to work with and modify sound forms that were created and stored through visual technologies that could measure their modulations. Levin mentions that, before developing his notational system, Pfenninger used "an oscilloscope and studied the visual patterns produced by specific sounds until he was able—sometime in late 1929 or early 1930—to isolate a unique graphic signature for each tone."[45] He would then draw what he believed this signature was while creating an archive of sound forms. Though breaking phonographic indexicality, Pfenninger still relied on indexical impressions of sounds projected by the oscilloscope, embracing the ways in which that technology isolates and translates acoustic patterns into visual waves in a manner modeled on perceptual filtering and attention. Though, as one reviewer exclaims, Pfenninger's sounds function as "tones from out of nowhere,"[46] they nonetheless emerge through a technical assemblage built around abstracting sensation as information that could be visualized, measured, and recorded.

Animated synthetic sound continued to work from this understanding of sensation as a technological frequency that could slip across sonic and visual registers, seen for example in John and James Whitney's *Five Film Exercises* (1943–45) (Plate 8). The film series was created through the development of a machine with pendulums whose movements could control the amount of light exposed to a camera. These recordings were then placed on an optical soundtrack. With the ability to control each pendulum and the camera's recording speed, the Whitneys could stack tones

onto one another so that, as John Whitney explains in 1959, "it was possible to start and stop a sequence of perhaps 20 pendulums within one frame."[47] The visual track consists of abstract graphic forms produced with airbrushes and stencil designs initially photographed onto black and white film before being rephotographed with an optical printer onto color stock. These processes were related to one another in the final film product by what the Whitneys describe as a compositional unity. Through sound and vision, they attempted to develop "some form of serial permutation to be juxtaposed dynamically against itself by retrogression, inversion, and mirroring."[48] This was an intuitive connection established between the two registers, not dissimilar to the color–scale correspondences discussed in chapter 2, where different theorists and practitioners argued for different color and musical scale alignments. These were often fraught with subjective impressions and disagreements over a note's color impression, exemplified in the musical note *D*'s association with seven distinct colors, depending on which of the various theorists one reads between the eighteenth and twenty-first centuries.[49]

The double projection of images on the optical and visual tracks of film provided a more stable or clear bond between a graphic form's visual and aural impressions, but this technical system was limited to projection and could not measure the intensity of the form's sensual impression. In short, the technologies McLaren, Fischinger, Pfenninger, and the Whitneys developed could not abstract graphics into information that could be used in other systems. This was a capability the oscilloscope had and one that fascinated Bute. While translating acoustic forms, the oscilloscope measured frequencies through a visual grid, thus enabling a quantification and abstraction of graphic information into other arenas.

The measurement of visual fields on a CRT display is a cornerstone in the technological history of oscilloscopes, and of televisions more generally. Because of television's focus on transmission and relationship to telegraphy and telephony discussed above, its means of image production and communication were built around technical quantifications and abstractions of forms. Accordingly, it distinguished itself from photography and cinematic recording by how it broke up images into pieces of light on a measured display. Doron Galili traces the history of experiments that attempt to do this

and shows how Carl Wilhelm Siemens's 1876 selenium plate experiment galvanized ideas about televisual transmission technology and attempts to produce an "electric eye":

> This instrument consisted of a selenium cell—an electric circuit connected to a plate of selenium—that Siemens mounted inside a hollow ball, opposite a circular opening covered by a glass lens. The similarities between the structure of the device and the eye were self-evident: the ball represented a human eyeball, the selenium substituted for the retina, and the opening opposite the selenium plate functioned as the pupil. In addition, Siemens furnished this artificial eye with artificial eyelids in the form of two sliding screens that were placed on the top and on the bottom of the lens.[50]

As light hit the selenium plate, it would conduct electricity based on the intensity and even color of the illumination, articulating a model of vision and transmission based on electrical frequency, a distinction that separated it from earlier camera obscura models of the eye popularized by scientists and philosophers like René Descartes in *La dioptrique* (1637) that emphasized image reproduction and visual fidelity.[51] Siemens's device could not produce images at all, but he believed that its analog to perceptual operations was truer to the ways in which images are sent to the brain and that this paved a path toward future image transmission systems that could decode electrical pulses in long wires and reproduce images on another device. Before scanning disk systems in the late nineteenth century, this was precisely how engineers produced early televisual technologies, using what R. W. Burns describes as a mosaic method of conversion. In this setup, a grid of selenium cells was placed in a camera obscura, with each cell connected to a wire that would transmit the electrical current registered by the amount of light emitted by the incoming image. This cache of wires would then replicate the light intensity of each cell on a receiver, with the goal of image reproduction through a pointillist gestalt.[52]

Though these systems were later overshadowed by Nipkow's scanning disk and Farnsworth's tube technologies, the precedent of abstracting vision through a two-dimensional matrix of coordinates that were converted into electrical signals remained. In the late nineteenth century,

this equivalence between electrical frequencies and the senses was increasingly prevalent across several technologies, to the point that John Durham Peters describes the widespread correspondence as creating a landscape of "neurophysiological mimicry" inspired by the telegraph.[53] As Timothy Lenoir also shows, Hermann von Helmholtz's studies of nerve response time and acoustic frequency isolation created a model of sensory representation in electrical systems that was generalized to all perceptual operations, extending understandings of the ear to other senses. In these models, the nervous system functions like a switchboard receiving various signals from reception points to be decoded according to frequency intensity. Lenoir explains how, inside the body, "Helmholtz postulated retinal structures—three receptors sensitive primarily to wavelengths in the red, green, and violet ranges respectively—[to be] analogous to the arches of Corti in the ear."[54] For Helmholtz, color was discernible through the same bodily mechanisms that distinguish acoustic tones, though the number of nerve fibers and connections to sensory input devices were different. But again, each carried frequencies in the same way as telegraphy. As Helmholtz explains, "supposing that every qualitatively different action is produced in an organ of a different kind, to which also separate fibres of nerve must proceed; then the actual process of irritation in individual nerves may always be precisely the same, just as the electrical current in the telegraph wires remains one and the same notwithstanding the various kinds of effects which it produces at its extremities."[55]

Again, at the center of this model of perception and transmission was electrical frequency intensity measured in time. And the crossing over of these signals from one form of sensation to another within this technological assemblage was an easy leap for many, beginning in the nineteenth century with, as Albert Abramson shows, Nipkow proposing the transmission of images to telephone receivers and continuing in the twentieth with Wiener's discussion of the same operations within cybernetic theory.[56] In the intervening years, the ability to measure those frequencies, store information about them, and extend them into other arenas changed. Though the model of sensation as electrical frequency was established through telegraphy, its abstraction as information that could exist independently within realms of algorithmic and mathematical applications developed in

the mid-twentieth century, especially as CRTs enabled the visualization of isolated frequencies in a clear manner.

Since the oscilloscope was built around the visual measurement of frequency pulses, voltage, sound waves, and other inputs, it quickly became a technology many turned to for this kind of work. After serving in World War II, Ben Laposky, a mathematician and draftsman, started exploring visualization techniques for harmonic patterns and quickly turned to the oscilloscope after learning about how it could project sine waves and other curves. Beginning in 1950, he started producing what he calls Oscillons, or "images in light,"[57] by manipulating input signals using "as many as 70 different settings of controls on the oscilloscope and of other combinations of input waveform generators, amplifiers, modulating circuits and so on."[58] The resulting signal movements that would loop through the electrical input variables would appear as static when recorded through photography, Laposky's preferred archival technique, since he did not desire to repeat the technological configuration that generated the image. He notes that his primary interest was in the aesthetic articulation developed through spontaneous interactions with the machine and that, though a compositional theory and record of each Oscillon could be kept for later replication, the goal was instead to generate as many as possible and sort through them, later claiming to have created "over 10,000 black and white traces . . . and several thousand in color." He explains that the effects of these are "perhaps similar to the abstract aspects of music—as is the appeal of other art using light," and that, "while giving impressions of sweeping rhythms, the pulsating trace of the oscillating electron beam reveals their formation."[59] Through a shared focus on abstraction in time, his work's relationship to music is often invoked, and he discusses a shared affinity with visual music and the work of Bute, McLaren, and Nam June Paik.[60] And, though he emphasizes the novelty of his Oscillons, he also recognizes their foundation in mathematical equations and trigonometry, explaining how Lissajous figures are made through the relation of sine waves interacting at right angles. He says that, though many of his images could "be plotted or analyzed by means of the equations, . . . [creators] obtain much more artistic feeling in the designs as they appear on the scope screen than would ever be possible by calculation alone."[61]

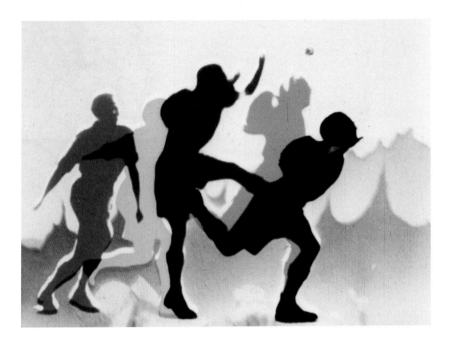

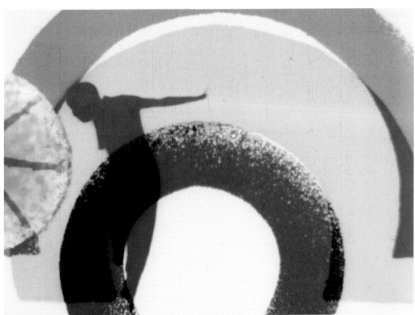

PLATE 1. Film stills from Len Lye, *Rainbow Dance,* 1936. 35mm, color, sound, 5 minutes. Courtesy of the Len Lye Foundation and Ngā Taonga Sound & Vision.

PLATE 2. Thomas Wilfred, *Lumia Suite, Op. 158,* 1963–64. Projectors, reflector unit, electrical and lighting elements, and projection screen; screen 6 × 8 feet; approximately 9 years, 127 days, 18 hours. Museum of Modern Art, New York, Mrs. Simon Guggenheim Fund, 582.1964. Photograph by author.

PLATE 3. Mary Elizabeth Hallock Greenewalt, "In the Village" score, musical and color notes. From Mary Elizabeth Hallock Greenewalt Papers (collection 0867), Historical Society of Pennsylvania.

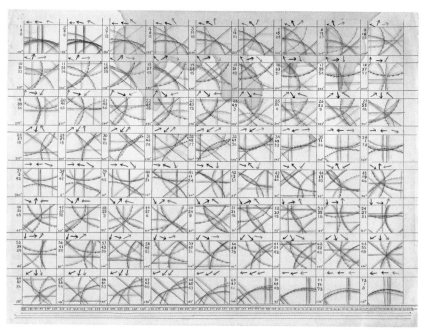

PLATE 4. Thomas Wilfred, *Sequential Development of Three Form Groups*, 1948. Colored pencil, ink, and colored ink on paper, 49.9 × 67.1 cm. Museum of Modern Art, New York.

PLATE 5. Jacques Mahé de la Villeglé, *Jazzmen,* 1961. Paper collage on canvas, 217 × 177 cm. Courtesy of Tate, London. Copyright 2019.

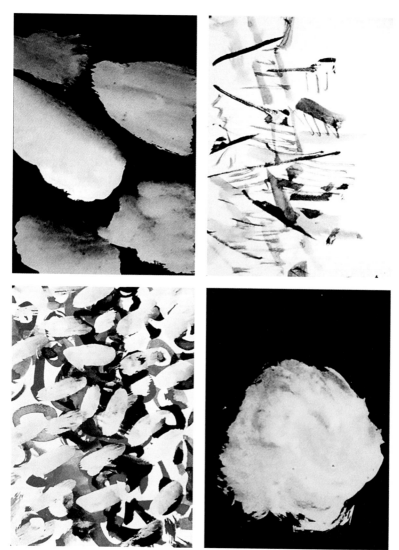

PLATE 6. Film stills from Robert Breer, *Blazes*, 1961. 16mm, color, sound, 3 minutes. Courtesy of Kate Flax and gb agency, Paris.

PLATE 7. Film still from Norman McLaren, *Synchromy*, 1971. 35mm, color, sound, 7 minutes.

PLATE 8. Film stills from John and James Whitney, *Five Film Exercises*, 1943–45. 16mm, color, sound, 21 minutes. Courtesy Whitney Editions™, Los Angeles.

PLATE 9. Film stills from John Whitney Sr., *Catalog,* 1961. 16mm, color, sound, 7 minutes. Courtesy of Whitney Editions™, Los Angeles.

PLATE 10. Film still from John Whitney Sr., *Experiments in Motion Graphics*, 1968. 16mm, color, sound, 13 minutes. Courtesy of Whitney Editions™, Los Angeles.

PLATE 11. Film still from Lewis Klahr, *Nimbus Seeds*, 2009. HD video, color, sound, 8 minutes. Courtesy of Lewis Klahr and Anthony Reynolds Gallery.

PLATE 12. Film stills from Lewis Klahr, *Wednesday Morning Two A.M.*, 2009. HD video, color, sound, 7 minutes. Courtesy of Lewis Klahr and Anthony Reynolds Gallery.

FIGURE 4.3. Ben F. Laposky, *Electronic Abstraction no. 4*, 1952. Courtesy of the Anne and Michael Spalter Digital Art Collection.

MATHEMATICS IN MOTION

The oscilloscope's mathematical shorthand in the visualization of sine waves and other frequencies may be why *Scripta Mathematica* was the first venue to publish Laposky's work in 1952. The journal reproduced five of his Oscillons, but alongside them also featured an earlier piece of his that he had created with a pendulum whose symmetrical pattern and style is similar to the electronic work, but with a different line texture and thickness. Calling the Oscillons a "new experimental art form," the editors of the journal point to the electrical foundation as a demarcation of their novelty, but note that "the mathematical aspect of these electronic creations is found in the basic wave patterns which compose them."[62] From its beginnings in the 1930s, the journal often published articles about the relationship between mathematics and the arts, as well as on the harmony of forms like the magic square and the impact of mathematics in the sciences or contemporary technologies, seen for example in an analysis of calculations for the telegraphic transmission of images.[63]

As detailed above, Bute's relationship with the editors complemented her research with Schillinger and over the course of making abstract films she developed her own mathematical system of compositional construction:

> I take the relationship of two or more numbers, for instance 7:2, 3:4, 9:5:4, fraction them around their axis, raise to powers, permeate, divide, multiply, subtract and invert until I have a complete composition of the desired length in numbers. . . . I use this composition of numbers to determine the length, width, and depth of the photographic field and everything in it.[64]

She acknowledges how this method was inspired by Schillinger, a connection established through his interest in the same types of numerical ratios and permutations within his theories of synchronization. His synchronization essay discussed above was published in *Experimental Cinema*, a journal edited by Lewis Jacobs, who had collaborated with Bute and Schillinger on the unfinished *Synchromy*. In the essay, Schillinger establishes a formula for the development of rhythms within film based on harmonic divisions, or the ways "one can split any given area into many fractional areas reserving the inherent relation of the whole. . . . For instance the rhythmic

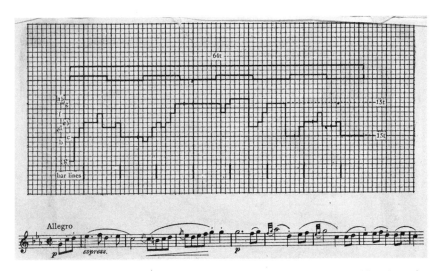

FIGURE 4.4. Joseph Schillinger, graph notation of the rondo of Beethoven's *Sonata Pathétique,* between 1915 and 1943. Joseph Schillinger papers, 1934–48. Archives of American Art, Smithsonian Institution.

center for an image on a given area will be more dynamic or dramatic at the ratio of 4:3 than at 1:1."[65] The composition of images within this theory focuses on permutations of action based on periodicity, symmetry, and balance. Schillinger's ideas often emphasize these aesthetic priorities as they analyze a work through its translation into another medium. His notation of *The Rondo* of Ludwig van Beethoven's *Sonata Pathétique* (1798) shows how this operates. Within his theory of melody construction, "the primary axis is a tonal center around which melody clusters," and when working through a musical score he uses squares to represent eighth notes and semitones on x and y axes respectively.[66] The resulting illustration reveals the most frequent sounds at the longest durations and in this piece shows that there are "two competing tonal centers," an indication of the need for melodic revision for better harmonic balance.

This focus on complementary structures between music and images is what Bute attempts to work through in her films, though she is not always attempting to produce the one-to-one correspondences seen in the work of Fischinger and others. For example, in *Synchromy No. 4: Escape* she utilizes

FIGURE 4.5. Film still from Mary Ellen Bute, *Synchromy No. 4: Escape*, 1938. 16mm, color, sound, 5 minutes.

a number of visual elements that move in coordination with one another in order to capture an aesthetic sense of the action and melody found within the musical piece. Though she calls this film, like many others, a "seeing sound" film, the musical movements of Johann Sebastian Bach's *Toccata and Fugue in D Minor* (ca. 1704) have been abstracted and measured to produce an analogous choreography for the many visual elements. Using rotating light sculptures reminiscent of Wilfred's lumia, as well as triangles and other abstract shapes that rotate and spin on the z axis, Bute stages these forms behind a black grid or field of spirals that helps measure and contextualize their actions within space. Movements of visual elements quantify aural action within this film, instead of providing an iconic correlate. They work together through formulaic ratios like Schillinger's "system of parabolas," an exploration taken up by Bute in her film *Parabola* from

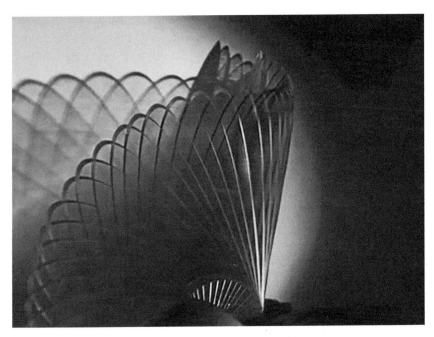

FIGURE 4.6. Film still from Mary Ellen Bute, *Parabola*, 1937. 16mm, black and white, sound, 9 minutes.

1937, which examines, as the opening lines to the film explain, "nature's poetry of motion written with a single line, parabola." Like *Escape*, this film puts geometric abstractions in motion, though the visual images here are all derivates of the titular form. Similar to Laposky's early exploration of the same element, this film focuses on the ways in which the form's parallel lines being stacked next to one another generate a symmetrical balance of different sized curves. Bute spins these around as well, seemingly inspecting the lines and shapes at a speed that matches the compositional structure of the soundtrack, Darius Milhaud's *La création du monde* (1923).

In both these films, there is a focus on measured structures of action in space that unite sound and vision, but the spinning of the geometries featured also produces Lissajous curves, a mathematical form that visualizes ratios of harmonic motion. Generated as an optical illusion of a curve

moving fluidly in three dimensions on a two-dimensional screen, Lissajous curves have symmetrical high and low points that phase, or move, in corresponding ways along a polar coordinate grid based on structured ratios. Here the importance of Bute's guiding ratios for her films becomes clear, since, without those principles, the calculations of movement would not generate this effect. Matching the sound with images of motion meant working through a musical piece's harmonic structure through a method like the one Schillinger developed and then using these mathematical ratios to guide the generation of movement within the visual track. For Bute, this harmonic calculus was a measuring of sensation. Its goal was to provide a mathematical model for perceptual reception, here within the realm of aesthetic harmony. The films "see sound" not through a theory of synaesthetic correspondence, but through a simultaneous projection of harmonic movement that has been distilled from one source.

This differed from her earlier collaboration with Theremin before turning to film. After her explorations in painting and stage lighting, Bute worked with Theremin on a projection technology developed with

> tiny mirrors, about one-eighth inch in diameter, on minute oscillators in time tubes of oil to cut down the friction and make them amenable to control. We would reflect light through prisms on these mirrors to get a range of spectral colors, then move the point of colored light about on the screen. . . . Needless to say these visual "goings on" were accompanied by electrical tones and sounds of the most unusual order. The wave lengths of the colors were arithmetically related to the wave length of the sounds and I found the results exhilarating as did the little group in the workshop.[67]

She notes how difficult it was to control this assemblage of materials and that the results were not something that could be publicly showcased, but that they did point her in the direction that she wished to pursue within her filmmaking that she began shortly afterward. It also shaped her understanding of sensation as the reception of patterned frequencies whose ratios could be measured and abstracted into other contexts. If color wavelengths and sonic vibrations had the same information pattern but affected different perceptual registrations, Bute postulated like later cybernetic theorists that

not only is sensation made of frequency modulations, but it can be isolated and made accessible through mathematical principles and technologies.

The means available for accessing these ratios was the problem, and as Bute investigated this through Schillinger's theories, many were exploring the same issue at the intersection of engineering and psychology. In 1946 the director of Harvard University's Psycho-Acoustic Laboratory, S. S. Stevens, took on this issue in *Science* magazine. Since the 1930s, Stevens had been researching psychological and physiological aspects of acoustics, including tone differentiation and auditory intensity. But, in the *Science* article, he addressed the question posed by a committee that had formed several years earlier to consider whether it was "possible to measure human sensation."[68] The committee's findings criticized Stevens's earlier work that quantitatively analyzed sound intensity, believing any mathematical constant applied to the measurement of sensation to be impossible. In his rebuttal, he explains how intensities of sensation can be measured through different scales of relative value, emphasizing that, in his research on acoustics, a ratio scale was the most applicable one to use based on the mathematical properties present within empirical findings of sonic phenomena. Accordingly, Stevens argued that an isomorphic equation that explains patterns of acoustic sensation can be derived. In 1957, he summarized a number of research findings gathered over a couple years to support what became known as the Stevens's power law, a mathematical formula that shows the relationship between the magnitude or power of a stimulus and the intensity of its sensation on a receiver.[69] As Stevens emphasizes in all his research on sensation, the mathematical analyses were intended to provide "a model to represent aspects of the empirical world."[70]

As it was for others interested in psychoacoustics, the oscilloscope was one tool Stevens used in his laboratory to visualize these ratios of magnitude and intensity, since it could project the phase shifts of audio waveforms. And in doing so, it helped concretize cybernetic paradigms of sensation that emphasize how perceptual operations can be abstracted from the human body within technical assemblages. When Bute first started using the oscilloscope, she saw this as one of its sources of potential, explaining that its "resulting beauty and movement contain intimations of occurrences in the sub-atomic world that hitherto have been accessible to the

human mind merely as mathematical possibilities."[71] Bute had been search-ing for a technology that would enable quick registrations of lines, but she was especially interested in the ability to "'draw' with a beam of light with as much freedom as with a brush."[72] That said, the device's ability to gener-ate Lissajous curves with light that repeats itself so that forms develop "in a time continuity" was the most promising aspect of the technology.[73] With its ability to automatically graph the relationships that Bute had been calcu-lating by hand, it allowed for an efficiency of design so that the visualized ratios of action that produce the curves "can be varied as much and as often as one pleases; the tempo of their movements can be changed at will."[74]

Abstronic and *Mood Contrasts* utilize a variety of these figures that change and modulate in synchronization with the music. But the repeat-ing waveforms and curves are clearly not always frequencies taken from the soundtrack. Instead, Bute produces a visual composition reminiscent of her earlier work where the on-screen forms move in space through the same articulated ratios of action present within the musical selections. In the first half of *Abstronic,* Bute features Aaron Copland's *Hoe-Down* (1942) with oscilloscope-produced Lissajous curves, as well as other isolated fre-quencies, alongside hand-drawn animations and optical printing effects, creating a medley of forms that move through the same scaled relations. Even using this new technology required mixing it with older ones, seen for example in the ways color was added to the oscillographs through an optical printer, but she also used many of the same methods from her past work, such as the visual mapping of melodies found in the musical score. In Figure 4.7, she illustrates the visual motifs she identifies in a particular sequence of *Hoe-Down* and provides the same ekphrastic translation for Don Gillis's song *Ranch House Party* (1940), the musical accompaniment to the second half of the film. This diagram plans the ways two forms will be joined in the film, requiring slightly different inputs in the oscilloscope but maintaining the same phase shifts or speed of frequency transforma-tions. Throughout both her notes on the film's construction and its final design Bute is clear that the oscilloscope adds an element of control and precision to her filmmaking repertoire, that it can operate as a shorthand for certain mathematical calculations necessary to generate synchronous actions between the musical and visual tracks.

FIGURE 4.7. Mary Ellen Bute, study for oscilloscope abstractions. From Mary Ellen Bute, "Abstronics: An Experimental Filmmaker Photographs the Esthetics of the Oscillograph," *Films in Review* (1954).

VECTOR PHASES

As discussed previously, oscilloscopes were often used in laboratories and in the same manner that Bute uses them in her animations. And because they were adept at efficiently measuring and modeling a variety of inputs, they were also frequently used with analog computers in the mid-twentieth century. The key components of analog computers were first developed in the nineteenth century by Lord Kelvin, who created a mechanical system with a feedback circuit to solve differential equations related to tide predictions. These were then integrated into larger machines that could solve higher-order equations from the 1920s through the 1950s, with a large growth in the number of analog computers during World War II as most of these became electrical and not just mechanical systems. At its core, analog computation is built to solve differential equations, which are functions that define a dynamic relationship between a number of variables whose derivatives and possible changes (over time, for instance) are accounted for. These often explain natural phenomena and are used in physics, engineering, and other fields that study fluid dynamics, heat transfers, or chemical reactions. In other words, the mathematical equations function as models or analogs of the interactions between elements under investigation, and these computers were developed to function as analogs of a given problem that could be described through differential equations. They accordingly have no stored programs or line-by-line instructions of code. Instead, they link together computing elements, or dynamic variables, in a continuous string for the one equation and then project an output through a device like the oscilloscope. Because of this, they are very fast and efficient machines that can make immediate calculations. But they also can work through only one calculation in a circuit of elements at a time and cannot store this information. Additionally, they were often very large, since each computing element had its own physical node. This meant that, for complex equations with more variables, there needed to be even more computing elements and more space for them. Different permutations of the equations would link these elements together using shielded patch cords, which made for delays in setting up or establishing the equation to be calculated.[75]

During World War II analog computers were used in a variety of military contexts that benefitted from the machine's strengths. One of these

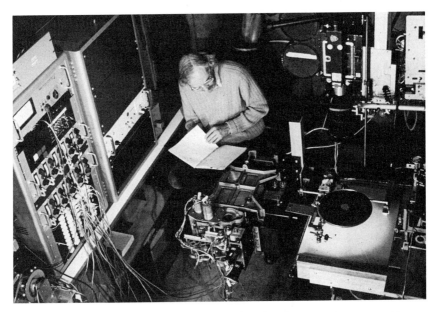

FIGURE 4.8. John Whitney Sr. with his M5 analog computer cam machine.
Photograph courtesy of Whitney Editions, Los Angeles, California.

was antiaircraft gunnery turrets on battleships that needed to make trigo-
nometric projections of moving targets like missiles or planes so that, when
a gunner attempted to shoot a target, the analog computer would automati-
cally make the necessary adjustments for the turret to fire just in front,
below, or to the side based on inputted variables related to speed, wind,
and distance. In the 1950s, the military decided to transition to digital com-
puters and started surplussing the analog machines at military depots.
Whitney visited one of these in California with his son, John Whitney Jr.,
a future digital effects artist for films like *Tron* (1982), and purchased a
discounted M5, a World War II–era antiaircraft gun director with an ana-
log computer specializing in ballistic tracking and predictive positioning.
By 1957 he had repurposed the analog computer for animations. With the
spinning gun controller attached to artwork in front of a camera, he could
calculate its movements with the computer and generate controlled articu-
lations of lines and curves to produce evenly spaced lattices rotating in

time or spirals emerging from the center of the frame in uniform progressions. This work quickly gained the attention of Hollywood special effects artists and visual designers, prompting Saul Bass to contract Whitney to make the spirographs in the opening titles of *Vertigo* (1958). Whitney later coupled the M5 with an optical printer and pioneered the slit-scan printing technique used by Douglas Trumbull in the Stargate sequence of *2001: A Space Odyssey* (1968).[76] Because of the ability to calculate the movements of a variety of elements in the motion picture system, such as the artwork in front of the camera, the operations of the lens, or the progression of the filmstrip, this technology helped usher in a new mode of image production based upon the manipulation of abstract variables and parameters to generate image composites and effects.

Whitney's achievements with this technology became well known, and while he was able to work on effects sequences for studio projects, his interest in his own experimental animations that he had been producing since the 1940s was always his primary focus. In 1961 he grouped a number of sequences that he had created using his analog computer operated cam machine into a film he entitled *Catalog* (1961) that illustrated both technologically what could be achieved using this system and how abstract elements could be programmed to move together in coordinated patterns and manipulate perceptual registrations of depth, motion, and color (Plate 9). In one sequence, red dots fill the frame and undulate in waves on the z axis, creating a hypnotic and dizzying registration of motion. Throughout *Catalog*, forms ripple and move in fluid patterns of action that expand across the screen or spiral in synchronized actions in multiple areas, showcasing Whitney's ability to replicate graphic elements across parts of the same frame with his optical printer. Whitney explained that the machine he was using "was really a mechanical model of the modern digital computer graphic systems," and in the 1970s, he also described the advantages of this system in attempting to achieve specific effects for film or television studios.[77] For Whitney, the mechanisms that he developed and utilized were all to serve an aesthetic ideal of perfect articulations whose regularity of organization was intended to produce a new form of harmony, mechanical and precise, whose mathematical foundations could provide regularity and reproducibility. Beginning with the M5, Whitney believed

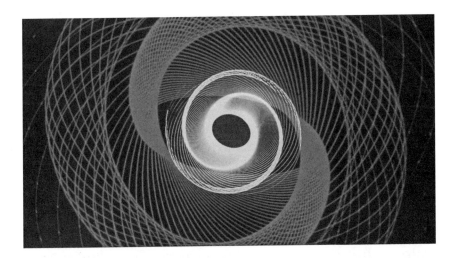

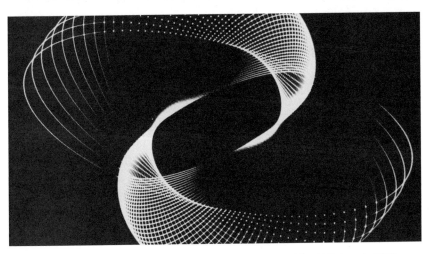

FIGURE 4.9. Film stills from *Vertigo*, directed by Alfred Hitchcock, 1958. VistaVision, color, sound.

he was close to this goal, claiming in 1962 that analog computation allowed motion graphics designers to judiciously develop texture and pattern that did not look static—a problem most animators encounter—but instead moved in a multiplex coordinated action across the frame.

But just a few years later Whitney praised the superiority of digital technology over analog machines and claimed to then abandon this technology. He explained that digital animation allows for the development of new forms of abstraction, providing new capabilities and also posing new aesthetic problems. Whitney articulated his growing dissatisfaction with the limitations of analog computers because analog processes slow the ability to replicate different forms and moving structures while also not allowing for certain kinds of actions, But most importantly, the analog machines would break down more easily and sometimes produce slippages in the registration of motion. This was a problem that his brother James had and complained of regularly when working with the cam machine to produce *Lapis* (1966), eventually helping to drive him away from film-making for a brief period.[78] For Whitney, the digital production of images marked a dramatic break in both his practice and aesthetic because it allowed for greater control over the creation of graphic form. Digital code is made up of discrete pieces of information that can be manipulated (like the fingers, or digits, of a hand), and it allowed him to experiment with the production of pattern through algorithmic differentials that could easily be repeated or mirrored in the same frame. These could be put into coordination with other abstract forms through time in a way that was previously impossible to achieve, and Whitney wished to index this digital grammar and explore its aesthetic and perceptual force.

By the early 1960s, others felt the same way and explored digital computing with the oscilloscope's programmed beam that could move efficiently and in a repeated fashion. Because it precisely measured frequency output, the device was a natural correlate for projecting information on these new platforms. Its beam also enabled it to function as a display for Ivan Sutherland as he developed a digital vector graphics system in the 1960s, since he was producing graphics through a symbolic articulation of the relation of points to one another on a two-dimensional plane, like a geometric function.[79] Using a light pen as an input device with the oscilloscope to

create lines, polygons, and other forms, each grid location on the screen selected by the pen, which directed the CRT beam, served as anchored coordinates for the drawn graphic objects so that they could be stored as symbolic or mathematical formulations and projected later onto the display through the computer's program. This system of vector storage and projection contains principles that continue to be used in a variety of ways.

But these advantages of quickly abstracting information about visual constructions cut two ways for the oscilloscope. Because it was built to project frequency modulations or phases of curves, its technological architecture was structured around the movement of a limited number of lines that could quickly be replicated or redrawn by the beam before they faded from view, a necessity for the continual projection of any singular image on the screen. Oscilloscopes did not have memory built into them, meaning that the CRT beam could not draw one image on the screen and then another on a different area or add nuances of shading or dimension. If it attempted to do so, the initial drawing would partially or completely fade before the beam finished the composition and returned to its starting position. As more researchers and artists turned to digital graphics systems to produce images, this issue of time became critical. But still, as Bute's animations and mathematical compositions demonstrate, the oscilloscope could visualize sensual information as isomorphic frequencies. Alongside cybernetic theorists and communication engineers, it rendered perception as a mechanism for sorting out pulse intensities and showed how technologies could abstract these operations. It was storing and synthesizing these through algorithmic programs that proved difficult. Just as sensations fade, so did the oscilloscope's beam.

5 CODE

MODELS OF TIME

We are in open circuits

Nam June Paik, "Cybernated Art"

CHARLES CSURI BEGAN CREATING STILL IMAGES WITH A DIGITAL COMPUTER in 1964, and the results, such as *Sine Curve Man* (1967), are still lauded as pioneering and captivating. Though successful with this new technology and mode of production, he quickly turned his attention to putting these rendered images in motion to explore how a computer could synthesize action and generate figurative gestalts. *Hummingbird* (1967), an eleven-minute computer animation produced using Fortran (Formula Translation) on an IBM 7094, was the first film from this early period of computer programming for Csuri, who was already an established visual artist and professor at Ohio State University. Making the film involved the mathematical computation of how different vector lines and abstract shapes would move in coordination with one another across the space of the screen, but in an incremental frame-by-frame progression while storing the calculations for the code of each frame on $7\frac{3}{8} \times 3\frac{1}{4}$-inch paper punch cards. In order to visualize these programmed movements, Csuri had to input the punched cards into a different computer, an IBM 1130, that was connected to a microfilm plotter, a graphics output device that could draw computed vector lines directly onto film. These kinds of digital platform limitations and laborious work processes were common in the 1960s and not only proved to be time-consuming but also introduced errors for many programmers at the time. While the bird at the opening of *Hummingbird* comes into being through the slow development of its outlines in a fashion reminiscent of the lightning sketches and early animations of filmmakers such as Winsor

FIGURE 5.1. Charles Csuri, *Sine Curve Man,* 1967. Ink on paper, IBM 7049 and drum plotter, 41 × 41 inches. Courtesy of Charles Csuri Archive.

FIGURE 5.2. Charles Csuri, *Hummingbird II,* 1969. Photo screen on Plexiglas, IBM 1130, and drum plotter, 18 × 30 inches. Courtesy of Charles Csuri Archive.

McCay, it then bursts apart into small pieces while twisting on the screen before finally reconstituting itself, requiring a precise mapping of how the abstract elements move in space. Planning these calculated actions without the simultaneous ability to monitor the progression of movement between frames on a computer screen necessitated an at times trying amount of patience.

Csuri was not alone in his frustration. Artists in the 1960s and early 1970s such as John Whitney Sr., Michael Noll, Ken Knowlton, and Lillian Schwartz were also exploring digital computer graphics and animation with different aesthetic goals, institutional support, computer languages, and platforms. A year before Csuri's *Hummingbird,* Whitney was awarded a research grant by IBM to be an artist in residence and use one of the company's IBM System/360 computers to develop digital animations such as *Homage to Rameau* (1967), *Experiments in Motion Graphics* (1968), and

Permutations (1968). Whitney focused solely on digital technology after encountering it, since he thought it was a better way to produce serial permutations of equilibriums in motion, a dynamic visual harmony generated from abstract lines and dots.[1] Yet, for all his emphasis on the power of digital motion created through differentials and articulated ratios of action, Whitney was constantly struggling to determine what he could actually create with his computer. The metamorphoses in Whitney's IBM films have many digital sources, but they are also animated through more traditional means. Because of technological constraints, Whitney had to take photographs of his computer monitor that displayed the equivalent of one frame of film and then project and edit these on an optical printer to create fluid motion. The optical printer also allowed him to add color to the image, since his IBM 2250 vector-scan display unit could project only black and white. Thus, after programming a sequence of abstract motion, he would connect his display to a camera whose shutter and filmstrip progression were programmed to operate in conjunction with the computer's rendering time. Whitney explains in the narration to *Experiments in Motion Graphics* that the abstract movements in his IBM films

> were not produced in real time. In fact, it takes three to six seconds to produce one image such as we see here passing at the rate of twenty-four frames per second. One twenty-second sequence requires about thirty minutes computer time. Then I must wait some twelve hours or more to see my film after it is processed. . . . Imagine how handicapped a pianist would be if his piano made not a sound as he played it, and he had to wait some twelve hours before he could hear the music he performed.[2]

Yet his papers and materials from this time reveal that this delay was actually much longer, since Whitney would create digital images on the computer in order to develop a library of graphic forms that he would draw from in the production of his films with the optical printer. For greater efficiency, he would reprint these images in a film frame rather than have the computer render each element. Additionally, for many of these frames, the platform he was using could not visualize all the graphic forms at one time. Even complex singular computer images required programming the camera to advance the filmstrip only after multiple exposures (Plate 10).[3]

Whitney embraced this technique, espousing its superiority over ana-
log computational machines by claiming that digital animation allows for
the development of new, previously unattainable forms of aesthetic abstrac-
tion. But the alignment also meant attuning his practice, expectations, and
platform to a new set of technological rhythms and temporal structures,
a pattern of resonance specific to information processing machines from
this era that could produce or make visible formal actions. As Whitney
and others explored this new terrain, they simultaneously helped define
its boundaries while beginning to isolate strategies through which those
barriers could be broken.

Tracing this landscape and the stakes for its aesthetic actions requires
interrogating the materials and technology of digital animation and rec-
ognizing that its hybrid technical nature during this period complicates
the divide that is commonly placed between photographic and digital pro-
duction practices while gesturing toward a little-known history of digital
computer animation in the 1960s and 1970s. This chapter will delineate
one strain of this history and examine how artists, programmers, and en-
gineers wrestled with the problem of time while developing digital graph-
ics systems, working through visions of animation and ideas circulating
through scientific and media landscapes of the moment. I argue that this
history indexes epistemological changes around the interdependencies
of film and other media, as well as a broader transformation in the mid-
twentieth century of how technologies were modeling experiences of tem-
porality. Yet this is not quite a story about pasts and futures or ruptures in
historical continuities. Instead, I argue that the early history of digital ani-
mation is a passage through which we can understand the ways that vari-
ous temporalities can be bound together within technical storage media.
Celluloid animation manufactures continuity through a technical means
in order to generate transformations of various shades, and digital anima-
tion did not forge an opposition with these practices through a new virtual
modality. Instead, technologies braided together to generate new aesthetic
and technical modes.

Whitney explains that he is attempting to produce a graphic system
that is both simple and complex in that, by creating a dynamic balance of
opposed forces through the production of an equilibrium that is constantly

in motion, a particular visual impact will be generated for the spectator.[4] Showing how he attempts to negotiate these desires through a matrix of various technologies provides insight into how animators and artists at the time began incorporating digital technologies into moving image media. The motivation for this animation system emerges from its calculated use of geometric forms that Whitney argues have a universal aesthetic appeal, but the difficulty lies in properly balancing these elements across time and space. Whitney wished to make images out of a "serial permutation to be juxtaposed dynamically against itself by retrogression, inversion, and mirroring."[5] These ideas are indebted to Piet Mondrian, who emphasizes the use of nonfigurative forms to free artworks from subjective expression. He describes how successful art "creates [a] dynamic equilibrium and reveals the true content of reality," which is held between universal and individual expression.[6] But Whitney argues that painting can only imply this equilibrium in motion and attempt to "seek a balance of contrasting plastic movements."[7] While unsatisfied with the expression, he explains that his graphic ideas have an analog in musical harmony, though they are not a synaesthetic translation. Instead, he is attempting to produce an abstract visual art of motion structured in time that has a perceptual impact akin to the one music can generate. He emphasizes that "we must learn to show a balance between tension and forces of shape and direction and color—all of this in a context of metered time. . . . That is to say we must create the image of time which is given the proper shape for human consumption."[8] For Whitney, this is an independent graphic form whose visual language has been insufficiently explored and theorized. Through his films, he is searching for a system of graphics that can be identified, replicated, and manipulated in other works.[9] These elements are all fundamental to his ideas of aesthetic harmony, since he attempts through his abstract patterns to work with or thwart visual expectations. In fact, he explains that his films develop and catalog this visual grammar of form and movement. Whitney is clear that, unlike other kinds of abstraction, this is not meant to transport the viewer into a transcendent or otherworldly state. Rather, it is meant to generate a pleasure rooted in the eye, which, for him, "is the natural master of pattern recognition."[10]

EPHEMERAL DISCOURSE, DIGITAL HARDWARE

In a moment when the fields of cinema and media studies have begun interrogating digital technology and the effects of computer graphics on aesthetics and the materiality of film, a research agenda like Whitney's laid out above cuts to the center of debates about the differences between what scholars characterize as analog and digital media. For years there was a tendency in this discourse to claim that a historical rupture in the techno-logical manufacturing of images occurred sometime in the late twentieth century and spurred the need for a renewed investigation first of film and then of digital media. Usually this investigation focused on the indexical powers of chemical-based photography, with claims that such images are reliable isomorphic records of the time and space before the camera at the instant of exposure. Digital images, on the other hand, are the stuff of numerical representations and computational tools, an algorithmic form that is formless, since, as D. N. Rodowick claims, they are "without sub-stance and therefore not easily identified as objects, Digital media are neither visual, nor textual, nor musical—they are simulations."[11] The focus on computational immateriality and distinctions among different moving image technologies often rests on issues regarding the stable impression of information onto an object. As Rodowick points out, the crisis over the rupture of the indexical bond in digital media is not truly about fidelity to a world or aesthetic realism, since many contemporary image technologies can create composite images that produce a perceptual realism or a veri-similar world that appears to be spatially contiguous or analogous to our own. Instead, the anxiety over digital technology is rooted in not knowing whether the world projected has been manipulated:

> The profound difference between the two processes is that digital input-ting itself produces symbolic notation and can be manipulated (or not) as such. Fully analogical devices reproduce or amplify a signal that is spatially isomorphic with their source in an act of transcription tempo-rally continuous with that source.[12]

For Rodowick and other critics, the technical mode of recording, includ-ing light's registration on a digital sensor that converts and stores it as an

aggregate of data, has produced a fundamental change, and a perceived continuity with the world in front of the lens is immediately suspect.

Like others, I believe this singular focus on the distinction between chemical and digital photography is misplaced.[13] Not only because of the history of photographic manipulation both in the camera and afterward that special effects historians, for instance, have documented, but also because the description of digital technology many times mischaracterizes it and is not attendant to its actual materiality or the history of its development.[14] This is due in part to a focus on the images that digital technology can produce rather than an analysis of how they are manufactured, rendered, and stored, a bias that stems from what Nick Montfort calls "screen essentialism." According to Montfort, this partiality results in a historical myopia that fails to account for digital objects produced before the mid-1970s, when fewer computer users had access to screens:

> When scholars consider electronic literature, the screen is often portrayed as an essential aspect of all creative and communicative computing—a fixture, perhaps even a basis, for new media. The screen is relatively new on the scene, however. Early interaction with computers happened largely on paper: on paper tape, on punchcards, and on print terminals and teletypewriters, with their scroll-like supplies of continuous paper for printing output and input both.[15]

Such neglect also contributes to what Matthew Kirschenbaum describes as a prevailing "medial ideology" in both popular and academic literature in the 1980s and 1990s, in which "one substitutes popular representations of a medium, socially constructed and culturally activated to perform specific kinds of work, for a more comprehensive treatment of the material particularities of a given technology." In this framework lies "the notion that in place of inscription, mechanism, sweat of the brow (or its mechanical equivalent steam), and cramp of the hand, there is light, reason, and energy unleashed in the electric empyrean."[16] Such substitutions can lead to confusion about digital technology and put cultural projections or fantasies about media in place of the media themselves, mistaking discourse and representations for their machinations.

Readings of these depictions as such can be insightful and can illumi-

nate how digital technologies are culturally imagined.[17] But, in order to explore claims of either an ontological shift or a new aesthetic of moving images based on different technological tools and objects, there needs to be more attention given to the actual stuff and material of computational media in order to better understand their relationship to ideas of cinema. Dudley Andrew's book *What Cinema Is!* claims that the French Cahiers line of cinema from the mid-twentieth century proclaims an "aesthetic of discovery" that stands "at the antipodes to a cinema of manipulation, including most animation and pure digital creation; it asks us to accommodate our vision to the conditions of visibility given by the world rather than, as in the aesthetics of new media, reworking the world until it conforms not only to our conditions of viewing but to our convenience and pleasure."[18] Though Andrew concedes that some critics have pointed out that digital cameras are many times utilized for the same purposes as 35mm or 16mm film cameras, he nonetheless argues that digital technology usually operates as a site of cinema magic, where compositing and editing technologies take the place of sets and produce illusionary spectacles. As a reaction to such technologies and the increased attention they have received within the discipline, Andrew takes the Cahiers line and "throw[s] it against an overconfident discourse of the digital."[19] To begin his analysis, he suggests that we "draw the line at camera-less animation,"[20] which for him includes cel animation, and focus on how the camera engages with the world. Instead, I propose that we look at this animation head on and engage with what it actually is, rather than look simply at the discourse of the digital, as Andrew admits to doing in the prologue of his book. Like the lines found in the cameraless animations of Len Lye described in chapter 1, this one twists, wiggles, multiplies, and dissolves, and when studying it, we find less a demarcation between different media forms and more an interweaving of technological tools and artifacts with different strengths, uses, capabilities, and histories.

But how do we tackle the problem of digital materiality? What is it composed of? How does it intertwine with and emerge from other forms? This is not an uncomplicated issue, and a growing field dedicated to materialism has developed in the past decade to best understand ways of studying digital platforms, history, infrastructure, objects, affects, and forms of sociality.[21]

For my purposes here, studying production practices for animated digital objects necessitates attending to the role of software and hardware in their development and final constitution. Scholars such as Matthew Fuller have emphasized studying code in what is described as software studies, where scholars analyze the tools, logical functions, and programming languages employed to generate algorithms that arrange databases, compress video files, produce operating systems, or do any of the other computational work whose formal instantiations are rendered on an interface of some kind.[22] Filled with different commands and artifacts and a variety of other elements, software is made of code, a special kind of language that Alex Galloway describes as "the only language that is executable."[23] Structured as an interface between machines and users, software and the code that built it is developed for running operations and producing conceptual and functional clarity for users. For this reason, as Katherine Hayles points out, computers employ a tower of languages with commands running along this vertical axis that have two kinds of addresses: one to human users in a "so-called natural language," and another that is addressed to machines, though she points out that some people can read its semantic expressions.[24]

Other scholars such as Kirschenbaum, Montfort, and Ian Bogost emphasize that software is generated to be run on hardware and platforms. This analysis of the physical properties of hardware and the technologies of inscription and storage that it employs focuses on the relationships between these technological systems and the design of digital objects that can be instantiated on them. Here, there is emphasis placed on the material hardware of digital media, explaining that recent focuses on software do not go far enough in explaining how digital artifacts are programmed to make possible certain experiences with media: "Little work has been done on how the hardware and the software of platforms influences, facilitates, or constrains particular forms of computational expression."[25] Montfort and Bogost make it clear that this is not a technologically determinist approach; rather, an understanding of the materiality of media objects is necessary alongside analyses of their interfaces and experiences, since different material forms afford different types of experiences. Additionally, this approach recognizes that, when interfacing with digital objects, any data manipulation or creation has a corresponding "modification of a physical

substratum," meaning that bits of data symbolically rendered in code have an analog twin that exists as "patterns of magnetic flux reversals," which are incredibly resilient.[26] For Kirschenbaum, understanding the materiality of digital media necessitates an acknowledgement of the differences between this forensic materiality, found in the physical inscriptions on hard drives and other objects, and formal materiality, understood as a computational "simulation or modeling of materiality via programmed software processes."[27] He further explains that

> whereas formal materiality depends upon the use of the machine's symbolic regimen to model particular properties or behaviors of documents or other electronic objects (CTRL-Z thereby allowing one to "undo" a deletion by recapturing an earlier, still-saved state of file), forensic materiality rests upon the instrumental mark or trace, the inscription that is as fundamental to new media as it is to other impositions and interventions in the long technological history of writing.[28]

Friedrich Kittler goes so far as to claim that, when examining this relationship between the manipulation of a formal element in the software of a computer and the inevitable change of voltage differentials in hardware that results, there is no software at all. Instead, the software operates as a mask for the algorithmic processing of different functions. Calling his DOS-based computer a tower of Babel with different kinds of languages and layers that build on top of one another, he explains how removed he is from the operations of his computer's processor through its interface.[29]

Though I still wish to recognize the power of software and formal instantiations of digital objects, approaches that work through interactions between software and hardware in computers are particularly useful for the study of digital media from the 1960s and 1970s, when a lot of software was developed for only one platform and could not easily be migrated across different kinds of machines. Scholars like Zabet Patterson have shown how particular pieces of hardware like the microfilm plotter influenced the development of different software packages and institutional research projects in the 1960s and 1970s, and Jacob Gaboury has illustrated the ways computer-generated images from this time were rendered as objects in two-dimensional space through algorithms that stored

information about projected depth.[30] Both studies emphasize the mutually constitutive constraints of hardware and software from the time and the creative articulations of engineers and artists to produce different effects. Similarly, Whitney and Larry Cuba many times had access to machines that could run only one kind of language, and these languages were usually different. This became significant when working in various time-based systems. While contemporary higher-level languages, such as Python, can be used across several operating systems and platforms, this earlier era of software development saw lower-level languages most often developed for individual machines that worked more directly with assembly code, the binary machine code that relays information and was developed for the manipulation of particular processors and circuits. What distinguishes lower-level languages from higher ones is (1) the address that Hayles describes, since higher-level languages usually employ semantic rules more akin to everyday language, and (2) the ability of higher-level languages to contain multiple operations within one line of code, rather than generating a line of code for the manipulation of each variable. The recognition of this distinction is important, since higher-level languages often require less programming time, but they also need faster processors and larger memory allocations to operate. Thus, the interaction between hardware and software comes to the foreground before the era of personal computers, at a time when having privileged access to a machine meant adapting not only to what it could process, or how powerful it was, but also to the way of communicating with it, or what language it could process.

DIGITAL CHRONOS

Such hierarchies of code emphasize a vector of temporality in their functioning and construction, leading to a constitutive development of processing chips and languages built around different conceptualizations of time. In digital systems, these technical operations of media exist below the threshold of human perception, with contemporary platforms both gathering and making actionable data that, as Mark Hansen shows, are not only designed to exist outside consciousness, *"but can never be, lived by consciousness."*[31] Functioning not only as a supplement to human perceptual systems, but also

as an autonomous agent, Hansen argues that the ubiquity of these actions in microprocessors differentiate twenty-first century media from earlier technical modes, though the model of experience that they generate has predecessors in the nineteenth century, especially in the work of Étienne-Jules Marey. Begun in the 1880s, Marey's chronophotography took several successive images of a subject on a single photographic plate in order to graphically analyze physiological motion. At issue for Marey was the recording of movement in time that is normally imperceptible, the invisible and habitual actions seeming lost to observers without the technical means to capture the interstices between states, and to those who desired to synthesize motion technologically, like Eadweard Muybridge with his zoopraxiscopes. Mary Ann Doane characterizes this as an obsession with Hermann von Helmholtz's ideas of a lost time that exists in the brief period between nervous impulses and muscle contractions in bodily actions, a loss or separation between points in time that would always exist between exposures in Marey's chronophotographs, no matter how quick the shutter speed.[32] Attempting to visualize this lost time generates a mapping of physiological action and stasis without any concern about technologically replicating perceptual syntheses of these movements, since his desire was, as Marta Braun explains, "to make visible what the unaided senses could not perceive."[33] His chronophotographs then, like his other technologies of recording, such as the sphygmograph that measured and recorded heart rates, were meant to examine movements with as little human interference as possible, thus producing what Joel Snyder characterizes as technical systems that possess their own sensory fields:

> The displacements registered by mechanical monitors and traced by clockwork-driven inscribers fall outside the scope of human sensibility. . . . Machines can be constitutive of their own field of investigation— one in which substitution is not an issue. These tools can provide access to an unknown world—to a new province of study generated by the instruments themselves."[34]

Hansen links this sensory system to contemporary digital media, arguing that this example reveals the ways in which technical systems can "open new dimensions of experience that operate alongside perceptual consciousness and impact it at the level of sensibility."[35]

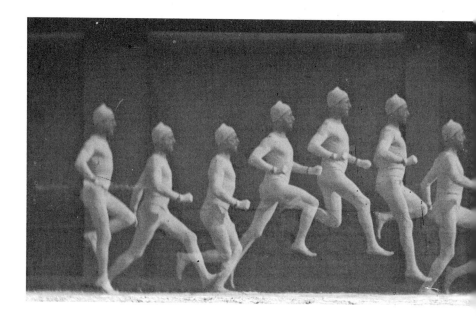

As Hansen and others note, a crucial difference between these nineteenth-century technics and digital ones is the sensory address of their operations. Both operate outside consciousness, but Marey was attempting to visualize these experiences while digital media often function solely within a machinic register. That said, the visualization remained one of temporal abstraction for Marey. Even when building a projector to work with some of his photographic studies that would generate syntheses of motion, he played with time, as Braun explains, "slowing down some movements and speeding up others. He was not after a machine that would replicate the continuity of perceived movement. . . . Marey chose to ignore the replication of what the eye could see."[36] Thus, the abstraction and synthesis in the visualization of these forms does not rely on a stable articulation of time, though it does manifest a graphic inscription or animation of it for us to perceive. Of course, this same instability exists in Muybridge's work, a point emphasized by Hollis Frampton in his essay "Eadweard

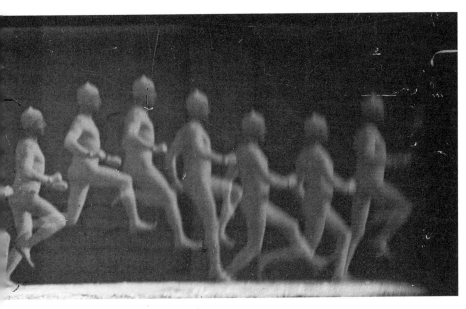

FIGURE 5.3. Étienne-Jules Marey, *Gallop*, 1883. Chronophotography on fixed plate. Collège de France Archives.

Muybridge: Fragments of a Tesseract," where he makes connections between Muybridge's still photographs of landscapes, which often capture waterfalls and other natural movements in long exposure, and his zooprax-ography that was also fascinated with the time-interval of action.[37] Though Muybridge reconstituted movement within his technical system, it could still operate within an accordion of time like Marey's projected syntheses, even if the slippages or fluctuations of time were not measured. This was Marey's chief complaint about Muybridge's work, since the final goal was to make an animation that was pictorially sufficient, sometimes relying on the editing together of different photographic actions to produce a synthesis with visual consistency.[38]

These movements along vectors of time were, for both Marey and Muybridge, explorations of the new relation between technical and perceptual registrations of time in animation. Hansen builds a bridge between the sensory operations of Marey's technical system and contemporary digital

media, but the visualization of such systems was integral to chronophotography's machinic perception, in part through a desire to understand and explore the sensory relations established through new technologies. The tie between digital media and these nineteenth-century technologies are still present in this vein, but they meet decades before Hansen's study, especially in the work of Lillian Schwartz. Schwartz produced her digital animations at Bell Laboratories beginning in 1968 after meeting Leon Harmon at the opening of the exhibit *The Machine as Seen at the End of the Mechanical Age*. Harmon and Kenneth Knowlton were the driving forces behind Bell's computer imaging division, which became a well-known space for this work in the 1960s and 1970s, in part by regularly inviting artists to work in the lab in a collaborative setting. In their modeling of computational imaging, they focused on perceptual gestalts, with Knowlton creating a computer animation language in 1964 called BEFLIX (Bell Flicks) for the lab's IBM 7090 computer and Stromberg-Carlson 4020 microfilm plotter.[39] This suited Schwartz's visual exploration of post-impressionist painter Georges Seurat's pointillism in a computational space, since it enabled her to generate figurative and formal continuities through relations of abstract shapes and colors.[40] BEFLIX was originally developed for a similar aesthetic, with Knowlton explaining that the language creates images through the mapping of symbols and abstractions onto a 252 x 184 representational grid of squares. Though there is no color, with the exception of "appropriate shades of gray," the language provides a "conceptual framework which includes a number of scanners which he (the programmer) imagines to be sitting on various squares of surfaces."[41] As Patterson shows, the language's constitution was centered around the capabilities of the microfilm plotter, since it was the final output device for this imaging system and helped associate Knowlton with early computer art through his well-publicized *Studies in Perception I* (1966), a mural-sized image of a reclining nude woman created with the Stromberg-Carlson 4020.[42]

Schwartz's frustrations with BEFLIX emerged immediately when she encountered the limitations of what the language would allow for artists attempting to produce metamorphoses in time. She describes the working process as one rooted in blindness, where data inputted into the language would sometimes lead to surprising results after a dramatic time

FIGURE 5.4. Film still from Lillian Schwartz, *Olympiad,* 1971. 16mm, color, sound, 3 minutes.

delay between its development, single-image visualization, and sequence in continuity.[43] Nonetheless, she completed *Pixillation* (1970) using this workflow with an updated version of BEFLIX Knowlton called EXPLOR, while also adding color to the computer images with an optical printer and incorporating sequences of hand-colored oil abstractions and stop-motion crystal growths to match the flickering grids of pixels. Continuing her study of nineteenth-century visual culture and technologies of perception, Schwartz completed *Olympiad* (1971) the following year, a film based on Muybridge's studies of a man running. While *Olympiad* contains formal qualities reminiscent of *Pixillation,* the later film grounds its investigation in the slow emergence and eventual animation of a figure against a black and then colorized background. As the wire-frame man first moves slowly and then rapidly across the screen, sometimes creating a blur through the frame, Schwartz moves between references to Muybridge and Marey's chronophotography. This film was produced more closely with Knowlton after Schwartz's first film caused him to realize that his languages were

oriented more toward mathematical calculations and that "it is necessary to develop special facilities for the artists" at Bell.[44] Knowlton updated EXPLOR to give "control over the size and position of octagons" on the screen, which allowed for a continuity of motion and the nesting of octagons inside larger ones to create a "sense of musculature and . . . shape."[45] The animated sequence was still created on an optical printer, but the extreme sense of blindness in the production process was less severe.

It is through this blindness, full or partial, that Schwartz's work during this period visualizes the new technical relations of digital temporality. Without the ability to see the encoded images generated on the IBM 7090, Schwartz was initially placed outside the technical circuit of time that the computer operates within. The decision to work through Muybridge's and Marey's explorations of a new technical inscription of time in *Olympiad* indexes her own recognition of the operations of abstraction and synthesis present in her computational renderings, a play with the flux and presentation of action most obvious in the ways she interrupts its smooth articulation. Here, the pixilated time of running slides along its own elastic band, gesturing toward the lost time of trial and error in generating the images and also indexing how the computational renderings reveal another sensory world available only to digital technics, just as Marey's chronophotographs did for that technical relation. This is a visualization of an inscription of time that exists below thresholds of perception, no longer offering what Hansen describes as "a technical temporal object [that] could serve as a surrogate for human time-consciousness."[46]

That said, the final work of *Olympiad* is found on film and created through multiple technologies like the optical printer that Knowlton concedes should be used to edit, colorize, and stretch the final animation from his machine, showcasing a clear recognition of the braided media weaving together computer animations from this moment.[47] More than revealing a static articulation of a new technics, Schwartz, like Marey and Muybridge, shows a new sense of time that is radically unstable and undergoing its own metamorphosis. Like Marey's obsession with high-speed photography to capture the ghostly losses between exposures or Muybridge's experiments with temporalizing space by surrounding a subject with cameras that fired successively (or nearly so) but whose images were placed sequentially, lay-

ing out spaces of a figure in time, so also nothing in the new digital regime was normative or defined. Even Knowlton's articulation of engaging with computational time changed for Schwartz between her first films. And because BEFLIX was a Fortran-based language built for the hardware at Bell, its articulations were determined through its hardware affordances and the punch card system of programming and data storage it employed, a radically different digital technics than the one examined by Hansen. In this vein, *Olympiad* marks the multiplicities of time bound in its technical syntheses and abstractions.

Perhaps unsurprisingly, after wrestling with this hybridity and laboring without visualizing their work, Schwartz, Csuri, and Whitney spent the next decade attempting to develop systems and films that employed real-time computer animation, working with organizations such as the National Science Foundation (NSF) and building partnerships between art and computer science departments at various universities. The goals of real-time digital animation laid out by all these artists offer historical windows into the process of this alignment and reveal that the narrative of past and future regimes of time is less clear-cut than previously assumed. Through the rest of this chapter, I will trace the historical rise of real-time digital animation and show that this technology reveals how the two models of temporal experience are synthesized in digital animation. Specifically, I argue that animation was fundamental to the shaping of digital media, not only because filmmakers helped develop the code, languages, and platforms that were and are used in this new technological landscape but also because these new technologies were eventually built around a mechanics of time taken from cinema. This is not an argument in the vein of Jay Bolter's and Richard Grusin's focus on remediation, whereby new technologies model themselves on sensory engagements with older media forms in a representative schema, showing therefore why the formatting of "pages" is so important in reading digital texts on displays.[48] Instead, my argument is indebted to Kittler, who wonders what effect the nineteenth-century observer, as imagined by Jonathan Crary, had on the development of technical storage media.[49] The technical history of real-time digital animation demonstrates the need for scholarship in visual culture to augment Crary's account of how technologies of vision rendered the body in various discursive and

optical regimes. For early digital animators in the 1960s and 1970s, contemporary understandings of physiology and the body's relation to visual images proved less important than the articulation of time indebted to notions of instantaneity that previously modeled cinema and animation. Though eventually not using photographic technology or displays metered in film frames, real-time digital animation was anything but "real," and was instead the time of cinema.

ARCHITECTURES OF CODE

The laborious process of coding the digital animations that Schwartz, Csuri, and Whitney produced in the 1960s was common in the style of computer usage and sharing known as "batch processing," where individuals would many times use a typewriter to write programs and then, for Fortran machines, create punch cards for these programs that could be fed into a computer. Often, these cards were inputted indirectly through a reception desk for a computer center, controlled by operators who would run a series of programs through the machine in quick succession and print out the results.[50] One could avoid using the punch cards and the common accidental reordering of the deck by writing code in certain programming languages and by employing a variant on batch processing called "time-sharing," such as a teletypewriter machine connected to a computer. This option was available for programmers using the Jet Propulsion Laboratory computer at the California Institute of Technology and was employed by Cuba in his animated film *First Fig* (1974). But programming in this manner still meant generating long scrolls of code and not being able to see the resulting animation except once a week when the processed footage made from the lab's film plotter was delivered. The delay in these systems meant that interactivity with the graphics or articulations of movement as they were being designed was severely limited, generating an aesthetic associated with trial and error that Ivan Sutherland famously pointed to as an "unsolved problem" for computer graphics. Sutherland uses Knowlton's BEFLIX as an example of a language that has the capability of mapping the force and acceleration of an object's movement in space, but only in written form: "The hard part of using Knowlton's language is figuring out

FIGURE 5.5. Larry Cuba's teletype workstation used for *First Fig*, circa 1974. Photograph courtesy of Larry Cuba.

what the picture is going to look like as you write. . . . You have to make a little sketch ahead of time on graph paper. You then pick off the coordinates from the sketch and jot the coordinates down on a piece of paper to give to the computer." He argues that, instead, "I should be able to sit at the console and draw what I want."[51] This complaint became so common and so associated with producing digital animations at the time that Cuba, in an interview, contrasts real-time systems with this laborious practice he calls "animated time."[52]

Andrew Utterson points out that Sutherland's ideas for eschewing typed commands and using direct input methods for the production of computer

graphics is reminiscent of the vector graphics system called Sketchpad that he designed in 1963 for his dissertation at MIT.[53] Rendering and storing graphics through vector coordinates enabled this platform to treat direct-input drawings as mathematical objects that could be dynamically changed. This experimental system, built from a large Lincoln Laboratory TX-2 computer at MIT with an oscilloscope, provided one of the goals for real-time graphics systems: interactivity. Unfortunately, the system was difficult to replicate in other software and hardware environments, especially since Sutherland's TX-2 was reassembled for batch-processing operations after he was finished with his thesis. Nonetheless, it provided one model for how real-time graphics systems could operate for artists and was, as Utterson argues, a guide for Csuri's ideas in the development of a real-time graphics platform using Fortran on IBM machines.[54]

In 1968 Csuri wrote an NSF grant proposal titled *A Software Requirement for Research and Education in the Visual Arts* that envisioned a graphics environment built around visual interactivity and instantaneous computational feedback that artists and students could use. In an article in 1972, he clarified both the problem and the vision that he laid out for his ideas of a real-time animation system in his grant proposal:

> In a real-time animation system the computer is programmed so that it can respond to the decisions of the user about the pictorial image and its movement. Whatever the user decides to do is transmitted almost instantaneously to the screen. This allows for a full interaction between the user and his images. It occurs in what we call "real-time," that is, time which is "real" because the moment the user makes a decision also becomes the moment of materialization. Stated in another way—the results of the interaction are immediately visible. A "real-time" image is one whose display is complete in less than the one-fifteenth of a second that determines the threshold of the persistence of vision.[55]

The NSF awarded Csuri $100,000 to produce this system, and over the next several years he pursued the renderings of real-time digital animation described above as "the moment of materialization," a definition that he first developed in his 1970 interim report to the NSF on his progress and that seeks to solve the problem of interactivity identified by Sutherland.[56] In the

1970 report, Csuri clarifies that the threshold he is seeking to find is rooted not in psychophysiology, but instead in cinema. Complaining about IBM's graphics software that relayed communications between the vector monitor and the 1130 computer employed by his animation group, he explains that "since IBM and Ohio State would not permit us to 'hard-wire' special functions that would give us unusual speeds in computation, everything had to be with software."[57] Such developments would lead to "images [that] can be viewed like a motion picture on the CRT (the computer is calculating 24 pictures per second), modified in a matter of seconds, until the moving images are acceptable as film. Then with a camera the film is made from the output on the CRT screen."[58] But this vision remained difficult to actualize using Fortran, a structured language that excels at numeric and scientific calculations but was designed around the limitations of the paper punch cards that stored its expressions, a not uncommon intersection between paper and computation that the history of ASCII (American Standard Code for Information Interchange) also reveals.[59]

Whitney encountered similar frustrations using Fortran. His programmer at IBM was Dr. Jack Citron, a physicist working there who was also a musician and an amateur historian of constructivism. Citron developed an animation program for the System/360 that he called GRAF (short for Graphic Additions to Fortran) and that allowed the manipulation not only of visual geometric forms but also of their planned metamorphosis over time. GRAF evolved from the manipulation of parameters around one simple polar-coordinate equation:

$$R = A(sinB\theta)^P$$

The operations of this sine wave function with variables that determine the amplitude, frequency, and phase of the curve structure the aesthetic operations of the three films that Whitney made while at IBM, though Citron expanded on the equation by adding different parameters to it that controlled other elements, such as where the function was mapped on the screen and how it rotated in time. The equation and each variable were visualized on a display that Whitney could operate with a light pen to experiment with various configurations. If satisfied with the result, he could print the assigned parameters for one graphic image to a punch card, though

FIGURE 5.6. Fortran punch card for *Experiments in Motion Graphics*.
Photograph courtesy of Whitney Editions™, Los Angeles, California.

each card could hold information for only five curves at a time, and many frames in his films have complex geometric forms even before being replicated in the optical printer. This made it necessary to program the filming and creation of digital vector images simultaneously.

However, this did not solve all of Whitney's display difficulties, since he was working with hardware that had difficulty drawing continuous curves. In a coauthored article with Citron, Whitney explains that, because of this, the values in the sine waves produced must be "enumerated in a discontinuous fashion so that if the discrete points (R, θ) are to be connected, they will be joined by straight lines."[60] Circular geometric forms in his IBM films are produced through individual points, a strategy employed often in *Permutations,* or through the intersection of several lines whose end points lie close to one another on a curve, seen in *Experiments in Motion Graphics.* This latter strategy was more complicated and involved mathematically linking several paths together so that parts of their lines would overlap.

Such creative negotiations proved to be cumbersome for Whitney but were in the service of developing a library of geometric forms as part of an aesthetic rooted in a tradition of abstract animation built around a visual harmony of coordinated action. A similar need for some type of image filing system for computers at the time is noted in Sutherland's dissertation.

FIGURE 5.7. Film still from John Whitney Sr., *Permutations,* 1968. 16mm, color, sound, 8 minutes. Courtesy of Whitney Editions™, Los Angeles, California.

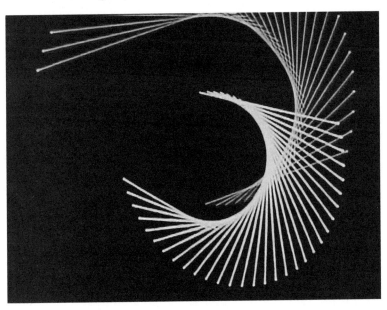

FIGURE 5.8. Film still from John Whitney Sr., *Experiments in Motion Graphics,* 1968. 16mm, color, sound, 13 minutes. Courtesy of Whitney Editions™, Los Angeles, California.

Sutherland focuses on interactivity in real-time graphics systems, but he points out that each image must be stored on magnetic tape that can be later fed into the platform. The building of a catalog of shapes that are most used is one strategy to avoid the time it takes to re-create and modify graphic forms.[61] Sutherland provides an example of Sketchpad producing the necessary line elements to animate a "winking girl," but the quick recording, storage, and retrieval of these component parts was secondary to their interactive development.[62]

For Whitney, operating in an aesthetic of abstraction rather than a figurative gestalt, the process of coding graphic elements was related to the manipulation of discrete frames of film. He explains how his films are essentially a form of mathematics put into motion, whereby the algebraic functions he produced allow greater control over graphic forms put together through ratios of movement in time:

> Motion in this context is determined by differential change. Differential increment plots new values of radius and theta for each point on each frame. This kind of motion is unique. It was an unknown form of visual moving pattern before computer graphics and motion-control made it possible to plot any differential dynamics for filming. More to the point this form of motion is distinguished by its harmonic relationships—its harmony. All points of the drawing cycle of any frame are changed by addition, continuously (point for point), of some differential increment.[63]

This new technology and its "differential dynamics," which Whitney defined as the production of coordinated movement through differentials in time, contained new aesthetic affordances and communicative potentialities. While he desired a system that could provide real-time interactivity in the creation of graphic elements, Whitney's priorities for real-time systems stemmed from the desire to quickly store and retrieve abstract forms in order to pattern their metamorphoses. This was because storage and retrieval, rather than interactivity, better allowed for the planning of action to occur between abstract elements or, to once again invoke Norman McLaren, between the frames.

When invited to an Aspen design conference in 1967 devoted to "Order and Disorder," Whitney's lecture focused on how the dialectic in the confer-

ence's theme produces the visual resonances and harmonies in his digital aesthetic practice, all made possible because of the "power of the computer to produce endless variations upon pattern, which stems from the basically mathematical foundation by which all images are formed."[64] Storing and planning these patterns proved to be the challenge, and in 1974 Whitney submitted an NSF grant proposal titled *Perceptual Studies in Dynamic, Interactive Computer Graphics* dedicated to not just interactive graphics display but also the "problem of temporal development."[65] Relating time and movement in digital graphics to the study of proprioception and the "sensory parameters of human perception," Whitney identifies a number of applications for his proposed software and hardware platform.[66] Yet, as his grant proposal addendum on "Philosophical Objectives and Background" makes clear, the perceptual dynamics at play in his proposed system stem from digital harmonic patterns evolving over time, creating "the effect of alternating order with disorder which becomes a species of tensional charge or discharge or anticipation and its satisfaction."[67] Returning to the analogy of a musical instrument, Whitney argues for funding to make a graphic instrumentation platform and extend harmonics beyond aural perceptual registers. In the end, this would create dynamic patterns produced for the eye to provide a pleasure by tapping into perceptual constants.[68]

Again, though Whitney argues that this action of harmony is commonplace in music, the translation of musical structure to graphic form is not a synaesthetic one but instead indebted to an act of ekphrasis requiring the mathematical precision of computers. In an unpublished essay, "Our Times—Our Perception of Time," Whitney develops an argument about harmonic operations and how rhythms affect the senses: "In music we perceive ACTION . . . [and] we acquire the dynamics of harmonic information unconsciously and directly, with a minimum of learning, for, even more than any language, the musical message is instantly absorbed."[69] Importantly, Whitney argues that these alternations are created through a technological arrangement that both the senses and the body adapt to, marking how the body functions in the environment and shaping understandings of time. For this reason, in a changing technological landscape, Whitney identifies the need for an aesthetic form that can articulate an experience of time akin to that which dictates everyday experiences. Computer graphics have

this power, with their ability to "demonstrate how visual patterns of energy can be made of resonant action" guided by algorithmic functions. Time is registered within information processing systems through electronic signals in megahertz frequencies and exists, as Whitney describes, "in a solid state" below perceptual thresholds. These frequencies "materialize" time and engender "a new perception of time-made-visible which has become material and substantial."[70] Since such mechanisms had begun delineating a new technical regime by reorganizing the means through which time is marked or registered by the body, Whitney argued that a new aesthetic form produced through such actions was necessary and that real-time digital animation could provide this mediation.

Unlike Csuri's proposal, Whitney's grant request did not gain funding from the NSF, most likely because Whitney's proposal lacked a clear vision for the type of software and hardware that he wished to develop. The NSF may also have decided instead to support Csuri's vision of real-time interactivity. Regardless, Whitney's grant proposal clearly articulates his vision for digital animation's future, and he continued to move between various platforms when making films to find a system that most approximated his ideals. Of course, while doing so, he also changed assistants, since at that time Whitney was not very good at programming computers.

COMPose SYMBIOSIS

Around the time Whitney was producing the grant proposal, he was also working on *Arabesque* (1975) with Cuba as his programmer. They were given access to a powerful PDP-10 computer at Information International Incorporated (Triple-I) to use in the middle of the night or on Sundays when others were not running programs. Previously, Whitney had worked with a platform that utilized a language called REL Animated Film Language, developed as an extension of REL, short for Rapidly Extensible Language. This is a programming language created at CalTech by Frederick Thompson and Bozena Dostert in 1969 that is (1) syntax driven through natural language structures, and therefore highly accessible to users, and (2) easily and quickly extensible, meaning that it could incorporate new languages, data packages, and algorithms to "provide a highly idiosyncratic

capability, tailored and built around . . . the logic of the particular application."[71] By 1971, Thompson and Dostert's group developed the Animated Film Language extension at CalTech, which Whitney used to program the digital images for *Matrix I* (1970).[72] Obviating the need for punch cards by utilizing a teletypewriter and functioning through more intuitive syntax structures, this extension was far preferable to the Fortran platform he worked with previously. But, when he moved to Triple-I, the PDP-10 system was connected to another computer with a CRT vector monitor and a film camera. This second platform could be independent or read the programming tape from the first and then quickly visualize those images for recording, nesting a photographic and cinematic technology inside the system. The language designed specifically for this was called COMPose and was used primarily for graphic texts and the printing of manuals or other books. Whitney and Cuba decided to work only with this secondary system because of its graphics capabilities. The difficulty with this setup was that the CRT monitor contained no frame buffer or storage tube, two contemporaneous devices that store rendered images into video memory so they can be projected in a timed sequence. Operating without this resulted in COMPose projecting an electron beam onto a screen to draw images that would immediately begin to fade. This required keeping the recording camera's shutter open for as many drawings as one needed on each frame and still operating outside a real-time system, though it did provide a visualization of the programmed curves and abstract elements to more easily determine the rhythm of a sequence.

After *Arabesque,* Cuba continued an off-hours arrangement with Triple-I and used their PDP-10 with a modified version of REL called RAP (REL Animated Picture) to begin his second film after making *First Fig.* For this film, *Two Space,* completed later in 1979, Cuba wanted to fill the screen with two-dimensional abstract moving graphic patterns that divided and subdivided across the screen to generate a perceptually immersive and expansive environment, an aesthetic idea he was developing while reading computational theory, James J. Gibson's studies of perceptual psychology, and *Eye and Brain: The Psychology of Seeing* (1966) by Richard Gregory. Additionally, Cuba was working for Bob Abel on commercial graphics and was awarded the contract for the digital special effects in *Star Wars* (1977). Amid

FIGURE 5.9. Film still from Larry Cuba, *Two Space*, 1979. 16mm, black and white, sound, 8 minutes. Courtesy of Larry Cuba.

Cuba's frustrations with late-hours programming and the time delays in RAP's platform, he by chance ran across a copy of Tom DeFanti's PhD dissertation while at Whitney's home and was immediately struck by it as a serious technological breakthrough.

Here, the parallel histories in the development of real-time digital animation systems intersect. In Csuri's final report for his 1968 NSF grant, DeFanti's 1973 dissertation is reproduced nearly in its entirety, and the title of the report is *Real-Time Film Animation,* indicating the outcome of his initial exploration of *A Software Requirement for Research and Education in the Visual Arts* and the successful development of an interactive real-time digital graphics platform.[73] DeFanti was a student of Csuri's at Ohio State and worked in the Computer Graphics Research Group funded by the NSF grant. For his dissertation, DeFanti created an animation computer language called GRAphics Symbiosis System (GRASS), which is an offshoot of BASIC. The change from Fortran to BASIC for the group was pivotal. BASIC was designed for use at teletype print terminals, just like REL, to foster more interactive programming and eliminate the need for batch-style processing while creating a more natural syntax for program-

mers in a time-sharing environment. As the authors of *10 PRINT* explain, BASIC was created at Dartmouth University and employed an early time-sharing environment called the Dartmouth Time-Sharing System that "allowed multiple programmers to use a single system at the same time . . . with many terminals connected to the mainframe."[74] While it was like REL in that it could be easily ported across platforms and was also extensible, BASIC grew more quickly in popularity, in part because of its relaxed syntax requirements, which, for instance, ignored spaces to prevent bugs based on common keyboarding errors and also displayed "error messages that were clear and friendly."[75] In contrast, Thompson explains that the REL "system does not print out a lot of diagnostics. If a person uses this system day in and day out he will know where to look for errors."[76] GRASS added parameters for three-dimensional graphics rendering and commands that were intuitive such as "ROTATE," and other operations aimed at scaling, shading, and merging design elements. GRASS was intended for artists, and thus simplified its command lines, but it also allowed for data from input devices such as tablets to be controlled by any variable in the language and for long macros to be used, facilitating the rendering of three-dimensional forms that could rotate in space with relatively few lines of code.

These were projected on a Vector General display that was similar to the one Whitney used at IBM in the 1960s but utilized a more sophisticated memory system with a view calculator to allow for real-time animations. Whitney's display system employed a second program follower, or subroutine system, that shares the memory from the computer in order to properly render a single image as it is being developed. As Theodor H. Nelson explains, subroutines go "down lists of picture-drawing instructions also stored in the same core memory," thus preventing electrons that are scanning across the screen from fading while simultaneously registering changes made in the program while coding.[77] DeFanti's system added storage to the display so that the subroutines described above that feed into the display terminal and the processor are then *additionally* stored in the display buffer, allowing the real-time rotation and manipulation of vector objects on the screen. This was the key to real-time interactivity in digital graphics. It enabled images to be created and stored in the memory of the mainframe computer and the memory of the display unit.

The development of this language and platform attracted the attention of the chemistry (for molecule models) and computer science departments at the University of Illinois at Chicago, where DeFanti became a professor and, with Dan Sandin, founded Circle Graphics Habitat (later named the Electronic Visualization Laboratory [EVL]). This early laboratory for the merger of digital technology and the arts later became known best for developing the data glove and the immersive environment software and technology called the Cave Automatic Virtual Environment, or CAVE. But in the 1970s it was associated most with real-time graphics through GRASS. After learning about this space, Cuba contacted DeFanti and traveled to Chicago, where EVL sponsored him and provided the equipment for Cuba's work on *Star Wars* as well as his film *3/78* (1978).

Though Cuba wished to develop film animations, DeFanti had originally intended for artists to use the GRASS platform for immediate projection at live shows. For this, Sandin created an image processor that added elements such as color to the GRASS moving graphics by manipulating the signal of a television camera aimed at the Vector General display. As Cuba began to work on the system, a fundamental animation problem that had also dogged Whitney emerged: the timing of frames. The vector display that GRASS used could not control frame speed, which meant that the speed of the drawings and animations on the display was dependent on the complexity of the drawn image. As soon as the display's electron beam completed an image it would begin the next drawing, so that complex, detailed images were displayed longer as they were rendered, while more simple forms in succession would be drawn rapidly one on top of the other. Cuba and other animators migrating to EVL pressed for time-based variables, which DeFanti added, though time was measured through electrical hertz clock cycles.[78] Cuba still had to translate this rendering of time into a slower twenty-four frames per second film when recording off the Vector General display. But the legacy of Whitney's goals for the management of time and Csuri's struggle to develop an interactive digital graphics system culminated at this moment. Cuba's film *3/78* bears witness to this ability to produce and plan on a digital system a rhythm previously much more difficult to predict, as do the digital effects for *Star Wars* showcased in the rear-projected stolen data plans of the Death Star that visualize the battle station's weakness. For *Star Wars*, Cuba inputted points using a tablet and then connected these into a wire-frame line drawing that

FIGURE 5.10. Film stills from Larry Cuba, *3/78,* 1978. 16mm, black and white, sound, 6 minutes. Courtesy of Larry Cuba.

could be rotated on the screen because of the display storage capabilities. In *3/78* dots are choreographed on the screen to produce a fluid articulation of motion that could easily be reversed and mirrored by quickly editing the code to run the time variable backward.

That said, like the difficulties Whitney encountered with the projection of multiple graphic elements on the screen, Cuba could not project multiple forms in the way he did earlier at Triple-I in the development of his partially completed film *Two Space*. Still working within the parameters of the GRASS platform's memory, animators could not give it too much to draw on the screen or it would produce a flicker as images began to pile up within the display's storage system. DeFanti recognized this problem, explaining that "the maximum number of parallel full-screen vectors that can be displayed flicker-free is about a thousand, although they can all be rotating, moving and scaling. We have to operate in a flicker-free environment because our television-based system [created by Sandin for immediate live projection] is not sophisticated enough to operate in anything but real-time."[79] Csuri also recognized this problem with GRASS, commenting at the Information Processing Congress in 1974 that there was a limit to "the number of transformations that can be linked together before the real-time display is lost" and that compound transformations could be difficult or impossible.[80] Cuba was frustrated by such limitations, and to work around them for some of the images in *Star Wars*, he had to render them in parts with multiple exposures for some frames. *3/78* works within the affordances of real-time animations set forth by the GRASS platform. While allowing for the faster registration of motion, Cuba wanted to fulfill his aesthetic ambitions developed for *Two Space* and fill the screen with more graphic elements that could move in coordinated patterns. But, in the 1970s, the GRASS platform could not provide for this level of activity, and making this film meant for Cuba a return to California, the RAP language, and a non-real-time system.

SHALL WE PLAY A GAME?

Cuba's movement across platforms and computing languages during this period of his career illustrates the aesthetic negotiations with projection

and movement in digital animation systems, a balance still in play for contemporary animators as they assess the aesthetic affordances of each platform. Cuba's 1979 article "The Rules of the Game" explains this kind of interaction and the ways in which animators must work with a mechanism's limitations while also being able to determine how certain parameters within their control can be commanded.[81] Articulations of time structured many of the limits within or against which animators found themselves working during the early history of digital animation. This was in part because of the various ways in which time was coded or stored in systems and the aesthetic visions of the programmers performing this work. As Bernard Stiegler points out, we measure time through technical objects in a perceived authenticity bound to the operations and pacing of that regime of experience. He describes how different technologies demarcate what time should feel like, a cultural ideology of time, and that real-time computation is "industrial time."[82] But to be more specific, the artists and programmers described above built their visions of digital time on cinematic representations of fluidity and metamorphoses generated without the flicker or contractions and dilations of time experienced in films made by artists such as Robert Breer and Tony Conrad.

Instead, the imperative for digital animation was the drive to construct a system modeled on a familiar experience of time found in cinema, namely full animation. The inlay of one technological form inside another's model of perceptual experience is not uncommon, especially in digital media. Jonathan Sterne calls this operation perceptual coding, whereby understandings of the human senses, as well as older media, are used to determine how to generate aesthetic objects that can be transmitted, stored, and rendered on computer platforms. He describes the development of the MP3 file format, for instance, and reveals the "shadows of the listener" that are built into the audio file format along with the legacy of telephony to show that the aesthetic experience and the technical form of this digital artifact date back to the early twentieth century.[83] When computer scientists and digital filmmakers from the 1960s and 1970s attempted to build real-time graphics systems, they too were triangulating a model of the human senses and a time of cinema in their media experiments. As Nam June Paik explains in his short piece "Cybernated Art" (1966), quoted in the epigraph of

this chapter, our bodies are a part of the circuits of these new technologies and help structure mutually imbricated histories.[84] This layering of various media around ideas of embodied and mechanical perception is never a complete, closed system, but instead moves in fits and starts as platforms and artists explore aesthetic limits in an ongoing technological game.

Through this game, novel understandings of embodied relations with technical media were being sorted through and reflected upon. While digital technics operate below thresholds of perception and conscious attention, their displays that function as a site of equilibrium or contact between human experience and information circuits were a contested field. Producing senses of motion predicated on the relation between human perceptual syntheses and a history of other storage and moving image technologies, early digital animation shaped not only senses of what computational media could make move, but also cultural senses of how computational media function. As Hansen argues about contemporary digital media, these technologies "mediate the technical condition of mediation itself" through supplementary images and forms of visualization that reveal the microtemporal logics of its infrastructure.[85] But, as I have shown, such supplementary forms were never self-evident nor easily built. Instead, they functioned as objects of play and indeterminacy, with early digital animation mediating time as it is experienced through multiple technical regimes, pulling the past and future into a dance of permutations.

CONCLUSION

RE-ANIMATING THE PAST

> *Like a comic-book Spider-Man, the solitary*
> *voyeur rides the web of occult forces.*
>
> Charles Simic, *Dime-Store Alchemy*

MINIATURE FLATS DANCE IN LEWIS KLAHR'S FILMS. IN THESE COLLAGES, he uses cutouts from ephemera like comic books, magazines, newspapers, telegrams, and found footage from mid-twentieth century American culture, evoking details of past moments seemingly preserved, a temporal closure ruptured by the tableau he puts into motion. Because of the restrictions of most definitions of animation that do not take into account the kinds of films Klahr makes, he explains that, "although I'm usually described as an animator, I've taken to publicly declaring that I don't consider myself to be one." Yet he also concedes that he "can't separate my use of cut-outs from animation," which leads him to describe his aesthetic as "re-animation," since he usually puts objects and forms into motion through a frame-by-frame technique.[1] As discussed in the introduction of this book, Klahr presses animators and critics to think through the Gordian knot of style and materiality in discussions of animation in order to unravel a more inclusive and flexible approach that will not only consider filmmakers like himself but also re-animate the history of animation. Klahr's films often reference the history examined in this book, reminding viewers of the abstractions seen in films by figures such as Robert Breer or plays on pop aesthetics found in the work of Andy Warhol. By incorporating this style and artifacts from this time, Klahr's films force us to engage with the charming sorcery of these objects and cinema's capacity to enlarge their worlds while simultaneously resuscitating their life. Like Phillipe-Alain Michaud's characterization of "the dizzying effect of photographic

enlargement,"[2] Klahr splices together instants of a forgotten time into new flows of history and cinematic temporality (Plate 11).

Conceptualizations of history run through Klahr's formal technique and how he describes his filmmaking identity. In his aesthetic, this happens through two material registers: the objects that he works with, which pull in the cultural past to explore how the present is created and weighted with that time, a "kind of archaeological detection," and the apparatus that he employs to make this past visible. Cinema functions for Klahr as "a kinetic interface between the personal and the cultural," a time machine that connects us to shared cultural heritages and lost narratives.[3] Films such as *The Pharaoh's Belt* (1993), *Pony Glass* (1997), *The Two Minutes to Zero Trilogy* (2003–2004), and *False Aging* (2008) index periods of American history using figurative and abstract forms that invite both recognition and pathos. There is a faint knowledge of periodization and an awareness of the gulf of time the objects have traversed because of Klahr's selection of things that "carry the charge or trace of the context they've been lifted from."[4] Klahr will also utilize genre conventions in his films, with Hollywood melodramas and science fiction tropes structuring a loose narrative arc. Here, the histories of these conventions work in conjunction with images from the past to play with what Klahr calls "the experience of then and now— lived time—that sense of the gap in time between what once was and what is that gives nostalgia its uncanny, stomach-churning power. It can be equal parts queasy and ecstatic."[5] This gap is immediately made visible at the beginning of several of Klahr's films when the first frame after the title displays an old watch, scratched and aged with a style from the same era as the other elements in the film. Clocks appear regularly throughout Klahr's work, at times running backward and sending the viewer into the vertiginous play with time that characterizes nostalgia.

This registration of the past does not just happen in an iconic fashion. Klahr's images and techniques also recall the history of abstract animation whose works he reminds us "are not considered animations or normally included in animation history," and his re-animation of them brings the weight of this history into the present, just like the genres, gendered and sexual relations, and other cultural forms from this time that haunt his films and our contemporary landscape.[6] Though digital technologies have

FIGURE C.1. Film still from Lewis Klahr, *Nimbus Seeds,* 2009. HD video, color, sound, 8 minutes. Courtesy of Lewis Klahr and Anthony Reynolds Gallery.

FIGURE C.2. Film still from Lewis Klahr, *Wednesday Morning Two A.M.,* 2009. HD video, color, sound, 7 minutes. Courtesy of Lewis Klahr and Anthony Reynolds Gallery.

made moving images appear to be newly transformed for some critics, as if a break in history occurred at the end of the twentieth century around cinematic ontologies, the incorporation of computational media into social fields and the fold of moving images occurred during the time that Klahr investigates, which, like his films, prompted explorations of materiality and form more generally. Similar to Klahr, this book has re-animated that history by connecting the dots, or pulses, among films and filmmakers within animation's technical syntheses. As detailed in the introduction, animation is always reactivating the history of moving images in a variety of ways, but rather than endlessly repeating, the nature of that recursive synthesis fluctuates with the media and social landscape in which it operates. The fast-paced technological transformations occurring from the 1950s through the 1970s resulted in changes and experiments within animation that indexed the shifting epistemological landscape. This was not a totalizing change, but instead produced questions and investigations about the relationship between machine and computational technologies with ideologically charged anxieties and ambitions attached. What was clear for many was that a transition was occurring, leading Marshall McLuhan to look backward and forward simultaneously while commenting on the ways work and labor would transform:

> Automation is not an extension of the mechanical principles of fragmentation and separation of operations. It is rather the invasion of the mechanical world by the instantaneous character of electricity. That is why those involved in automation insist that it is a way of thinking, as much as it is a way of doing. Instant synchronization of numerous operations has ended the old mechanical pattern of setting up operations in lineal sequence.[7]

The epistemological stakes are clear in this formulation, as the coordination of thought and action within this new arrangement are both in states of flux as new ways of calibrating work, leisure, and social organizations to technical syntheses emerge. Just as in Jim Henson's *Paperwork Explosion* discussed in the Introduction, the question of who thinks and who works—machines or people—was under scrutiny with new regimes of time and

perceptions of technological instantaneity, or what McLuhan calls automation's "instant inclusive embrace."[8]

Klahr's continual return to this moment includes references to its shifting technological landscape, seen in the mainframe computers, atoms, and radioactive material that both populate his films and catalyze metamorphoses in its characters. And like other forgotten cultural dreams and nightmares from this moment, the development of computational and information technologies that laid the foundation for sometimes iterative and other times more substantial media and technology shifts in the latter part of the twentieth century were overshadowed. But the machines and devices were not the only neglected aspects of this assemblage. Though computational and digital technologies emerged in postwar cultures, the epistemological transition that McLuhan and others anticipated was never fully complete, and technological mixes of these and industrial machine forms defined that period while also setting precedents for contemporary media landscapes. Through Klahr's activation of history, the materiality of the technologies within the films brings to light their role within larger social and media ecologies, simultaneously referencing changes to everyday life and, through Klahr's animation techniques, changes to moving images. The objects Klahr works with are not only souvenirs of that time, marking their forgotten power, but also souvenirs of technological movement, of the ways moving images were animated. Plays of abstract lines, flicker montages, color fields, and punctuated displays of emerging computational technologies gesture to the history that pulses in this book. Like that history, Klahr's is not totalizing or complete, nor does it attempt to be. Instead, one of the goals of this book and Klahr's films is to open up historical and epistemological relations to contemporary media ecologies that are normally occluded so that ontological demarcations and canon formations don't shape senses of style, history, and experience.

The strange ecstasy of the past welling into contemporary culture in Klahr's films is magnified by the animus that he grants them. Like the hand of the artist breathing life into forms that permeates the history of animation, Klahr similarly touches the objects seen in his films to, as he says, reanimate their form, sometimes lowering the customary frame rate of animated movements, which cause objects to jerk and stutter. This produces

FIGURE C.3. Film stills from Lewis Klahr, *Pony Glass,* 1997. 16mm, color, sound, 15 minutes. Courtesy of Lewis Klahr and Anthony Reynolds Gallery.

an artificiality of action that is punctuated by his ephemera moving across the flat plane of the screen. These usually lack perspective depth and possess layered interactions whose contexts generate moods and associations that mix and complicate those usually reserved for the stock genres from which these images come. Playing and mixing, at times in a chance manner, from the pop culture cabinet that Klahr mines evokes both senses of childish innocence or fantasies as well as the social relations that threaten these cultural dreams. Thus, in *Pony Glass*, Superman's Jimmy Olsen travels through a sexual identity crisis in a melodramatic fashion that, Klahr explains, "unmasks . . . this collective iconic inheritance."[9] These cultural myths, whose enchantment lies in advertisements and other images from consumer culture, are condensed and explored in miniature cinematic worlds that share traits with Joseph Cornell's shadow box and films. As in Cornell's *Thimble Theater* (1938), an oneiric exploration of metamorphosis seen through the eyes of children that culminates in an inverted and reverse double projection of a *Jack and the Beanstalk* cartoon, Klahr's *Pulls*, which is part of his *Picture Books for Adults* series (1983–1985), also bears witness to magical transformations in childhood. Though both films use double projections of cartoons and other filmstrips in similar manner, the differences are punctuated by Klahr's images of a military bombing and the degradation of the filmstrips that run parallel to one another. As the epigraph above from Charles Simic's book of short essays and poems on Cornell explains, if Cornell is indebted to Romanticism and "like a comic-book Spider-Man, the solitary voyeur riding the web of occult forces," then Klahr rides this same web but simultaneously exposes both its nightmares and its fetishistic beauty.[10]

Klahr is clear that the images he works with are from the fashion of a period that has passed yet whose power lingers. The miracle of their re-animation emerges through his cinematic thaumaturgy. Handling the images provides access to this time, all the while generating associations sometimes structured through chance arrangements while opening an interior world that only the miniature, according to Susan Stewart, can disclose. It provides access to fantasy in a ludic fashion where "to toy with something is to manipulate it, to try it out within sets of contexts, none of which is determinate."[11] This is one reason why playing cards routinely

FIGURE C.4. Lewis Klahr, *Pony Glass,* 1997. Paper collage on cardboard. Courtesy of Lewis Klahr and Anthony Reynolds Gallery.

FIGURE C.5. Film still from Lewis Klahr, *False Aging*, 2008. HD video, color, sound, 15 minutes. Courtesy of Lewis Klahr and Anthony Reynolds Gallery.

appear in his films like *Altair* (1994) and *The Pettifogger* (2011), the latter detailing a first-person account of a year in the life of a gambler and con man in 1963, whose chance dealings with cards and life, as Tony Pipolo points out, serve as metaphors for Klahr's own manipulation of ephemera.[12] Such self-referentiality is not uncommon in his cinematic technique. This occurs with regularity when the distinctive textures and backgrounds move alongside or with objects in that space, sometimes curling to create shadows and layers of paper to accentuate the controlled action of their form that had been ignited into motion by Klahr's hand, all the while accentuating the Janus-faced time of animation: what was materially rendered and ordered by a past operation that is simultaneously projected now. In *False Aging*, the hand of the animator trope is visually laid bare during a scene when Klahr animates the joining of dots in a drawing by the numbers image of a midcentury sedan, an allusion to Warhol's paint-by-numbers series and the soundtrack of this part of the film, which is Lou Reed and

John Cale's "A Dream," the lyrics of which Reed wrote based on *The Andy Warhol Diaries* (1989). In this short sequence, Klahr breaks the smooth movement of the line that produces the car's form with frames that show part of the drawing complete or blank in a jerky, staccato rhythm. He also includes an image of his hand holding a pencil over the picture and occasionally the head of a comics character from *Man from U.N.C.L.E.* that appears throughout this part of the film and serves as a protagonist of sorts, an embodied anchor for the narration on the soundtrack about the punctuated vertigo of aging. In this sequence, this character looks directly at the camera for only one frame and the word bubble printed over his head in the original comic has been cropped but still includes the words "eyes play," another allusion, but one that indexes the rapid-fire montage that Klahr employs here.

In his *Two Minutes to Zero Trilogy* this eye play takes on more force. Klahr cuts up panels from *77 Sunset Strip* comic books that depict heists and presents them in a fast-paced flow of panning close-ups and extreme close-ups. Several issues are used, and Klahr experiments with the ability of spectators to locate narrative threads from genre cues and juxtapositions of action. He explains that the series is about narrative compression and the relationship between history and narrative that coalesces around time periods.[13] This play on the perception of a logical narrative chain versus its sensual impact is made apparent through the structure of the trilogy that projects these images first over the course of twenty-two minutes, then eight, and then one, with each reduction simultaneously utilizing faster editing to explode cinematic time while preserving cause–effect narrative chains. Revealing the technological seams of cinematic time and space, the trilogy relies on genre cues and narrative actions coded into the associations with various images from the 1960s, when the comic book was published, a historical time gleaned through the style of drawing, inking, and printing featured in the images.

Even though the images pulse at breakneck speed, this time is activated and understood through the recognition of style and materiality that are embedded within the objects and images Klahr displays. Time in his films distends its normal boundaries, partly by the number of images taken from what he calls the flotsam and jetsam of the past that he shoots through the

present, and partly by how he films these artifacts. Slowing or speeding up time makes the objects animated seem more historically precious, as if they are souvenirs from the discarded and forgotten past Klahr believes to be so important. Stewart explains that objects that seemingly "serve as traces of authentic experience" are just that: "The souvenir distinguishes experiences. We do not need to desire souvenirs of events that are repeatable. Rather we need and desire souvenirs of events that are reportable, events whose materiality has escaped us, events that thereby exist only through the invention of narrative."[14] As Klahr points out, his films are not about memories of the past, but rather its forgetting.[15] And the objects in his films activate a past through their textures, plays with light, and color saturations, all the while imploring spectators to connect historical dots like Warhol's paintings. Through these triangulations, senses of narrative within these aesthetic arcs become tangible, if not always legible, and Klahr's expansion and collapse of their form reveals how such structures shape experiences of time and history, much in the way Paul Ricoeur argues. For Ricoeur, narrative becomes a means of integrating the two ways we experience time: a sense of our phenomenological time, or our immediate recognition of the past, present, and future, and our perception of cosmological time, or our understanding of how our lives from birth to death operate within a longer *durée* of history. Interweaving the two within fiction reveals the aporias present in each for Ricoeur: "Between the activity of narrating a story and the temporal character of human experience there exists a correlation that is not merely accidental but that presents a transcultural form of necessity. To put it another way, *time becomes human to the extent that it is articulated through a narrative mode, and narrative attains its full meaning when it becomes a condition of temporal existence.*"[16]

Klahr's cautious deployment of narrative within a historical whirlpool reminds viewers of how weighted our contemporary experience is through images, narratives, and materials of the past, what he calls "the pastness of the present."[17] His films, like this book, cast light on lingering shadows whose sources were forgotten. This helps explain his frequent references to myths. For example, Klahr describes how *The Pharaoh's Belt* was inspired by the three-thousand-year usage of a bull's tail in Egyptian ceremonial clothing,[18] and other films also make direct reference to mythical narratives,

such as *Sixty Six* (2015), a compilation of short films made over fourteen years that opens with an epigraph from André Breton: "Let the dreams you have forgotten equal the value of what you do not know." The series is bookended with *Mercury* (2015), which animates double-sided comic pages of *The Flash* by using a lightbox to punctuate the protagonist's action, and *Lethe* (2010), a genre pastiche of science fiction and noir. The title of this last film references the river in Hades from which the dead would drink in order to forget their former life. Klahr's films resuscitate this forgotten life through the often mundane, quotidian artifacts that are cast into a river of time whose current in contemporary culture moves all too quickly while occluding the cultural power and lingering effects of these objects. One film in the series, *Saturn's Diary* (2014), records the everyday routine of the Roman god as a corporate businessman through repeated images of calendars, clocks, and the mixture of monotonous events and convoluted romances during a four-month stretch of 1966. At the end of this film, the god of time disappears into abstractions, which Klahr describes as a "color diary."[19] As with the history of animation and media, there are often temptations to declare radical breaks between technological modes, a practice that sweeps hybrid technologies or experimental forms into lost currents of time and commonly pulls abstract animation into its undertow. By re-animating images from that moment and techniques that brought them into motion, this book, like Klahr's films, reveals their persistent legacy that investigates form, technology, and aesthetic experience.

Klahr's films thus feel timely because of their focus on how aesthetic and technological forms from the mid-twentieth century bear on the current media environment. This is especially put on display in *Wednesday Morning Two A.M.* (2009), a film structured in two parts through a repetition of the Shangri-Las' "I'll Never Learn" as its soundtrack. Also opening with a watch, the first part plays like a fever dream of nostalgia for love lost in a domestic world of wallpaper, kitchen cabinets, and paper towels. But, as in *Saturn's Diary*, the visualization of this emotional landscape is made possible through its cinematic re-animation that can spin time backward and forward. The medium is, as the Shangri-Las sing, "a looking glass that reflects the past," a line that Klahr pairs with the protagonist's face superimposed over another image of her body and scrolling images of rooms

FIGURE C.6. Film still from Lewis Klahr, *Lethe,* 2009. HD video, color, sound, 22 minutes. Courtesy of Lewis Klahr and Anthony Reynolds Gallery.

FIGURE C.7. Film still from Lewis Klahr, *Saturn's Diary,* 2014. HD video, color, sound, 6 minutes. Courtesy of Lewis Klahr and Anthony Reynolds Gallery.

from her comic book home. These layers of images are seen through a spinning glass, giving them an aqueous texture, as if they were dipped in a loss lurching itself into the present. The second half maintains this play on texture but focuses on abstraction through color fields similar to those in *Saturn's Diary* by using close-ups of wallpaper patterns that move in and out of focus (Plate 12). These are reminiscent of feminist abstractions that use fabric and scraps of material usually associated with private or domestic spaces in a collage aesthetic that Melissa Meyer and Miriam Schapiro call "femmage," which reveals often neglected artistic practices and gendered orders of public and intimate spheres.[20] But they also gesture toward structures of loss and nostalgia associated with mid-twentieth-century cinematic melodramas through the triangulation of the music, the design style from that time, and the color saturation in the film. This genre, as Linda Williams explains, is structured around senses of time, producing feelings of "too late" or "in the nick of time" to develop suspense or pathos, both of which generate "the feeling or threat of loss suffused throughout the form."[21]

Animation's history is often riddled with this melodramatic structure and of being seen as a threat to cinema or of being pitifully omitted. But, as its weave through media ecologies is more recognized, it is clear how animation's power and identity exist through modes of revelation, both of cinema's continuing evolution as a form and of the epistemic practices that index contemporaneous perceptions of moving image technologies. Calling attention to plays on materiality and how a black box was built around photographic movement, animation reminds viewers of the ways in which aesthetic experience is triangulated with technology and formal compositions. This positioning and resulting motion in its form produces animation's quasi autonomy that is so captivating: its presentation of technical illusions. It generates a dream world that can call attention to the gaps, shadows, and fissures in the world we habitually encounter every day, leading Walter Benjamin to explain the popularity of Mickey Mouse films by pointing out that "it is simply the fact that the public recognizes its own life in them."[22] How this encounter occurs changes, moving with different technical assemblages in history so that the mimetic action Benjamin identifies with animation shifts in time, like the mimetic play of children

that is "irresistibly drawn by the detritus generated by building, gardening, housework, tailoring, or carpentry." Children see "the face that the world of things turns directly and solely to them" in their play with obsolescent and discarded things.[23] And Benjamin sees in this play excavations of the past that reveal the ways in which that recently bygone moment lurks in the present, like the "Old Forgotten Children's Books" that title his essay. It is this failure to cast aside things that enables children to recognize and imitate the power within these objects and call attention to their neglected existence, moving through imaginative spaces of color, line, and texture that reveal history's folds. Animation threads the same envelope of time, as artists like Klahr make iconic this historical relation while others tinker with the black box of cinematic form, sending animation back to its moment of inception through webs of new technologies, social relations, and pulses of movement.

ACKNOWLEDGMENTS

THOUGH WRITING IS OFTEN SOLITARY WORK, I HAVE HAD THE VERY GOOD fortune of writing this book with the support and advice of a number of people. Its initial form was a dissertation written at the University of Chicago, where my adviser, Tom Gunning, enthusiastically supported this project and the many other ideas I would talk over with him. His friendship and mentorship modeled intellectual curiosity and set an example for being a scholar and teacher. The other members of the dissertation committee, James Lastra, Yuri Tsivian, and Jennifer Wild, helped shape my questions and arguments to make my writing more rigorous. Matthew Kirschenbaum sparked my interest in media and materiality years ago while at the University of Maryland, and I thank him for continuing to read and encourage my work from a distance.

I am also indebted to the wonderful support of friends and colleagues whose comments, conversations, advice, and support shaped this book and made it a pleasure to write. Many thanks to Lauren Berlant, Robert Bird, Anston Bosman, Lee Carruthers, Jon Cates, Scott Curtis, Shane Denson, Hannah Frank, Jacob Gaboury, Doron Galili, Oliver Gaycken, Rory Graham, Marsha Gordon, Adam Hart, Matthew Hauske, Nathan Holmes, Sarah Keller, Michael Kelly, Daniel Morgan, Devin Orgeron, Kirsten Ostherr, Andy Parker, Christina Petersen, Inga Pollmann, Ariel Rogers, Ivan Ross, Charles Tepperman, Julie Turnock, Allison Whitney, Colin Williamson, Joshua Yumibe, and Lisa Zaher. I am particularly grateful for the inspiration, good-natured debate, and warm friendship of Helen Burgess, James Hodge, Scott Richmond, and Gregory Zinman. Each pushed me and kept me steady over meals, drinks, or formal academic discussions.

Thanks are due as well to the institutions and audiences whose generosity and feedback informed this book, including the Mass Culture and New Media workshops at the University of Chicago; the Chicago Film Seminar; the University of Wisconsin, Madison, Department of Communication Arts Film Colloquium; the Columbia University Film Studies Department; the Museum of the Moving Image; the Wayne State University Film Studies Program; the University of Massachusetts, Amherst, Department of Communication; the Rutgers University Program in Comparative Literature; the Maryland Institute for Technology in the Humanities at the University of Maryland, College Park; and the Triangle Film Salon at the University of North Carolina, Chapel Hill.

I am also grateful for the sponsorship of a number of academic institutions. For material support, I thank the Department of Cinema and Media Studies at the University of Chicago for various fellowships and grants, as well as a Provost's Summer Fellowship and a Provost's Dissertation-Year Fellowship affiliated with the Franke Institute for the Humanities. Thanks as well to the Department of English and the dean of faculty at Amherst College, whose generous subvention helped make possible the illustrations in this book. The Department of English at North Carolina State University also provided me with timely course releases while finishing the manuscript.

This book could not have been written without the intellectual labor and support of many archivists. I am grateful for the time and resources of May Haduong and Mark Toscano at the Academy of Motion Picture Arts and Sciences and for John Whitney Jr. in allowing me to access his father's papers that are a part of the Whitney estate. Cindy Keefer at the Center for Visual Music provided great support as did the iotaCenter and its wonderful staff, particularly Derek Haugen and Stephanie Sapienza. Stephanie's time going through the uncatalogued papers of John Whitney Sr. with me not only was pivotal in helping sort through this material but also awakened a number of ideas. To Larry Cuba I owe a great deal, and I very much value the time he took speaking with me about his work, explaining to me some of the nearly forgotten computer languages and machines from the 1960s and 1970s and helping me gain access to many resources in Los Angeles. Eugene Epstein generously spoke at length with me about Thomas Wilfred

and was kind enough to show his collection of Clavilux devices and share his knowledge. The staff at Yale University's Manuscripts and Archives division, especially Stephen Ross and Michael Frost, helped me navigate through the many boxes that encompass the Thomas Wilfred papers. Lindy Smith at the Ohio State University Archives helped me work through Charles Csuri's papers and aided me in tracking down and preserving some of his National Science Foundation reports. Andrew Lampert and Robert Haller also provided guidance and suggestions as I dug through the Anthology Film Archives. And Lewis Klahr's charitable spirit and support both buoyed me and illuminated his aesthetic and conceptual ideas.

I have had the incredible good fortune to work with Jason Weidemann as my editor at the University of Minnesota Press. His support of this project upon first hearing about it and his patience and care throughout the writing and publication process have shown how he values the work and the well-being of his authors. This sincere thanks extends to Danielle Kasprzak as well. Her help coordinating feedback and talking with me at conferences about this project put some of my ideas into focus. I would also like to thank my readers, Lea Jacobs and Karen Redrobe, for both their insightful suggestions and their support of me generally. They gave feedback that opened lines of argumentation and coherence that helped define the scope of this book.

My family has played the most pivotal role in my life while I worked on this book. My in-laws, Richard and Christine Fernsler, have consistently been there with a warm smile and helping hand. My brother, Michael, along with Joy, has offered inspiration even from afar. To my parents, Alex and Charlene, I am eternally grateful. Their encouragement and support are always unfailing, as is the example they set. I'm glad you get to add another book to the collection of ones I gave you long ago. My daughters, Nina and Flora, were born and grew over the course of my writing this book and remind me of the wonderful life outside academia through dance parties, big piles, and fairy tales. Your smiles keep me going. And Sarah, you have made this, and so much else, possible. Thank you for helping me be productive and ensuring that I have a necessary perspective on this work and my life. Both would be impoverished without your presence, and both are dedicated to you.

NOTES

INTRODUCTION

1. Alan Cholodenko, "Introduction," in *The Illusion of Life: Essays on Animation*, ed. Alan Cholodenko (Sydney: Power Publications and the Australian Film Commission, 1991), 20.

2. Pierre Hébert, "Cinema, Animation and the Other Arts: An Unanswered Question," in *The Sharpest Point: Animation at the End of Cinema*, ed. Chris Gehman and Steve Reinke (Toronto: YYZ, 2005), 183.

3. Norman McLaren, "The Definition of Animation: A Letter from Norman McLaren," *Animation Journal* 3, no. 2 (1995): 62.

4. Cholodenko, "Introduction"; Keith Broadfoot and Rex Butler, "The Illusion of Illusion," in Cholondenko, *Illusion of Life*, 263–98; Suzanne Buchan, *The Quay Brothers: Into a Metaphysical Playroom* (Minneapolis: University of Minnesota Press, 2011); Tom Gunning, "Animating the Instant: The Secret Symmetry between Animation and Photography," in *Animating Film Theory*, ed. Karen Beckman (Durham, N.C.: Duke University Press, 2014), 37–53; Gunning, "Moving Away from the Index: Cinema and the Impression of Reality," *differences: A Journal of Feminist Cultural Studies* 18, no. 1 (2007): 29–52; Thomas Lamarre, *The Anime Machine: A Media Theory of Animation* (Minneapolis: University of Minnesota Press, 2009).

5. Jonathan Crary, *Techniques of the Observer: On Vision and Modernity in the Nineteenth Century* (Cambridge, Mass.: MIT Press, 1990), 98.

6. Lev Manovich, *The Language of New Media* (Cambridge, Mass.: MIT Press, 2001), 302 (italics original).

7. See Kristin Thompson, "Implications of the Cel Animation Technique," in *The Cinematic Apparatus*, ed. Teresa de Lauretis and Stephen Heath (New York: St. Martin's Press, 1980), 106–20, and Donald Crafton, "The Veiled Genealogies of Animation and Cinema," *Animation: An Interdisciplinary Journal* 6, no. 2 (2011): 93–110.

8. Gunning, "Animating the Instant," 47.

9. Jimena Canales, *A Tenth of a Second: A History* (Chicago: University of Chicago Press, 2009).

10. Tom Gunning, "The Cinema of Attraction[s]: Early Film, Its Spectator and the Avant-Garde," in *The Cinema of Attractions Reloaded*, ed. Wanda Strauven (Amsterdam: Amsterdam University Press, 2006), 387.

11. Pamela Lee, *Chronophobia: On Time in the Art of the 1960s* (Cambridge, Mass.: MIT Press, 2004), xii.

12. Alvin Toffler, *Future Shock* (New York: Random House, 1970).

13. Jonathan Crary, *24/7: Late Capitalism and the Ends of Sleep* (London: Verso, 2013), 29.

14. Crary, *24/7*, 37.

15. Wolfgang Ernst describes how the division between the storage and transmission of media is made obsolete by digital technologies that render the models as "two sides of the same coin: storage is transfer across a temporal distance" in networked computer memory systems (*Digital Memory and the Archive*, ed. Jussi Parikka [Minneapolis: University of Minnesota Press, 2013], 100).

16. Ben Kafka, *The Demon of Writing: Powers and Failures of Paperwork* (New York: Zone, 2012); Lisa Gitelman, *Paper Knowledge: Toward a Media History of Documents* (Durham, N.C.: Duke University Press, 2014).

17. Kafka, *Demon of Writing*,150.

18. Norbert Wiener, *Cybernetics: Or the Control and Communication in the Animal and Machine*, 2nd ed. (Cambridge, Mass.: MIT Press, 1961); cited in Lee, *Chronophobia*, 235–36.

19. Lewis Klahr, "A Clarification," in Gehman and Reinke, *Sharpest Point*, 234.

20. On these gaps in film theory, see: Gerald Mast, "What Isn't Cinema?" *Critical Inquiry* 1, no. 2 1974): 374–75; Gunning, "Moving Away," 38; Karen Beckman, "Animating Film Theory: An Introduction," in Beckman, *Animating Film Theory*, 1–22.

21. Gunning, "Animating the Instant," 40.

22. See Tom Gunning, "Gollum and Golem: Special Effects and the Technology of Artificial Bodies," in *From Hobbits to Hollywood: Essays on Peter Jackson's Lord of the Rings*, ed. Ernest Mathijs and Murray Pomerance (Amsterdam: Rodopi, 2006), 319–49.

23. Crafton, "Veiled Genealogies," 104.

24. Carolyn R. Miller, "Genre as Social Action," *Quarterly Journal of Speech* 70, no. 2 (1984): 163.

25. Miller, 158.

26. Gitelman, *Paper Knowledge*,1–3.

27. Miller, "Genre as Social Action," 156.

28. Friedrich A. Kittler, *Gramophone, Typewriter, Film*, trans. Geoffrey Winthrop-Young and Michael Wutz (Stanford, Calif.: Stanford University Press, 1999), xxxix.

29. Carolyn R. Miller, "What Can Automation Tell Us about Agency?" *Rhetoric Society Quarterly* 37, no. 2 (2007): 147, 149.

30. Thomas Rickert, *Ambient Rhetoric* (Pittsburgh, Pa.: University of Pittsburgh Press, 2013), 212. For more on the issue of energy and its relation to agency and vitalism within this discourse, see Chris Ingraham, "Energy: Rhetoric's Vitality," *Rhetoric Society Quarterly* 48, no. 3 (2018): 260–68.

31. See: Walter Benjamin, "A Little History of Photography" (1931), trans. Edmund Jephcott and Kingsley Shorter, in *Selected Writings*, vol. 2, *1927–1934*, ed. Michael W. Jennings, Howard Eiland, and Gary Smith (Cambridge, Mass.: Belknap, 1999), 507–30; Joel Snyder, "Visualization and Visibility," in *Picturing Science, Producing Art*, ed. Caroline A. Jones and Peter Galison (New York and London: Routledge, 1998), 379–97.

32. Neil Harris, *Humbug: The Art of P.T. Barnum* (Chicago: University of Chicago Press, 1973).

33. See Bruno Latour, *We Have Never Been Modern*, trans. Catherine Porter (Cambridge, Mass.: Harvard University Press, 1993), and *Reassembling the Social: An Introduction to Actor-Network Theory* (Oxford: Oxford University Press, 2005), 1–25.

34. Latour, *Reassembling the Social*, 72.
35. John Law, "Actor Network Theory and Material Semiotics," in *The New Blackwell Companion to Social Theory*, ed. Bryan S. Turner (Oxford: Wiley-Blackwell, 2009), 144.
36. Ian Bogost, *Alien Phenomenology, or What It's Like to Be a Thing* (Minneapolis: University of Minnesota Press, 2012), 7.
37. Jane Bennett, *Vibrant Matter: A Political Ecology of Things* (Durham, N.C.: Duke University Press), 1.
38. Bennett, 9.
39. Latour, *Reassembling the Social*, 71.
40. Latour, 76. Though Latour uses the term "assemblage" as a synonym, as do I in various places, there is a subtle distinction between actor-network theory and theories of an assemblage as articulated by Gilles Deleuze and Félix Guattari (see: "Introduction: Rhizome" and "Conclusion: Concrete Rules and Abstract Machines" in *A Thousand Plateaus: Capitalism and Schizophrenia*, trans. Brian Massumi [Minneapolis: University of Minnesota Press, 1987]; "What is an Assemblage?" in *Kafka: Toward a Minor Literature*, trans. Dana Polan [Minneapolis: University of Minnesota Press, 1986]). As N. Katherine Hayles points out, networks usually connote clean lines and nodes as exemplified in graph theory, while assemblages allow for greater contiguity and mutability (*Unthought: The Power of the Cognitive Nonconscious* [Chicago: University of Chicago Press, 2017], 118). Others note that assemblages can have constitutive elements whose identity exists outside its relational action (Ben Anderson, Matthew Kearnes, Colin McFarlane, Dan Swanton, "On Assemblages and Geography," *Dialogues in Human Geography* 2, no. 2 [2012]: 171–89). Because of the very relative aspects of animation within the dynamics I trace here, where the term is deployed in various contexts and changes depending upon historicized fields of technical and social action, my study is more reliant on actor-network theory. This both highlights animation's contingent nature and shows how the methodological intervention that Latour and others provide is less associated with ideas of clean materiality than previously assumed.
41. Bennett, *Vibrant Matter*, 80–81.
42. Bernard Stiegler, *Technics and Time*, vol. 1, *The Fault of Epimetheus*, trans. Richard Beardsworth and George Collins (Stanford, Calif.: Stanford University Press, 1998), 17.
43. Wolfgang Ernst, "Media Archaeology: Method and Machine versus History and Narrative of Media," in *Media Archaeology: Approaches, Applications, and Implications*, ed. Erkki Huhtamo and Jussi Parikka (Berkeley: University of California Press, 2011), 239.
44. See: Lisa Gitelman, *Always Already New: Media, History, and the Data of Culture* (Cambridge, Mass.: MIT Press, 2008); Alison Griffiths, *Shivers Down Your Spine: Cinema, Museums, and the Immersive View* (New York: Columbia University Press, 2013), Erkki Huhtamo, *Illusions in Motion: Media Archaeology of the Moving Panorama and Related Spectacles* (Cambridge, Mass.: MIT Press, 2013). Shannon Mattern nicely summarizes the tensions between media archaeology and social histories of media, the contours of which can include or exclude a variety of writers, approaches, and perspectives; see the introduction of her *Code and Clay, Data and Dirt: Five Thousand Years of Urban Media* (Minneapolis: University of Minnesota Press, 2017).
45. Lamarre, *Anime Machine*, xxiii.
46. Lamarre, 15.
47. For more on this, see Félix Guattari, *Chaosmosis: An Ethico-Aesthetic Paradigm*, trans. Paul Bains and Julian Pefanis (Sydney: Power Publications, 1995).

48. Steven Shaviro, *The Universe of Things: On Speculative Realism* (Minneapolis: University of Minnesota Press, 2014), 148.

49. Gilbert Simondon, *Du mode d'existence des objects techniques* (Paris: Éditions Aubier, 1958). Stiegler also emphasizes this approach in his analysis of digital images and animation; see "The Discrete Image," in Jacques Derrida and Bernard Stiegler, *Echographies of Television: Filmed Interviews*, trans. Jennifer Bajorek (Cambridge, U.K.: Polity, 2002), 147–63.

50. Annette Michelson, "Film and the Radical Aspiration," *Film Culture* 42 (1966), repr. in *Film Culture Reader*, ed. P. Adams Sitney (New York: Praeger, 1970), 404–21.

51. Peter Wollen, "The Two Avant-Gardes," *Studio International* 190, no. 978 (1975): 171–75. David James's influential *Allegories of Cinema: American Film in the Sixties* (Princeton, N.J.: Princeton University, 1989) is also structured by this divide.

52. For more on political modernism and its relation to this divide Michelson identifies, see D. N. Rodowick, *The Crisis of Political Modernism: Criticism and Ideology in Contemporary Film Theory* (Urbana: University of Illinois, 1988).

53. Sergei Eisenstein as quoted in Yves-Alan Bois, *Painting as Model* (Cambridge, Mass.: MIT Press, 1990), xxi.

54. Bois, xix.

55. Bois, xix.

56. Johanna Drucker, *The Visible Word: Experimental Typography and Modern Art, 1909–1923* (Chicago: University of Chicago, 1994). Drucker explains that materiality has "two major intertwined strands: that of a relational, insubstantial, and nontranscendent difference and that of a phenomenological, apprehendable, immanent substance" (43). She elaborates: "The force of stone, of ink, of papyrus, and of print all function within the signifying activity—not only because of their encoding within a cultural system of values whereby a stone inscription is accorded a higher stature than a typewritten memo, but because these values themselves come into being on account of the physical, material properties of these different media. Durability, scale, reflectiveness, richness and density of saturation and color, tactile and visual pleasure—all of these factor in—not as transcendent and historically independent universals, but as aspects whose historical and cultural specificity cannot be divorced from their substantial properties. No amount of ideological or cultural valuation can transform the propensity of papyrus to deteriorate into gold's capacity to endure. The inherent physical properties of stuff function in the process of signification in intertwined but not determined or subordinate relation to their place within the cultural codes of difference where they also function" (45–46). In *Mechanisms: New Media and the Forensic Imagination* (Cambridge, Mass.: MIT Press, 2008), Matthew G. Kirschenbaum emphasizes this dialectic in his analysis of new media and their materiality as technologies of digital and analogue inscription.

57. This struggle is particularly evident in abstract animations that were scripted and discussed in Bauhaus classrooms in the 1920s and 1930s, some of which were never made into films while others, such as those made by Werner Graeff and Kurt Kranz, were not filmed until the 1950s and 1970s.

58. Kirk Varnedoe, *Pictures of Nothing: Abstract Art Since Pollock* (Princeton, N.J.: Princeton University, 2006), 40–41.

59. Susan Sontag, "Against Interpretation," in *Against Interpretation and Other Essays* (New York: Picador, 2001), 14.

60. Karin Knorr Cetina, "Objectual Practice," in *The Practice Turn in Contemporary Theory*, ed. Theodore R. Schatzki, Karin Knorr Cetina, and Eike von Savigny (New York: Routledge, 2001), 190.

1. LINE

1. Len Lye, "Experiment in Colour" (1936), in *Figures of Motion: Len Lye Selected Writings*, ed. Wystan Curnow and Roger Horrocks (Auckland, N.Z.: Auckland University Press, 1984), 48.

2. Lye was supported by John Grierson at the GPO film unit in the mid-1930s and was afterward commissioned by corporations such as Imperial Airways to generate advertisements, which complicated both the production and reception of these films, especially since they could not be distributed in the United States because of restrictions on advertising films; see Roger Horrocks, *Len Lye: A Biography* (Auckland, N.Z.: Auckland University Press, 2001), 170. For more on Lye's transition into documentary and military films, see Horrocks, 189–207, and Sarah Davy, "Lye: The Film Artist in Wartime," in *Len Lye*, ed. Jean-Michel Bouhours and Roger Horrocks (Paris: Editions du Centre Pompidou, 2000), 196–98. For an analysis of these films, especially *Kill or Be Killed* (1942), see Hanna Rose Shell, *Hide and Seek: Camouflage, Photography, and the Media of Reconnaissance* (New York: Zone, 2012), 127–69.

3. Wystan Curnow, "Lye and Abstract Expressionism," in Bouhours and Horrocks, *Len Lye*, 205–12. Arthur Cantrill makes a similar claim in his analysis of Lye's 1968 lecture "The Absolute Truth of the Happiness Acid," tying Lye's ideas to surrealism as well. Ultimately, though, this is Cantrill's own argument. Paraphrasing much of the lecture, Cantrill adds that, "although he didn't mention it, Lye's ideas were reminiscent of the surrealist project of creating art that drew on material submerged in the subconscious, except that Lye referred to the site for this information as 'the old brain' (the right hemisphere)" (Arthur Cantrill, "'The Absolute Truth of the Happiness Acid,'" *Senses of Cinema*, no. 19 [March 2002], sensesofcinema.com /2002/feature-articles/lye-2/). Though Lye was aware of Surrealist modes of production and aesthetic practices, his ideas and aesthetic differs significantly, evident in his own explicit rejection of Surrealism in the early 1930s.

4. T. J. Clark, *Farewell to an Idea: Episodes from a History of Modernism* (New Haven, Conn.: Yale University Press, 1999), 331–32.

5. Len Lye, "Why I Scratch, or How I Got to Particles" (1979), in Curnow and Horrocks, *Figures of Motion*, 95. These scratch films were created and exhibited in the late 1950s and early 1960s by Lye, but he afterward stopped making films and dedicated all of his energy to kinetic sculpture, claiming that the culture of avant-garde filmmaking and exhibition was caustic at the time. At the end of his life (he passed in 1980), he revised *Free Radicals* and *Particles in Space*, but he failed to finish the revision of *Tal Farlow*. This was completed after his death by one of his assistants, Steve Jones.

6. Alfred North Whitehead, *Process and Reality* (1929; repr. New York: Free Press, 1978), 166.

7. Len Lye and Laura Riding, "Film-making" (1935), in Curnow and Horrocks, *Figures of Motion*, 40.

8. Caroline A. Jones, *Eyesight Alone: Clement Greenberg's Modernism and the Bureaucratization of the Senses* (Chicago: University of Chicago Press, 2005), xxii.

9. Clement Greenberg, "Modernist Painting," in *Clement Greenberg: The Collected Essays and Criticism*, vol. 4, *Modernism with a Vengeance, 1957–1969*, ed. John O'Brian (Chicago: University of Chicago Press, 1986), 85.

10. Greenberg, 86.

11. Greenberg, 88.

12. Michael Fried, "Art and Objecthood" (1967), in *Art and Objecthood: Essays and Reviews* (Chicago: University of Chicago Press, 1998), 160–61 (emphasis original).

13. Fried, 160.

14. Leo Steinberg, "Introduction," in *Artists of the New York School: Second Generation* (New York: The Jewish Museum, 1957), 6 (quoted in Achim Hochdörfer, "A Hidden Reserve: Painting from 1958 to 1965," *Artforum* 47, no. 6 [2009]: 153).

15. Michael Fried, "Shape as Form: Frank Stella's Irregular Polygons" (1966), in *Art and Objecthood*, 79.

16. Greenberg, "Modernist Painting," 90.

17. Michael Fried, "Three American Painters: Kenneth Noland, Jules Olitski, Frank Stella" (1965), in *Art and Objecthood*, 230.

18. Rosalind Krauss, "The Crisis of the Easel Picture," in *Jackson Pollock: New Approaches*, ed. Kirk Varnedoe and Pepe Karmel (New York: Museum of Modern Art, 1999), 165.

19. Krauss, 165.

20. Rosalind Krauss, *A Voyage on the North Sea: Art in the Age of the Post-Medium Condition* (London: Thames and Hudson, 1999), 6–7.

21. Lye and Riding, "Film-making," 39.

22. Len Lye, "The Art that Moves" (1964), in Curnow and Horrocks, *Figures of Motion*, 82.

23. Lye and Riding, "Film-making," 41.

24. Horrocks, *Len Lye: A Biography*, 266.

25. Len Lye, "Len Lye Speaks at the Film-Makers' Cinematheque," *Film Culture* 44 (Spring 1967): 50.

26. Lye, "Experiment," 48.

27. Lye and Riding, "Film-making," 41.

28. Akira Mizuta Lippitt, *Ex-Cinema: From a Theory of Experimental Film and Video* (Berkeley: University of California Press, 2012), 123.

29. André Bazin, "The Ontology of the Photographic Image," in *What is Cinema?*, vol. 1, trans. Hugh Gray (Berkeley: University of California Press, 2005), 9–16. For interrogations of the belief that Bazin is a naïve realist, see Philip Rosen, *Change Mummified: Cinema, Historicity, Theory* (Minneapolis: University of Minnesota Press, 2001), and Daniel Morgan, "Rethinking Bazin: Ontology and Realist Aesthetics," *Critical Inquiry* 32, no. 3 (2006): 443–81.

30. Stanley Cavell, *The World Viewed*, enlarged ed. (Cambridge, Mass.: Harvard University Press, 1979), 72.

31. Cavell, 24.

32. Cavell, 20.

33. Cavell, 102–3 (emphasis mine).

34. Cavell, 170.

35. Cavell, 171; see also 74. Cavell is, of course, not alone in such a formulation. Issues

of cinematic realism and questions of indexicality and photography have dominated film theory. Animation, in contrast, has historically been ignored or dismissed in much of this discourse. One of the first to note this was Gerald Mast, "What Isn't Cinema?," *Critical Inquiry* 1, no. 2 (1974): 373–93. More recent writings have shed light on both animation and the greater attention paid to it by film theorists than was previously thought, though still marginally. See Esther Leslie, *Hollywood Flatlands: Animation, Critical Theory and the Avant-Garde* (London: Verso, 2002), and Miriam Bratu Hansen, *Cinema and Experience: Siegfried Kracauer, Walter Benjamin, and Theodor W. Adorno* (Berkeley: University of California Press, 2012).

36. For discussions of this move and an exemplary case of it, see D. N. Rodowick, *The Virtual Life of Film* (Cambridge, Mass.: Harvard University Press, 2007).

37. See Tom Gunning, "Moving Away from the Index: Cinema and the Impression of Reality," *differences: A Journal of Feminist Cultural Studies* 18, no. 1 (2007): 29–52, and Giorgio Agamben, *Means without End: Notes on Politics*, trans. Vincenzo Binetti and Cesare Casarino (Minneapolis: University of Minnesota Press, 2000).

38. Agamben, *Means without End*, 55.

39. Cavell, *World Viewed*, 24 (emphasis original).

40. Len Lye, "Is Film Art?" (1959), in Curnow and Roger Horrocks, *Figures of Motion*, 52.

41. Lippit, *Ex-Cinema*, 130.

42. Gilles Deleuze, *Francis Bacon: The Logic of Sensation*, trans. Daniel W. Smith (Minneapolis: University of Minnesota Press, 2002), 35. For analyses of Marey's images and their relation to aesthetics and influence on artists, see Marta Braun, *Picturing Time: The Work of Étienne-Jules Marey (1830–1904)* (Chicago: University of Chicago Press, 1995).

43. Deleuze, *Francis Bacon*, 36 (emphasis original).

44. Deleuze, 29.

45. Roland Barthes, "Non Multa Sed Multum" (1976), in *Writings on Cy Twombly*, ed. Nicola del Roscio (Munich: Schirmer-Mosel, 2002), 90.

46. Letter to Wystan Curnow, September 2, 1979, quoted in Wystan Curnow, "Len Lye's Sculpture and the Body of His Work," *Art New Zealand* 17 (Spring 1980), art-newzealand.com/Issues11to20/Lye05.htm.

47. André Leroi-Gourhan, *Gesture and Speech*, trans. Anna Bostock Berger (Cambridge, Mass.: MIT Press, 1993), 187.

48. See Bernard Stiegler, *Technics and Time*, vol. 1, *The Fault of Epimetheus*, trans. Richard Beardsworth and George Collins (Stanford, Calif.: Stanford University Press, 1998), 140.

49. Leroi-Gourhan, *Gesture and Speech*, 106.

50. Leroi-Gourhan, 107.

51. Lye, "Why I Scratch," 94.

52. Len Lye, "Considering a Temple" (1975), in Curnow and Horrocks, *Figures of Motion*, 88.

53. Lye, "Why I Scratch," 95.

54. Sergei Eisenstein, *Eisenstein on Disney*, ed. Jay Leyda, trans. Alan Upchurch (London: Methuen, 1988), 35.

55. Eisenstein, 54.

56. William Hogarth, *The Analysis of Beauty* (1753) (Pittsfield, Mass.: Silver Lotus, 1909), 55.

57. Eisenstein, *Eisenstein on Disney*, 59.

58. For analyses of Cohl's film, see: Donald Crafton, *Emile Cohl, Caricature, and Film* (Princeton, N.J.: Princeton University Press, 1990); Sean Cubitt, *The Cinema Effect* (Cambridge, Mass.: MIT Press, 2004), 70–98. For a cursory reading of Breer's film, see Lois Mendelson, *Robert Breer: A Study of His Work in the Context of the Modernist Tradition* (Ann Arbor, Mich.: UMI Research, 1981).

59. Paul Klee, *Notebooks*, vol. 1, *The Thinking Eye*, ed. Jürg Spiller, trans. Ralph Manheim (New York: Overlook, 1992), 105.

60. Paul Klee, *Notebooks*, vol. 2, *The Nature of Nature*, ed. Jürg Spiller, trans. Heinz Norden (New York: Overlook, 1992), 43.

61. For more on Lye's description of this action and the differing empathetic responses to natural forces see Lye, "Art that Moves," 80, "from No Trouble," 112.

62. Lye, "Art that Moves," 82.

63. For an analysis of Lye's early work and relationship to music, see Malcolm Cook, "A Primitivism of the Senses: The Role of Music in Len Lye's Experimental Animation," in *The Music and Sound of Experimental Film*, ed. Holly Rogers and Jeremy Barham (Oxford: Oxford University Press, 2017), 45–68.

64. For more on Norman McLaren, see: Terence Dobson, *The Film Work of Norman McLaren* (Bloomington: Indiana University Press, 2006); Cecile Starr, "Norman McLaren and the National Film Board of Canada," in Robert Russett and Cecile Starr, *Experimental Animation: Origins of a New Art*, 2nd ed. (New York: De Capo: 1988), 116–28. Starr includes a page from McLaren's booklet *Cameraless Animation* (National Film Board of Canada, 1958), which details the fundamental principles of this type of filmmaking.

65. See André Leroux, "Une oeuvre ouverte," *Séquences: revue de cinema* 82 (October 1975 [Norman McLaren issue]): 118, cited in Jean-Michel Bouhours, "Uniting Form and Movement," in Bouhours and Horrocks, *Len Lye*, 201.

66. Stan Brakhage, Introduction to the film *The Act of Seeing with One's Own Eyes* (1971), in "Death Is a Meaningless Word, Part 1," The Cinémathèque Québecoise, Montreal, January 27–28, 2001, transcribed by Donato Totaro, *Offscreen* 7, no. 2 (2003), offscreen.com/view/stan_brakhage.

67. Stan Brakhage, 2002 interview with Bruce Kawin, in *By Brakhage: An Anthology*, vol. 1 (disc 2 of 2), DVD (Criterion Collection, 2003).

68. Wilhelm Worringer, *Abstraction and Empathy: A Contribution to the Psychology of Style* (1908; repr. Chicago: Ivan R. Dee, 1997), 112–13. See also Worringer, *Form in Gothic* (1927; repr. New York: Schocken, 1964).

69. Maurice Merleau-Ponty, "Eye and Mind," trans. Carleton Dallery, in *The Primacy of Perception and Other Essays on Phenomenological Psychology, the Philosophy of Art, History and Politics*, ed. James M. Edie (Evanston, Ill.: Northwestern University Press, 1964), 184.

70. Merleau-Ponty, 168.

71. Merleau-Ponty, 184.

72. Merleau-Ponty, 184.

73. Merleau-Ponty, 165.

74. Theodor Lipps, "Einfühlung, innere Nachahmung, und Organempfindungen," *Archiv für gesamte Psychologie* 1 (1903): 188, trans. Gustav Jahoda, "Theodor Lipps and the Shift from 'Sympathy' to 'Empathy,'" *Journal of the History of Behavioral Sciences* 41, no. 2 (2005): 154–55.

75. Theodor Lipps, "Empathy and Aesthetic Pleasure" (1906), trans. Karl Aschenbrenner, in *Aesthetic Theories: Studies in the Philosophy of Art*, ed. Karl Aschenbrenner and Arnold Isenberg (Englewood Cliffs, N.J.: Prentice-Hall, 1965), 405.

76. Theodor Lipps, *Grundlegung der Ästhetik* (Hamburg: Leopold Voss, 1903), 196, trans. in Robin Curtis, "Einfühlung and Abstraction in the Moving Image: Historical and Contemporary Reflections," *Science in Context* 25, no. 3 (2012): 429.

77. Lipps, "Empathy," 406.

78. Lipps, 407.

79. Lipps, 408.

80. Lipps, *Grundlegung*, 196, trans. Curtis, in "Einfühlung and Abstraction," 429.

81. See Lipps's work from the late nineteenth century on optical illusions and Lipps, *Raumästhetik und geometrisch-optische Täuschungen* (1897; repr. Amsterdam: E. J. Bonset, 1966).

82. Worringer, *Abstraction and Empathy*, 14.

83. Juliet Koss, "On the Limits of Empathy," *The Art Bulletin* 88, no. 1 (2006): 146.

84. Roger Horrocks, *Art that Moves: the Work of Len Lye* (Auckland, N.Z.: Auckland University Press, 2010), 10. On these counter-critiques, see: Koss, "On the Limits"; Stacey Hand, "Embodied Abstraction: Biomorphic Fantasy and Empathy Aesthetics in the Work of Hermann Obrist, August Endell, and their Followers" (PhD diss., University of Chicago, 2008); David Morgan, "The Enchantment of Art: Abstraction and Empathy from German Romanticism to Expressionism," *Journal of the History of Ideas* 52, no. 2 (1996): 317–41; Geoffrey C. W. Waite, "Worringer's *Abstraction and Empathy*: Remarks on Its Reception and on the Rhetoric of Its Criticism," in *Invisible Cathedrals: The Expressionist Art History of Wilhelm Worringer*, ed. Neil H. Donahue (University Park: Pennsylvania State University Press, 1995), 13–40.

85. Wilhelm Worringer, "Transcendence and Immanence in Art" (1910), appendix to *Abstraction and Empathy*, 128.

86. Worringer, *Abstraction and Empathy*, 20.

87. Worringer, 44.

88. Worringer, "Transcendence and Immanence," 134.

89. Worringer, *Form in Gothic*, 41 (emphasis original).

90. Vivian Sobchack, "The Line and the Animorph or 'Travel Is More than Just A to B,'" *Animation: An Interdisciplinary Journal* 3, no. 3 (2008): 253.

91. See Henri Bergson, *Creative Evolution*, trans. Arthur Mitchell (1907; repr. Mineola: Dover, 1998).

92. Worringer, *Form in Gothic*, 42–43.

93. Henri Focillon, "In Praise of Hands," in *The Life Forms of Art* (1934), trans. Charles Beecher Hogan and George Kubler (New York: Zone Books, 1992), 174–75.

94. Lye, "Art that Moves," 78.

95. Lye, 85–86.

96. Deleuze, *Francis Bacon*, 41.

97. Gilles Deleuze and Félix Guattari, *What is Philosophy?*, trans. Hugh Tomlinson and Graham Burchell (New York: Columbia University Press, 1994), 193.

98. Deleuze, *Francis Bacon*, 40; Deleuze and Guattari, *What is Philosophy?*, 172.

99. Gilles Deleuze, *Cinema 1: The Movement-Image*, trans. Hugh Tomlinson and Barbara Habberjam (Minneapolis: University of Minnesota Press, 1986), 50–51.

100. Horrocks, *Art that Moves*, 173–74.

101. Krauss, *Voyage on the North Sea*, 53.

102. Lye and Riding, "Film-Making," 39.

103. Len Lye, "Tangible Motion Sculpture," in Curnow and Horrocks, *Figures of Motion*, 75.

104. Many of the sounds that these sculptures produce have been recorded and presented independently by Wayne Laird on *Len Lye: Composing Motion, the Sound of Tangible Motion Sculpture*, 2006, Atoll, ACD 305, compact disc.

105. Walter Benjamin, "Painting, or Signs and Marks" (1917), trans. Rodney Livingstone, in *Selected Writings*, vol. 1, *1913–1926*, ed. Marcus Bullock and Michael W. Jennings (Cambridge, Mass.: Belknap, 1996), 85.

2. COLOR

1. For the series history and a sense of its purpose, see Dorothy C. Miller, Foreword in *15 Americans* Exhibition Catalogue, ed. Dorothy C. Miller (New York: Museum of Modern Art, 1952), 5.

2. See "Jackson Pollock: Is He the Greatest Living Painter in the United States?" *Life*, August 8, 1949, 42–45.

3. MoMA director Alfred H. Barr Jr. wrote a letter to Wilfred telling him that "I think it would please you to know that we receive more letters and telephone calls about *Lumia* than about any other single work in the museum's collection" (Alfred H. Barr Jr., Letter to Thomas Wilfred of February 26, 1959, Thomas Wilfred Papers, Manuscripts, and Archives, Yale University).

4. Jackson Pollock, for instance, reportedly spent hours viewing Wilfred's lumia in the 1930s, according to interviews William Moritz conducted with Palmer Schoppe and Tony Smith, two friends of Pollock (William Moritz, "Abstract Film and Color Music," in *The Spiritual in Art: Abstract Painting, 1890–1985*, ed. Maurice Tuchman [New York: Abbeville, 1986], 310).

5. Claude Bragdon, *More Lives Than One* (1917; rep. New York: Cosimo, 2006), 102.

6. Claude Bragdon, *The Secret Springs: An Autobiography* (1938; repr. New York: Cosimo, 2005), 121.

7. Thomas Wilfred, "Light and the Artist," *The Journal of Aesthetics & Art Criticism* 5, no. 4 (1947): 250.

8. Wilfred, "Light and the Artist," 250.

9. Thomas Wilfred, "Composing in the Art of Lumia," *The Journal of Aesthetics & Art Criticism* 7, no. 2 (1948): 89.

10. Upon seeing a Wilfred Clavilux and lumia projection in the 1950s, Jordan Belson explains that he dramatically changed his aesthetic and technological practices of animation and continued to distance himself from his earlier works throughout his career (William Moritz, "Jordan Belson," in *Kinetica 3* Catalog [Los Angeles: iotaCenter, 2001], 20; Moritz, "The Dream of Color Music and the Machines that Made it Possible," *Animation World Magazine* 2, no.1 [1997]: 20–24; Moritz, "Jordan Belson," in *Articulated Light: The Emergence of Abstract Film in America*, ed. Gerald O'Grady and Bruce Posner [Cambridge, Mass.: Harvard Film Archive and Anthology Film Archive, 1995], 12). Mary Ellen Bute knew Wilfred in the late 1920s while an undergraduate at Yale University. She was interested in both stage lighting and colored music and assisted Wilfred when he installed

a Clavilux at St. Mark's Church in-the-Bouwerie in lower Manhattan (see Mary Ellen Bute, "Statement I" [1976], in O'Grady and Posner, *Articulated Light*, 8; Cecile Starr, "Mary Ellen Bute," in Robert Russett and Cecile Starr, *Experimental Animation: Origins of a New Art*, 2nd ed. (New York: De Capo: 1988), 102; William Moritz, "Mary Ellen Bute: Seeing Sound," *Animation World Magazine* 1, no. 2 [1996]: 29–32). Oskar Fischinger also developed a colored light projection apparatus akin to the Clavilux called the lumigraph, which produced a similar aesthetic effect as well (Kerry Brougher, "Visual-Music Culture," in *Visual Music: Synaesthesia in Art and Music since 1900*, ed. Kerry Brougher and Judith Zilczer [London: Thames and Hudson, 2005], 89; William Moritz, *Optical Poetry: The Life and Work of Oskar Fischinger* [Bloomington: Indiana University Press, 2004], 137–38).

11. Gregory Zinman, "Thomas Wilfred's Aesthetic Legacy," in *Lumia: Thomas Wilfred and the Art of Light*, ed. Keely Orgeman (New Haven, Conn.: Yale University Press, 2017), 80–88.

12. Howard Devree, "Diverse Americans: Fifteen in Museum of Modern Art Show—New Work by Nordfeldt and Laurent," *New York Times*, April 13, 1952, X9.

13. There is a growing body of literature on color aesthetics in film. For primers on various issues and debates, see: *Color: The Film Reader*, ed. Angela Dalle Vacche and Brian Price (New York: Routledge, 2006); Scott Higgins, *Harnessing the Technicolor Rainbow: Color Design in the 1930s* (Austin: University of Texas Press, 2007); Joshua Yumibe, *Moving Color: Early Film, Mass Culture, Modernism* (New Brunswick, N.J.: Rutgers University Press, 2012); *Color and the Moving Image: History, Theory, Aesthetics, Archive*, ed. Simon Brown, Sarah Street, and Liz Watkins (New York: Routledge, 2013); Tom Gunning, Joshua Yumibe, Giovanna Fossati, and Jonathan Rosen, *Fantasia of Color in Early Cinema* (Amsterdam: Amsterdam University Press, 2015); Paolo Church Usai, *Silent Cinema: An Introduction* (London: British Film Institute Press, 2000).

14. Thomas Wilfred's use of this term became well known within avant-garde film communities through Gene Youngblood's quotation of its usage by Wilfred in an epigraph to a part of his book *Expanded Cinema* ([New York: E. P. Dutton, 1970], 345). The term originates from Richard Maurice Bucke, who saw perception and intellectual activity as having the potential to evolve into mystical dimensions in *Cosmic Consciousness: A Study in the Evolution of the Human Mind* (Philadelphia: Innes and Sons, 1901).

15. Wilfred, "Light and the Artist," 247.

16. Léopold Survage, "Colored Rhythm" (1914), in *French Film Theory and Criticism: A History/Anthology*, vol. 1, *1907–1929*, ed. Richard Abel (Princeton: Princeton University Press, 1988), 91.

17. See Wassily Kandinsky, *Concerning the Spiritual in Art*, trans. M. T. H. Sadler (New York: Dover, 1977).

18. Annie Besant and C. W. Leadbeater, *Thought-Forms* (London: Theosophical Publishing Society, 1905).

19. P. D. Ouspensky, *Tertium Organum, the Third Canon of Thought: A Key to the Enigmas of the World* (1911), trans. Nicholas Bessaraboff and Claude Bragdon, 2nd ed. (New York: Knopf, 1922), 242.

20. See Linda Dalrymple Henderson, *The Fourth Dimension and non-Euclidean Geometry in Modern Art* (Princeton, N.J.: Princeton University, 1983), and Henderson, "Mysticism, Romanticism, and the Fourth Dimension," in *The Spiritual in Art: Abstract Painting, 1890–1985*, ed. Maurice Tuchman (New York: Abbeville, 1986), 219–37.

21. Claude Bragdon, *Four-Dimensional Vistas* (New York: Alfred A. Knopf, 1916), 7.

22. Thomas Wilfred, "Lumia, The Art of Light," Thomas Wilfred Papers, Manuscripts, and Archives, Yale University, 193.

23. Mary Hallock-Greenewalt, *Nourathar: The Fine Art of Light Color Playing* (Philadelphia: Westbrook, 1946), 45.

24. Mary Hallock-Greenewalt, *Light: Fine Art the Sixth, a Running Nomenclature to Underlay the use of Light as a Fine Art* (Philadelphia: State Library of Pennsylvania, 1918), 10. Judith Zilczer found that this monograph was originally presented as an address before the Illuminating Engineers' Society at the Engineers' Club in Philadelphia on April 19, 1918 ("'Color Music': Synaesthesia and Nineteenth-Century Sources for Abstract Art," *Artibus et Historiae* 8, no. 16 [1987]: 101–26).

25. Mary Hallock-Greenewalt, Notation for indicating lighting effects, U.S. Patent 1,385,944, filed August 18, 1919, and issued July 26, 1921.

26. She sent a copy of this letter to Wilfred (Mary Hallock-Greenewalt, "The Color Organ," February 25, 1922, Thomas Wilfred Papers, Manuscripts, and Archives, Yale University; see also, Howson and Howsen, Letter to Rogers, Kennedy and Campbell, Attorneys at Law, of April 24, 1922, Thomas Wilfred Papers, Manuscripts, and Archives, Yale University).

27. Greenewalt v. Stanley Co. of America, 54 F.2d 195 (3d Cir. 1931).

28. Michael Betancourt, "Mary Hallock-Greenewalt's 'Abstract Films,'" *Millenium Film Journal* 45/46 (Fall 2006): 52–60.

29. Wilfred, "Light and the Artist," 249.

30. Johann Wolfgang von Goethe, *Theory of Colours* (1810), trans. Charles Lock Eastlake (Cambridge, Mass.: MIT Press, 1970), 298–99.

31. See Wilfred's note "Goethe: 'Zur Farbenlehre' 1810," Thomas Wilfred Papers, Manuscripts, and Archives, Yale University.

32. David W. Griffith, Method and apparatus for projecting moving and other pictures with color effects, U.S. patent 1,334,853, filed May 14, 1919, and issued March 23, 1920.

33. Edwin M. Blake and Thomas Wilfred, "Letters Pro and Con," *The Journal of Aesthetics and Art Criticism* 6, no. 3 (1948): 266, 272.

34. Gilbert Seldes, Letter to Thomas Wilfred of April 4, 1939, Thomas Wilfred Papers, Manuscripts, and Archives, Yale University.

35. Thomas Wilfred, "Lumia, the Art of Light," 112b.

36. For more on these materials, as well as the ways in which they were restored, see Carol Snow and Jason DeBlock, "Working with Wilfred: The Conservation of Lumia," in Ogreman, *Lumia*, 63–73.

37. James Lastra, *Sound Technology and the American Cinema: Perception, Representation, Modernity* (New York: Columbia University Press, 2000), 48.

38. Blake and Wilfred, "Letters Pro and Con," 272.

39. Keith Broadfoot and Rex Butler, "The Illusion of Illusion," in *The Illusion of Life: Essays on Animation,* ed. Alan Cholodenko (Sydney: Power Publications and the Australian Film Commission, 1991), 266.

40. Broadfoot and Butler, 278.

41. Broadfoot and Butler, 280.

42. Alexis Carrel, *Man: The Unknown* (New York: Harper & Brothers, 1935).

43. See Wilfred notes "Alexis Carrel—Man the Unknown" and "Excerpts from 'The Simplified Human Figure' by Adolfo Best-Maugard," both from the Thomas Wilfred

Papers, Manuscripts, and Archives, Yale University. See also Adolfo Best-Maugard, *The Simplified Figure: Intuitional Expression* (New York: Alfred A. Knopf, 1936), especially the chapter "The New Attitude." Adam Lauder ("Digital Materialisms: Information Art in English Canada, 1910–1978" [PhD diss., University of Toronto, 2016]) reveals a similar influence of Bergson's ideas on Best-Maugard in the artist's earlier book *A Method for Creative Design* (New York: Alfread A. Knopf, 1926).

44. Henri Bergson, "An Extract from Bergson," *Camera Work* 36 (October 1911): 20–21; Bergson, "What is the Object of Art?" *Camera Work* 37 (January 1912): 22–26.

45. Bragdon, *Four-Dimensional Vistas*, 125.

46. For a primer on this secondary literature and criticism, see Gaston Bachelard, *The Dialectic of Duration*, trans. Mary McAllester Jones (Manchester: Clinamen, 2000); Jimena Canales, "Einstein, Bergson, and the Experiment that Failed: Intellectual Co-operation at the League of Nations," *MLN* 120, no. 5 (2005): 1168–91; Elizabeth Grosz, "Deleuze, Bergson and the Concept of Life," *Revue internationale de philosophie* 3, no. 241 (2007): 287–300; Mark B. N. Hansen, *Bodies in Code: Interfaces with Digital Media* (London: Routledge, 2006); Hansen, *New Philosophy for New Media* (Cambridge, Mass.: MIT Press, 2004); Eugene Thacker, *Biomedia* (Minneapolis: University of Minnesota Press, 2004).

47. Henri Bergson, *An Introduction to Metaphysics*, trans. T. E. Hulme (1912) (Indianapolis: Hackett, 1999), 24.

48. Bergson, 46.

49. Henri Bergson, *Time and Free Will: An Essay on the Immediate Data of Consciousness*, trans. F. L. Pogson (1913) (Mineola: Dover, 2001), 91.

50. Bergson, 126.

51. Bergson, *Introduction to Metaphysics*, 46.

52. Bergson, *Creative Evolution* 306.

53. Bergson, 306.

54. Bergson, *Introduction to Metaphysics*, 21.

55. Bergson, 25.

56. Bergson, 21–22.

57. Gilles Deleuze, *Bergsonism*, trans. Hugh Tomlinson and Barbara Habberjam (New York: Zone Books, 1991), 27.

58. Bergson, *Introduction to Metaphysics*, 51.

59. See: Henri Bergson, *Matter and Memory*, trans. N. M. Paul and W. S. Palmer (New York: Zone Books, 1991), 49; Bergson, *Time and Free Will*, 126.

60. Henri Bergson, *Laughter: An Essay on the Meaning of the Comic* (1911), trans. Cloudesley Brereton and Fred Rothwell (Mineola, N.Y: Dover, 2005), 74.

61. Bergson, 76–77.

62. Bragdon, *Four-Dimensional Vistas*, 112.

63. Claude Bragdon, *Architecture and Democracy* (New York: Alfred A. Knopf, 1918), 129.

64. Bragdon, 140.

65. For more on the relation of this illusion to film movement in works like *2001: A Space Odyssey* (1968), see Scott Richmond, *Cinema's Bodily Illusions: Flying, Floating, and Hallucinating* (Minneapolis: University of Minnesota Press, 2016), 55.

66. Sheldon Cheney, *A Primer of Modern Art* (1924), 14th ed. (New York: Liveright, 1966), 180.

67. Henderson, "Mysticism, Romanticism, and the Fourth Dimension," 221.

68. Thomas Wilfred, "First Lecture," 7, Thomas Wilfred Papers, Manuscripts, and Archives, Yale University.

69. Wilfred, "Composing in the Art of Lumia," 90.

70. Wilfred, "Light and the Artist," 247, and Wilfred, "Composing in the Art of Lumia," 90.

71. Stark Young, "The Color Organ," *Theatre Arts Magazine* 6, no. 1 (1922): 20–21.

72. See, e.g.: Walter Benjamin, "Experience and Poverty" (1933), trans. Rodney Livingstone, in *Selected Writings*, vol. 2, *1927–1934*, ed. Michael W. Jennings, Howard Eiland, and Gary Smith (Cambridge, Mass.: Belknap, 1999), 731–36; Benjamin, "Mickey Mouse" (1931), trans. Rodney Livingstone, in *Selected Writings*, 2:545–546; Benjamin, "The Work of Art in the Age of its Technological Reproducibility: Second Version" (1936), trans. Edmund Jephcott and Harry Zohn, in *Selected Writings*, vol. 3, *1935–1938*, ed. Howard Eiland and Michael W. Jennings (Cambridge, MA: Belknap, 2002), 101–33; Sergei Eisenstein, *Eisenstein on Disney*, ed. Jay Leyda, trans. Alan Upchurch (London: Methuen, 1988).

73. Eisenstein, *Eisenstein on Disney*, 24, 46.

74. Eisenstein, 47.

75. Walter Benjamin, "A Child's View of Color" (1914–1915), trans. Rodney Livingstone, in *Selected Writings*, vol. 1, *1913–1926*, ed. Marcus Bullock and Michael W. Jennings (Cambridge, Mass.: Belknap, 1996), 50.

76. Walter Benjamin, "A Glimpse into the World of Children's Books" (1926), trans. Rodney Livingstone, in *Selected Writings*, 1:443.

77. Benjamin, "Child's View of Color," 51.

78. For more on Benjamin's explorations of color, see Esther Leslie, *Hollywood Flatlands: Animation, Critical Theory and the Avant-Garde* (London: Verso, 2002), 263–78.

79. Greenewalt, *Nourathar*, 45.

80. Wilfred, "Light and the Artist," 253.

81. Rudolf Steiner, *Nature's Open Secret: Introductions to Goethe's Scientific Writings*, trans. John Barnes and Mado Spiegler (Great Barrington, Mass.: Anthroposophic, 2000), 44.

82. Goethe, *Theory of Colours*, xxxvii–viii.

83. Jonathan Crary, *Techniques of the Observer: On Vision and Modernity in the Nineteenth Century* (Cambridge, Mass.: MIT Press, 1990), 69.

84. Sir Isaac Newton, *Opticks: Or a Treatise of the Reflections, Refractions, Inflections & Colours of Light-Based on the Fourth Edition London, 1730* (1730; repr. Mineola, N.Y: Dover, 2012).

85. Goethe, *Theory of Colours*, 16–17.

86. Crary, *Techniques of the Observer*, 98.

87. See Wilfred note "Bibliography of Writings by Others on Light Art," Thomas Wilfred Papers, Manuscripts, and Archives, Yale University.

88. Arthur Schopenhauer, *On Vision and Colors*, trans. Georg Stahl (Princeton, N.J.: Princeton Architectural Press, 2012), 57. See also, Schopenhauer, *The World as Will and Representation*, vol. 2, trans. E. F. J. Payne, rev. ed. (New York: Dover, 1966), 22.

89. Edwin H. Land, "Experiments in Color Vision," *Scientific American*, May 1959, 84–99. See also Land, "The Retinex Theory of Color Vision," *Scientific American*, December 1977, 108–30.

90. Neil Ribe and Friedrich Steinle, "Exploratory Experimentation: Goethe, Land, and Color Theory," *Physics Today* 55, no.7 (2002): 47.

91. Ludwig Wittgenstein, *Remarks on Color*, ed. G. E. M. Anscombe (Berkeley: University of California Press, 1977), 9e.

92. Maurice Merleau-Ponty, *Phenomenology of Perception*, trans. Colin Smith (New York: Routledge, 2002), 248–49.

93. See Thomas Wilfred, "Psychology of Sight," Thomas Wilfred Papers, Manuscripts, and Archives, Yale University.

94. Wilfred, "First Lecture," 6.

95. Thomas Wilfred, "Musings on the Spheres," Thomas Wilfred Papers, Manuscripts, and Archives, Yale University.

3. INTERVAL

1. Robert Breer, "A Statement" (April 1959), *Film Culture* 29 (1963): 73, repr. in Robert Russett and Cecile Starr, *Experimental Animation: Origins of a New Art*, 2nd ed. (New York: De Capo: 1988), 134.

2. Scott MacDonald, "Robert Breer," in *A Critical Cinema 2: Interviews with Independent Filmmakers* (Berkeley: University of California Press, 1992), 25. Additionally, Breer came across the *Merz* pieces in the first postwar exhibition of Schwitters work (Mendelson, *Robert Breer,* 111n3).

3. Breer, "Statement," 135.

4. Norman McLaren, "The Definition of Animation: A Letter from Norman McLaren," *Animation Journal* 3, no. 2 (1995): 62.

5. Guy Coté, "Interview with Robert Breer," *Film Culture* 27 (Winter 1962–1963): 17–20, repr. in Russett and Starr, *Experimental Animation*, 134.

6. Jonas Mekas, "On the Expanding Eye" (February 6, 1964), in *Movie Journal: The Rise of the New American Cinema 1959–1971*, ed. Gregory Smulewicz-Zucker (New York: Macmillan, 1972), 119.

7. See Gene Youngblood, *Expanded Cinema* (New York: E. P. Dutton, 1970).

8. Mekas, "On the Expanding Eye," 118.

9. Viktor Shklovsky, "Art as Technique," in *Russian Formalist Criticism: Four Essays*, trans. Lee T. Lemon and Marion J. Reis (Lincoln: University of Nebraska Press, 1965), 12. See also P. Adams Sitney, "Structural Film," *Film Culture* 47 (Summer 1969), repr. in *Film Culture Reader*, ed. P. Adams Sitney (New York: Praeger, 1970), 326–48.

10. Coté, "Interview with Robert Breer," 134.

11. Robert Breer, *Light Cone* catalog supplement, September 1998, 5 (cited in Jennifer L. Burford, *Robert Breer* (Paris: Éditions Paris Expérimental and RE:Voir Éditions, 1999], 125).

12. See William C. Seitz, *The Art of Assemblage* (New York: Museum of Modern Art, 1961), and Richard Shattuck, transcript of introduction and discussion with Joseph Ruzicka in "The Art of Assemblage: A Symposium (1961)," in *Essays on Assemblage*, ed. John Elderfield (New York: Museum of Modern Art, 1992).

13. See: Benjamin H. D. Buchloh, *Neo-Avantgarde and Culture Industry: Essays on European and American Art from 1955 to 1975* (Cambridge, Mass.: MIT Press, 2000); Hal Foster, "Who's Afraid of the Neo-Avant-Garde?" in *The Return of the Real* (Cambridge,

Mass.: MIT Press, 1996), 1–33; Branden W. Joseph, *Random Order: Robert Rauschenberg and the Neo-Avant-Garde* (Cambridge, Mass.: MIT Press, 2003).

14. Yann Beauvais, Interview with Robert Breer on November 15, 1983, in *Robert Breer: Films, Floats & Panoramas*, ed. Brigitte Liabeuf and Nathalie Roux (Montreuil: Oiel, 2006), 161.

15. Calvin Tomkins, *The Bride and the Bachelors: Five Masters of the Avant-Garde* (New York: Viking, 1965), 150.

16. Beauvais, Interview with Robert Breer, 160.

17. See Rosalind E. Krauss, *The Optical Unconscious* (Cambridge, Mass.: MIT Press, 1993), 108–25.

18. Robert Breer, "Interview," *The American Film Institute Report* 5, no. 2 (Summer 1974), repr. in Russett and Starr, *Experimental Animation*, 135.

19. Laura Hoptman, "Breer in the World: From Then 'Til Now," in Liabeuf and Roux, *Robert Breer*, 29.

20. Marcel Duchamp, *The Writings of Marcel Duchamp*, ed. Michael Sanouillet and Elmer Peterson (New York: Da Capo, 1989), 194.

21. Marcel Duchamp, *Notes*, trans. Paul Matisse (Boston: G. K. Hall, 1983), no. 7.

22. Robert Breer, "Letter from Robert Breer to Jonas Mekas, 5/25/70," *Film Culture* 56–57 (Spring, 1973): 70.

23. Sergei Eisenstein, "A Dialectic Approach to Film Form," in *Film Form: Essays in Film Theory*, ed. and trans. Jay Leyda (New York: Harcourt Brace, 1949), 56.

24. Edward S. Small and Eugene Levinson, "Toward a Theory of Animation," *Velvet Light Trap* 24 (Fall 1989): 69.

25. Standish Lawder, *The Cubist Cinema* (New York: New York University Press, 1975), 163.

26. Fernand Léger, "Ballet Mécanique," in *Functions of Painting*, ed. Edward F. Fry, trans. Alexandra Anderson (New York: Viking, 1973), 50.

27. Small and Levinson, "Toward a Theory of Animation," 73.

28. Coté, "Interview with Robert Breer," 133.

29. Peter Bürger, *Theory of the Avant-Garde* (Minneapolis: University of Minnesota Press, 1984), 34.

30. Bürger, 58.

31. Benjamin H. D. Buchloh, "Allegorical Procedures: Appropriation and Montage in Contemporary Art," *Artforum* 21.1 (September, 1982): 43–56.

32. Walter Benjamin, "The Work of Art in the Age of its Technological Reproducibility: Third Version" (1939), in *Selected Writings*, vol. 4, *1938–1940*, ed. Howard Eiland and Michael W. Jennings, trans. Edmund Jephcott et al. (Cambridge, Mass.: Belknap, 2003), 267.

33. Bürger, *Theory of the Avant-Garde*, 72.

34. Bürger, 94.

35. Foster, "Who's Afraid of the Neo-Avant-Garde?" 234.

36. Benjamin H. D. Buchloh, "Michael Asher and the Conclusion of Modernist Sculpture," in *Neo-Avantgarde and Culture Industry*, 9.

37. Foster, "Who's Afraid of the Neo-Avant-Garde?" 29.

38. Benjamin H. D. Buchloh, "Introduction," in *Neo-Avantgarde and Culture Industry*, xxv.

39. John Cage, "History of Experimental Music in the United States" (1959), in *Silence: Lectures and Writings* (Middletown: Wesleyan University Press, 1961), 69–70.

40. Joseph, *Random Order*, 157.

41. Dziga Vertov, "WE: Variant of a Manifesto," in *Kino-Eye: The Writings of Dziga Vertov*, ed. Annette Michelson, trans. Kevin O'Brien (Berkeley: University of California Press, 1984), 8.

42. This difference is actually quite pronounced, though it is not the subject of this work. I wish here to simply point to an emphasis on montage that each filmmaker articulates in their writings and films. For more on the debates and animosities between these filmmakers, see Yuri Tsivian, "Introduction: Dziga Vertov and His Time," in *Lines of Resistance: Dziga Vertov and the Twenties*, ed. Yuri Tsivian (Gemona: La Giornate del Cinema Muto, 2004), 5–8, as well as the section of the book dedicated to primary documents illustrating these disagreements, "Vertov Versus Eisenstein" (125–56).

43. See Sergei Eisenstein, "The Cinematographic Principle and the Ideogram," in *Film Form*, 28–44, and Eisenstein, "Dialectic Approach," 57.

44. Sergei Eisenstein, "The Problem of the Materialist Approach to Form," in *The Eisenstein Reader*, ed. Richard Taylor, trans. Richard Taylor and William Powell (London: British Film Institute, 1998), 56.

45. Jacques Rancière, *Film Fables*, trans. Emiliano Battista (Oxford: Berg, 2006), 24.

46. Jacques Rancière, *The Future of the Image*, trans. Gregory Elliott (London: Verso, 2007), 12.

47. Rancière, 17.

48. Fulvia Carnevale and John Kelsey, "Art of the Possible: An Interview with Jacques Rancière," *Art Forum* 45, no. 7 (2007): 259.

49. Carnevale and Kelsey, 263. See also Jacques Rancière, *The Politics of Aesthetics*, trans. Gabriel Rockhill (London: Continuum, 2004), 27.

50. Rancière, *Film Fables*, 8–11.

51. For more on this performance and Breer's relationship with Stockhausen, see Carlos Kase, "A Cinema of Anxiety: American Experimental Film in the Realm of Art (1965–1975)" (PhD diss., University of Southern California, 2009).

52. Scott McCloud, *Understanding Comics: The Invisible Art* (Northampton, Mass.: Tundra, 1993), 114.

53. I discovered evidence of this technique while examining the filmstrip at Anthology Film Archives in New York City.

54. For an introduction to work on Villeglé and Hains see: Benjamin H. D. Buchloh, "Villeglé: From Fragment to Detail," in *Neo-Avantgarde and Culture Industry*, 443–60; Tom McDonough, "Raymond Hains's 'France in Shreds' and the Politics of *Décollage*," *Representations* 90 (Spring 2005): 75–97; François Bon and Nicolas Bourriaud, *Villeglé: Jacques Villeglé*, trans. Deke Dusinberre (Paris: Flammarion, 2007).

55. Donald Crafton, "Animation Iconography: The 'Hand of the Artist,'" *Quarterly Review of Film Studies* (Fall 1979): 413–14.

56. Peter Kubelka, "The Theory of Metrical Film," in *The Avant-Garde Film: A Reader of Theory and Criticism*, ed. P. Adams Sitney (New York: New York University Press, 1978), 140.

57. Kubelka, 141.

58. See Sergei Eisenstein, "The Structure of the Film," in *Film Form*, 166–67, 172–73.

59. Kubelka, "Theory of Metrical Film,"158.

60. Kubelka, 156.

61. When describing how *Schwechater* is constructed, Sitney explains: "The intercutting between black and images follows a repetitive pattern of one frame of black, one of an image, two black, two image, four black, four image, eight black, eight image, sixteen black, sixteen image; then it begins again with one black frame, etc." Furthermore, of the four sets of images Kubelka uses in the film, if he wishes to use a part of a shot from the first group: "He must use that number corresponding to what its place would be in the film if the film were a simple loop. For instance, he can use the thirtieth frame from (a) as the thirtieth, sixtieth, ninetieth, etc., frame of his film. He can use the last frame of (b) as the ninetieth, 180th, etc." See P. Adams Sitney, *Visionary Film: The American Avant-Garde, 1943–2000*, 3rd ed. (Oxford: Oxford University Press, 2002), 286.

62. Robert Breer, "Robert Breer on His Work," *Film Culture* 42 (Fall 1966): 112.

63. Coté, "Interview with Robert Breer," 134.

64. Breer, "Statement," 134.

65. Breer, 135.

66. Jonas Mekas and P. Adams Sitney, "Interview with Robert Breer Conducted by Jonas Mekas and P. Adams Sitney on Mary 13, 1971—In New York City," *Film Culture* 56–57 (Spring 1973): 42.

67. Sitney, *Visionary Film*, 348.

68. Sitney, "Structural Film," 327.

69. Sitney, 343.

70. Sitney, *Visionary Film*, 285.

71. See: George Maciunas, "Some Comments on Structural Film by P. Adams Sitney," *Film Culture* 47 (1969), repr. in Sitney, *Film Culture Reader*, 349; Malcom LeGrice, "On The Flicker," in *Structural Film Anthology*, ed. Peter Gidal (London: British Film Institute, 1976), 135–36.

72. Quoted in Branden W. Joseph, *Beyond the Dream Syndicate: Tony Conrad and the Arts after Cage (A "Minor" History)* (New York: Zone Books, 2008), 299.

73. Steven Shaviro, *The Universe of Things: On Speculative Realism* (Minneapolis: University of Minnesota Press, 2014), 54.

74. Robert Breer, "Untitled," in Liabeuf and Roux, *Robert Breer*, 62.

75. Coté, "Interview with Robert Breer," 134.

76. Bergson, *Matter and Memory*, 33.

77. Bergson, 34.

78. See Gilles Deleuze, *Cinema 1: The Movement-Image*, trans. Hugh Tomlinson and Barbara Habberjam (Minneapolis: University of Minnesota Press, 1986), 14, 23, 58–59. In *Cinema 2*, Deleuze argues that cinema "spreads an 'experimental night' or white space over us; it works with 'dancing seeds' and a 'luminous dust'; it affects the visible with a fundamental disturbance, and the world with a suspension, which contradicts all natural perception." See Gilles Deleuze, *Cinema 2: The Time-Image*, trans. Hugh Tomlinson and Robert Galeta (Minneapolis: University of Minnesota Press, 1989), 201.

79. Deleuze, *Cinema 1*, 74.

80. Deleuze, 83.

81. Deleuze, 230.

82. Deleuze, 85.

83. Deleuze, *Cinema 2*, 47, 82.

84. Deleuze, 181.

85. Deleuze, 215.

86. Mekas and Sitney, "Interview with Robert Breer," 49–50.

87. Beauvais, "Interview with Robert Breer," 162.

88. John Cage, "Composition as Process: Indeterminacy" (1958), in *Silence: Lectures and Writings by John Cage* (Hanover, N.H.: Wesleyan University Press, 1973), 38.

89. Joseph, *Beyond the Dream Syndicate*, 77.

90. Andrew V. Uroskie, *Between the Black Box and the White Cube* (Chicago: University of Chicago Press, 2014), 108.

4. PROJECTION

1. For more on this early history of television and technologies, see: Albert Abramson, *The History of Television, 1880 to 1941* (London: McFarlend, 1987); Russel W. Burns, *Television: An International History of the Formative Years* (London: Institution of Electrical Engineers, 1998); Doron Galili, *Seeing by Electricity: The Emergence of Television, 1878–1939* (Durham, N.C.: Duke University Press, 2020); William Urrichio, "Television's First Seventy-Five Years: The Interpretative Flexibility of a Medium in Transition," in *The Oxford Handbook of Film and Media Studies*, ed. Robert Kolker (Oxford: Oxford University Press, 2008), 286–305.

2. "Expanding Cinema's Synchromy 2," *Literary Digest*, August 8, 1936; Mary Ellen Bute, "Light, Form, Movement, Sound," *Design* 42, no. 8 (1941): 25.

3. See Joseph Schillinger, *The Mathematical Basis of the Arts* (New York: Philosophical Library, 1948).

4. Joseph Schillinger, "Excerpts from a Theory of Synchronization," *Experimental Cinema*, no. 5 (February 1934), 30.

5. William Moritz, "Mary Ellen Bute: Seeing Sound," *Animation World Magazine* 1, no. 2 (1996): 29–32.

6. Mary Ellen Bute, "Light as an Art Material and Its Possible Synchronization with Sound," unpublished lecture dated January 30, 1932, Mary Ellen Bute Papers, Manuscripts and, Archives, Yale University.

7. For more on Hans Richter's theories of abstraction as a universal language, see R. Bruce Elder, *Harmony and Dissent: Film and Avant-garde Art Movements in the Early Twentieth Century* (Waterloo: Wilfred Laurier University Press, 2008), 125–49; *Hans Richter: Activism, Modernism, and the Avant-Garde*, ed. Stephen C. Foster (Cambridge, Mass.: MIT Press, 1998); Hans Richter, *Hans Richter by Hans Richter*, ed. Cleve Gray (New York: Holt, Rinehart, and Winston, 1971); Malcom Turvey, "Dada Between Heaven and Hell: Abstraction and Universal Language in the *Rhythm* Films of Hans Richter," *October* 105 (Summer 2003): 13–36.

8. Michael Cowan, "Absolute Advertising: Walter Ruttmann and the Weimar Advertising Film," *Cinema Journal* 52, no. 4 (2013): 67, (emphasis original).

9. Walter Ruttmann, "Art and the Cinema" (1913–1917), in *The German Avant-Garde Film of the 1920s*, ed. A. Leitner and U. Nitschke, trans. J. Roth, S. Praeder, and T. Schwartzberg (Munich: Goethe-Institut, 1989), 6.

10. See Gene Youngblood, *Expanded Cinema* (New York: E. P. Dutton, 1970).

11. *Literary Digest* , "Expanding Cinema's Synchromy 2."

12. See Norbert Wiener, *Cybernetics: Or the Control and Communication in the Animal and Machine,* 2nd ed. (Cambridge, Mass.: MIT Press, 1961).

13. Peter Galison, "The Ontology of the Enemy: Norbert Wiener and the Cybernetic Vision," *Critical Inquiry* 21, no. 1 (1994): 229.

14. Galison, 246.

15. Norbert Wiener, *The Human Use of Human Beings: Cybernetics and Society* (London: Free Association Books, 1989), 96.

16. N. Katherine Hayles, *How We Became Posthuman: Virtual Bodies in Cybernetics, Literature, and Informatics* (Chicago: University of Chicago Press, 1999), 56.

17. Wiener, *Cybernetics,* 132.

18. Hayles, *How We Became Posthuman,* 56.

19. Hayles, 57.

20. Claude E. Shannon and Warren Weaver, *The Mathematical Theory of Communication* (Urbana: University of Illinois Press, 1964), 8.

21. Shannon and Weaver, 9.

22. Shannon and Weaver, 25.

23. Shannon and Weaver, 31.

24. Arturo Rosenblueth, Norbert Wiener, and Julian Bigelow, "Behavior, Purpose and Teleology," *Philosophy of Science* 10, no. 1 (1943): 18.

25. Rosenbleuth, Wiener, and Bigelow, 22.

26. Jonathan Sterne, *MP3: The Meaning of a Format* (Durham, N.C.: Duke University Press, 2012), 78–79.

27. Sterne, 82–83.

28. R. V. L. Hartley, "Transmission of Information." *Bell System Technical Journal* 7, no. 3 (1928): 542 and 536.

29. Wiener, *Cybernetics,* 137.

30. Wiener, 136.

31. Wiener, 136.

32. Wiener, 139.

33. For more on this relation, especially with touch and hearing, see Mara Mills, "On Disability and Cybernetics: Helen Keller, Norbert Wiener, and the Hearing Glove," *differences: A Journal of Feminist Cultural Studies* 22, no. 2–3 (2011): 74–111. Mills shows how the hearing glove indexes an attention to materiality and embodiment in cybernetics from this time that is often overlooked, since it aided in the understanding of sensation as physical signals relayed to various destinations. Even within this model, I believe that there is a still an emphasis on abstracting these signals as they lead to different perceptual systems.

34. Wiener, *Cybernetics,* 141.

35. Thomas Y. Levin, "'Tones from out of Nowhere': Rudolph Pfenninger and the Archaeology of Synthetic Sound," *Grey Room* 12 (Summer 2003): 37–79. For more on the history of the development and industrial diffusion of sound technology such as Tri-Ergon and Movietone, see Douglas Gomery, *The Coming of Sound: A History* (New York: Routledge, 2005), 87–114.

36. "Synthetic Speech Demonstrated in London; Engineer Creates Voice Which Never Existed," *New York Times,* February 16, 1931, 2.

37. See especially Lázló Moholy-Nagy, "Production—Reproduction" (1922), in *Moholy-Nagy*, ed. Krisztina Passuth (London: Thames and Hudson, 1987), 289–90.

38. Levin, "'Tones,'" 48.

39. Norman McLaren, "Animated Sound on Film" (1950), repr. in Robert Russett and Cecile Starr, *Experimental Animation: Origins of a New Art*, 2nd ed. (New York: De Capo: 1988), 166.

40. McLaren, 168.

41. Quoted in Levin, "'Tones,'" 58.

42. Levin, 58.

43. James Lastra, *Sound Technology and the American Cinema: Perception, Representation, Modernity* (New York: Columbia University Press, 2000), 85.

44. William Henry Fox Talbot, *The Pencil of Nature* (London: Longman, Brown, Green, and Longmans, 1844).

45. Levin, "'Tones,'" 53.

46. Cited in Levin, 58.

47. John Whitney, "Moving Pictures and Electronic Pictures" (1959), in *Digital Harmony: On the Complementarity of Music and Visual Art* (Peterborough: Byte Books / McGraw-Hill, 1980), 153.

48. John Whitney, 155.

49. For more on the history of color and its relationship with specific notes, see John Gage, *Colour and Culture: Practice and Meaning from Antiquity to Abstraction* (Berkeley: University of California Press, 1999).

50. Galili, *Seeing by Electricity*, 56.

51. See René Descartes, *Discourse on Method, Optics, Geometry, and Meteorology*, trans. Paul J. Olscamp, rev. ed. (Indianapolis, Ind.: Hackett, 2001); for more on the reciprocal history of image technologies and contemporaneous understandings of vision see Jonathan Crary, *Techniques of the Observer: On Vision and Modernity in the Nineteenth Century* (Cambridge, Mass.: MIT Press, 1990).

52. Burns, *Television*, 41. Galili also describes this technology and the cultural fantasies that brought it into being and that followed in its wake (Galili, *Seeing by Electricity*, 60).

53. John Durham Peters, "Helmholtz, Edison, and Sound History," in *Memory Bytes: History, Technology, and Digital Culture*, ed. Lauren Rabinovitz and Abraham Geil (Durham, N.C.: Duke University Press, 2004), 178.

54. Timothy Lenoir, "Helmholtz and the Materialities of Communication," *Osiris* 9 (1994): 186.

55. Quoted in Lenoir, 207.

56. Abramson, *History of Television*, 15.

57. Ben F. Laposky, "Oscillons: Electronic Abstractions," *Leonardo* 2, no. 4 (1969): 345.

58. Laposky, 348.

59. Laposky, 352.

60. Laposky, 353, and Ben F. Laposky, *Electronic Abstractions* exhibition catalog (Cherokee, Iowa: Sanford Museum, 1953), 15 (vasulka.org/archive/Artists3/Laposky,BenF/ElectronicAbstractions.pdf).

61. Laposky, *Electronic Abstractions*, 15.

62. Ben F. Laposky, "Electronic Abstractions," *Scripta Mathematica* 18, no. 3–4 (1952): 314.

63. See Arthur Korn, "Some Mathematical Problems in Early Telegraphic Transmission of Pictures," *Scripta Mathematica* 8, no. 2 (1941): 93–98.

64. Mary Ellen Bute, "New Music for New Films" *Film Music* 12, no. 4 (1953): 17.

65. Schillinger, "Excerpts," 30.

66. Joseph Schillinger, "Graph Notation of the Rondo of Beethoven's Pathetique," Joseph Schillinger papers, Smithsonian Archives of American Art.

67. Bute, "New Music," 16.

68. S. S. Stevens, "On the Theory of Scales of Measurement," *Science* 103, no. 2684 (1946): 677.

69. S. S. Stevens, "On the Psychological Law," *The Psychological Review* 64, no. 3 (1957): 153–81.

70. Stevens, "On the Theory of Scales of Measurement," 677. See also Stevens's book coauthored with Hallowell Davis, *Hearing: Its Psychology and Physiology* (New York: John Wiley and Sons, 1938).

71. Mary Ellen Bute, "Abstronics: An Experimental Filmaker Photographs the Esthetics of the Oscillograph," *Films in Review* 5, no. 6 (1954), centerforvisualmusic.org/ABSTRONICS.pdf.

72. Bute, "Abstronics."

73. Mary Ellen Bute, "Abstract Films," unpublished essay, Mary Ellen Bute Papers, Manuscripts and, Archives, Yale University, 6.

74. Bute, "Abstronics."

75. For more on the history of analog computing, see: Charles J. Bashe, Lyle R. Johnson, John H. Palmer, and Emerson W. Pugh, *IBM's Early Computers* (Cambridge, Mass.: MIT, 1986), 1–33; Martin Campbell-Kelly and William Aspray, *Computer: A History of the Information Machine* (New York: Basic, 1996); *IEEE Control Systems* 25, no. 3 [special issue: *The History of Analog Computing*] (2005).

76. See: Julie A. Turnock, *Plastic Reality: Special Effects, Technology, and the Emergence of 1970s Blockbuster Aesthetics* (New York: Columbia University Press, 2015); John Whitney, "Animation Mechanisms" (1971), in *Digital Harmony: On the Complementarity of Music and Visual Art* (Peterborough: Byte Books / McGraw-Hill, 1980), 187–88.

77. John Whitney, "John Whitney at Cal Tech" (1968), in *Digital Harmony: On the Complementarity of Music and Visual Art* (Peterborough: Byte Books / McGraw-Hill, 1980), 171. See also John Whitney, "Cam Essay," Whitney Files, Academy of Motion Pictures Arts and Sciences.

78. John Whitney Jr. interview with present author, Andrew R. Johnston, on July 24, 2010.

79. See Ivan Edward Sutherland, "Sketchpad: A Man-Machine Graphical Communication System" (PhD Diss., MIT, 1963).

5. CODE

1. See: John Whitney, "Moving Pictures and Electronic Pictures" (1959), repr. in part 2 of *Digital Harmony: On the Complementarity of Music and Visual Art* (Peterborough: Byte Books / McGraw-Hill, 1980), 155; John Whitney, "John Whitney at CalTech" (1968), repr. in part 2 of *Digital Harmony*, 171.

2. John Whitney, "Narration to *Experiments in Motion Graphics*," Whitney Files, Academy of Motion Pictures Arts and Sciences.

3. J. Citron and John H. Whitney, "Camp—Computer Assisted Movie Production," *AFIPS (American Federation of Information Processing Societies) Conference Proceedings* 33, no. 2 (1968 [Fall Joint Computer Conference]): 1299–305.

4. John Whitney, "Southern California Computer Society Lecture," handwritten notes, Whitney Files, Academy of Motion Pictures Arts and Sciences; Whitney, "ASID Talk and Belgian Competition" (1963), repr. in part 2 of *Digital Harmony*, 158–61.

5. Whitney, "Moving Pictures and Electronic Pictures," 155.

6. Piet Mondrian, "Plastic Art and Pure Plastic Art" (1937), in *Art in Theory, 1900–2000: An Anthology of Changing Ideas*, ed. Charles Harrison and Paul Wood (Oxford: Blackwell, 2003), 390.

7. John Whitney, "Audio-Visual Music and Program Notes" (1946), repr. in part 2 of *Digital Harmony*, 147.

8. Whitney, "Southern California Computer Society Lecture."

9. Whitney, "ASID Talk and Belgian Competition," 160.

10. John Whitney, *Digital Harmony*, 24 (part 1).

11. D. N. Rodowick, *The Virtual Life of Film* (Cambridge, Mass.: Harvard University Press, 2007), 10. See also Philip Rosen, *Change Mummified: Cinema, Historicity, Theory* (Minneapolis: University of Minnesota Press, 2001), 301–49, and Mary Ann Doane, "The Indexical and the Concept of Medium Specificity," *differences: A Journal of Feminist Cultural Studies* 18, no. 1 (2007): 128–52.

12. Rodowick, *Virtual Life of Film*, 116.

13. See "Tom Gunning, "Moving Away from the Index: Cinema and the Impression of Reality," *differences: A Journal of Feminist Cultural Studies* 18, no. 1 (2007): 29–52, and Julie A. Turnock, *Plastic Reality: Special Effects, Technology, and the Emergence of 1970s Blockbuster Aesthetics* (New York: Columbia University Press, 2015).

14. This has generated confusions around Whitney's films in particular with critics associating the look of his films with their technical makeup (Rodowick, *Virtual Life of Film*, 132). That said, the focus on aesthetic and affective responses to images that seem different technologically can be fruitful in analyzing shifting cultural attitudes and social responses to media environments, which Rodowick attempts to trace. Others like Steven Shaviro also work through this dynamic and the expression of technical images in contemporary culture (*Post-Cinematic Affect* [Ropley, U.K.: Zero, 2010]).

15. Nick Montfort, "Continuous Paper: The Early Materiality and Workings of Electronic Literature" (paper presented Modern Language Association Conference, Philadelphia, December 2004, nickm.com/writing/essays/continuous_paper_mla.html).

16. Matthew G. Kirschenbaum, *Mechanisms: New Media and the Forensic Imagination* (Cambridge, Mass.: MIT Press, 2008), 36, 39.

17. Paul Young, for instance, examines how film imagines other kinds of media and technological forms in a very compelling manner (*The Cinema Dreams its Rivals: Media Fantasy from Radio to the Internet* [Minneapolis: University of Minnesota Press, 2006]).

18. Dudley Andrew, *What Cinema Is!: Bazin's Quest and its Charge* (Chichester, U.K.: Wiley-Blackwell, 2010), 42.

19. Andrew, 5.

20. Andrew, 4.

21. For primers and introductions to this area, see: Orit Halpern, *Beautiful Data: A History of Vision and Reason since 1945* (Durham, N.C.: Duke University Press, 2015);

Tung-Hui Hu, *A Prehistory of the Cloud* (Cambridge, Mass.: MIT Press, 2015); Nicole Starosielski, *The Undersea Network* (Durham, N.C.: Duke University Press, 2015); Shannon Mattern, *Code and Clay, Data and Dirt: Five Thousand Years of Urban Media* (Minneapolis: University of Minnesota Press, 2017); Aubrey Anable, *Playing with Feelings: Video Games and Affect* (Minneapolis: University of Minnesota Press, 2018); Safiya Umoja Noble, *Algorithms of Oppression: How Search Engines Reinforce Racism* (New York: New York University Press, 2018); Grant Bollmer, *Materialist Media Theory: An Introduction* (London: Bloomsbury Academic, 2019).

22. For an introduction see: *Software Studies: A Lexicon*, ed. Matthew Fuller (Cambridge, Mass.: MIT Press, 2008); N. Katherine Hayles, *Electronic Literature: New Horizons for the Literary* (Notre Dame, Ind.: University of Notre Dame Press, 2008); Hayles, *My Mother Was a Computer: Digital Subjects and Literary Texts* (Chicago: University of Chicago Press, 2005).

23. Alex Galloway, *Protocol: How Control Exists after Decentralization* (Cambridge, Mass.: MIT Press, 2004), 165.

24. N. Katherine Hayles, "Traumas of Code," *Critical Inquiry* 33 (Autumn 2006): 136.

25. Nick Montfort and Ian Bogost, *Racing the Beam: The Atari Video Computer System* (Cambridge, Mass.: MIT Press, 2009), 3.

26. Kirschenbaum, *Mechanisms*, 59, 61.

27. Kirschenbaum, 9.

28. Kirschenbaum, 70.

29. Friedrich Kittler, "There is No Software," CTHEORY, October 18, 1995, ctheory.net /articles.aspx?id=74.

30. Zabet Patterson, *Peripheral Vision: Bell Labs, the S-C 4020, and the Origins of Computer Art* (Cambridge, Mass.: MIT Press, 2015); Jacob Gaboury, "Hidden Surface Problems: On the Digital Image as Material Object," *Journal of Visual Culture* 14, no. 1 (2015): 40–60; Gaboury, *Image Objects* (Cambridge, Mass.: MIT Press, forthcoming).

31. Mark B. N. Hansen, *Feed Forward: On the Future of Twenty-First Century Media* (Chicago: University of Chicago Press, 2016), 53.

32. Mary Ann Doane, *The Emergence of Cinematic Time: Modernity, Contingency, the Archive* (Cambridge, Mass.: Harvard University Press, 2002), 47.

33. Marta Braun, *Picturing Time: The Work of Étienne-Jules Marey (1830–1904)* (Chicago: University of Chicago Press, 1995), 174.

34. Joel Snyder, "Visualization and Visibility," in *Picturing Science, Producing Art*, ed. Caroline A. Jones and Peter Galison (New York and London: Routledge, 1998), 380–81.

35. Hansen, *Feed-Forward*, 55.

36. Braun, *Picturing Time*, 174.

37. Hollis Frampton, "Eadweard Muybridge: Fragments of a Tesseract," in *On the Camera Arts and Consecutive Matters: The Writings of Hollis Frampton*, ed. Bruce Jenkins (Cambridge, Mass.: MIT Press), 22–32.

38. Braun, *Picturing Time*, 238.

39. Kenneth C. Knowlton, "A Computer Technique for Producing Animated Movies," *AFIPS (American Federation of Information Processing Societies) Conference Proceedings* 25 (1964 [Spring Joint Computer Conference]): 67–87.

40. Lillian F. Schwartz, with Laurens R. Schwartz, *The Computer Artist's Handbook: Concepts, Techniques and Applications* (New York: Norton, 1992), 5.

41. Knowlton, "A Computer Technique," 69, 67.

42. Patterson, *Peripheral Vision*, 45–63.

43. Schwartz, *Computer Artist's Handbook*, 32.

44. Schwartz, 151.

45. Schwartz, 166, 169.

46. Mark B. N. Hansen, "Living (with) Technical Time: From Media Surrogacy to Distributed Cognition," *Theory, Culture & Society*, 26, no. 2–3 (2009): 298.

47. For additional context about this technological mix, see Kenneth C. Knowlton, "Computer-Generated Movies, Designs and Diagrams," *Design Quarterly*, 66/67 (1966 [*Design and the Computer*]): 58–63.

48. Jay David Bolter and Richard Grusin, *Remediation: Understanding New Media* (Cambridge, Mass.: MIT Press, 1999).

49. Friedrich Kittler, *Optical Media: Berlin Lectures 1999*, trans. Anthony Enns (Cambridge, U.K.: Polity, 2010), 148.

50. For a detailed description on this style of computing, see Martin Campbell-Kelly and William Aspray, *Computer: A History of the Information Machine* (New York: Basic, 1996), 208.

51. Ivan E. Sutherland, "Computer Graphics: Ten Unsolved Problems," *Datamation* 12, no. 5 (1966): 25.

52. Larry Cuba, interview by present author, Andrew R. Johnston, on July 27, 2010.

53. Andrew Utterson, "Early Visions of Interactivity: The In(put)s and Out(put)s of Real-Time Computing," *Leonardo* 46, no. 1 (2013): 69.

54. Utterson, 69.

55. Charles A. Csuri, "Real-Time Computer Animation," *Proceedings of the International Federation for Information Processing (IFIP) Congress 74*, ed. Jack L. Rosenfeld (Amsterdam: North-Holland Publishing, 1974), 707.

56. Charles A. Csuri, *A Software Requirement for Research and Education in the Visual Arts*, National Science Foundation Grant No. GJ-204, Interim Report (1970), The Ohio State University Archives, Charles A. Csuri Papers (40/206), 6.

57. Csuri, 2.

58. Csuri, 3

59. Paul E. Ceruzzi and Kirschenbaum both point out that the American National Standards Institute (ANSI) in 1967 employed "a 7-bit rather than an 8-bit code because it was felt that eight holes, punched across a thin piece of paper tape, would render the paper weak and vulnerable to tearing" (Kirschenbaum, *Mechanisms*, 238, and Paul E. Ceruzzi, *A History of Modern Computing* [Cambridge, Mass.: MIT Press, 1998], 152).

60. Citron and Whitney, "Camp," 1300.

61. Ivan Edward Sutherland, "Sketchpad: A Man-Machine Graphical Communication System" (PhD Diss., MIT, 1963), 22.

62. Sutherland, 130, 132.

63. John Whitney, "Motion-Control: An Overview," *American Cinematographer* 62 (December 1981): 1223.

64. John Whitney, "Aspen Design Conference" (1967), repr. in part 2 of *Digital Harmony*, 168.

65. John Whitney, *Perceptual Studies in Dynamic, Interactive Computer Graphics*, National

Science Foundation Grant Proposal, December 6, 1974, Whitney Files, Academy of Motion Pictures Arts and Sciences, 9.

66. Whitney, 3.

67. John Whitney, "Addendum," in *Perceptual Studies in Dynamic, Interactive Computer Graphics*, 3.

68. Whitney, *Digital Harmony*, 41 (part 1).

69. John Whitney, "Our Times—Our Perception of Time," Whitney Files, Academy of Motion Pictures Arts and Sciences.

70. John Whitney, "Our Times."

71. Frederick B. Thompson, "An Advanced Computer System for Social Science Research," *Proceedings of the Conference on the Validation and Distribution of Computer Software, March 30–31, 1972, Boulder, Colorado*, ed. Lloyd D. Fosdick (Boulder: University of Colorado Department of Computer Science, 1972), 2. Also see Bozena Henisz Dostert, *REL—An Information System for a Dynamic Environment, REL Project Report No. 3* (Pasadena: California Institute of Technology, 1971).

72. John Whitney, "Notes on Matrix," *Film Culture*, no. 53, 54, 55 (Spring 1972): 79–80.

73. Charles A. Csuri, *Real-Time Film Animation*, Annual Report to the National Science Foundation Office of Computing Activities, National Science Foundation Grant No. GJ-204 (1972), The Ohio State University Archives, Charles A. Csuri Papers (40/206).

74. Nick Montfort et al., *10 PRINT CHR$(205.5+RND(1)); : GOTO 10* (Cambridge, Mass.: MIT Press, 2013), 158.

75. John G. Kemeny and Thomas E. Kurtz, *Back to BASIC: The History, Corruption, and Future of the Language* (Boston: Addison-Wesley, 1985), 9, quoted in Montfort et al., *10 PRINT CHR$(205.5+RND(1)); : GOTO 10*, 164.

76. Thompson, "Advanced Computer System," 7.

77. Theodor H. Nelson, *Computer Lib/Dream Machines* (Theodor H. Nelson, 1974), DM23.

78. Many programmers were dealing with similar issues when trying to create animations on various displays in the 1970s. Montfort and Bogost detail the history of how the Atari 2600 interfaced the clock cycles of its platform and a CRT television through the development of their Television Interface Adaptor. It could render the graphic information from the Atari as fast as the "electron beam that traces each [horizontal line] by moving across and down a picture tube" (*Racing the Beam*, 4).

79. Thomas A. DeFanti, "The Digital Component of the Circle Graphics Habitat," *AFIPS (American Federation of Information Processing Societies) Conference Proceedings* 45 (June 1976): 202.

80. Csuri, "Real-Time Computer Animation," 708.

81. Larry Cuba, "The Rules of the Game," *Computer Graphics* 2, no. 8 (1979): 52–55.

82. Bernard Stiegler, *Technics and Time*, vol. 2, *Disorientation*, trans. Stephen Barker (Stanford, Calif.: Stanford University Press, 2009), 63.

83. Jonathan Sterne, *MP3: The Meaning of a Format* (Durham, N.C.: Duke University Press, 2012),

84. Nam June Paik, "Cybernated Art," in *Manifestos, Great Bear Pamphlets* (New York: Something Else Press, 1966), 24.

85. Hansen, *Feed-Forward*, 43.

CONCLUSION

1. Lewis Klahr, "A Clarification," in *The Sharpest Point: Animation at the End of Cinema*, ed. Chris Gehman and Steve Reinke (Toronto: YYZ, 2005), 234.

2. Phillipe-Allain Michaud, *Aby Warburg and the Image in Motion*, trans. Sophie Hawkes (New York: Zone, 2004), 41.

3. Klahr, "Clarification," 235.

4. Lewis Klahr, "Flotsam and Jetsam," *Animation: An Interdisciplinary Journal* 6, no. 3 (2011): 393.

5. Marc Woodworth, "A Correspondence with Lewis Klahr," in *Bee Thousand* (New York: Continuum, 2006), 38.

6. Klahr, "Clarification," 234.

7. Marshall McLuhan, *Understanding Media: The Extensions of Man* (Cambridge, Mass.: MIT Press, 2001), 349.

8. McLuhan, 349.

9. Lewis Klahr, introductory notes to *Pony Glass*, Lux, lux.org.uk/work/pony-glass.

10. Charles Simic, *Dime-Store Alchemy: The Art of Joseph Cornell* (New York: New York Review of Books, 1992), 11.

11. Susan Stewart, *On Longing: Narratives of the Miniature, the Gigantic, the Souvenir, the Collection* (Durham, N.C.: Duke University, 1993), 56.

12. Tony Pipolo, "The Illustrated Man: Tony Pipolo Talks with Filmmaker Lewis Klahr," *Artforum*, March 2013, 244–45.

13. Lewis Klahr, interview by author, Andrew R. Johnston, on April 10, 2012.

14. Stewart, *On Longing*, 135.

15. Lewis Klahr, "Inevitability of Forgetting: Films of Lewis Klahr—Memory and Collage," introductory notes to film screening by San Francisco Cinematheque (in association with the Cinema Department of San Francisco State University), August Coppola Theatre (SFSU), February 19, 2015, sfcinematheque.org/screenings/inevitability-of-forgetting-films-of-lewis-klahr-memory-and-collage/.

16. Paul Ricoeur, *Time and Narrative*,3 vols., trans. Kathleen McLaughlin and David Pellhauer (Chicago: University of Chicago Press, 1990), 1:52 (italics original).

17. Klahr, "Flotsam and Jetsam," 395.

18. Pipolo, "The Illustrated Man," 248.

19. Lewis Klahr, introductory notes to *Sixty Six*, Lux, lux.org.uk/work/sixty-six.

20. Melissa Meyer and Miriam Schapiro, "Waste Not, Want Not: An Inquiry into What Women Saved and Assembled—FEMMAGE," *Heresies* 1, no. 4 (1977–1978): 66–69. Klahr met and was friends with Meyer since the early 1980s and routinely found inspiration in her abstract work (email from Lewis Klahr to author, Andrew R. Johnston, on April 21, 2019).

21. Linda Williams, *Playing the Race Card: Melodramas of Black and White from Uncle Tom to O. J. Simpson* (Princeton, N.J.: Princeton University Press, 2001), 31.

22. Walter Benjamin, "Mickey Mouse," (1931), trans. Rodney Livingstone, in *Selected Writings*, vol. 2, *1927–1934*, ed. Michael W. Jennings, Howard Eiland, and Gary Smith (Cambridge, Mass.: Belknap, 1999), 545.

23. Walter Benjamin, "Old Forgotten Children's Books" (1924), trans. Rodney Livingstone, in *Selected Writings*, vol. 1, *1913–1926*, ed. Marcus Bullock and Michael W. Jennings

(Cambridge, Mass.: Belknap, 1996), 408. For more on Benjamin's analysis of mimesis in relation to children's play with things, see Miriam Bratu Hansen, *Cinema and Experience: Siegfried Kracauer, Walter Benjamin, and Theodor W. Adorno* (Berkeley: University of California Press, 2012), 149–51.

INDEX

25–26, 28–37, 43–46, 56–57; vector, 142, 162, 168, 177, 200; Worringer and, 48, 53–56. *See also* abstraction; gesture; hand of the artist
Lippit, Akira, 38, 41
Lipps, Theodor, 50–53
Loops (McLaren), 154
Louis, Morris, 34
lumia, 22, 64–74, 87, 97, 164; animation and, 74, 76, 79–80, 89; notational system, 70, 74, 91; photography and, 74; television and, 78; time and, 76, 80, 86–87. *See also* Clavilux; Wilfred, Thomas
Lye, Len, 21–22, 105, 147, 185; abstract expressionism and, 26, 28, 35, 63; abstract lines and, 26, 45–48; conceptualization of cinema, 35–37; direct animations with color, 25–26, 61; gesture and, 37–38, 40, 42; kinetic sculpture, 60–61; mimesis and, 30–31, 43, 52, 54–57

Machine as Seen at the End of the Mechanical Age, The, 6, 192
Maciunas, George, 131
MacKay, Donald, 149
Malevich, Kasmir, 113
Mallarmé, Stéphane, 121
Man and His Dog Out for Air, A (Breer), 44, 124
Manovich, Lev, 5–6
Man: The Unknown (Carrel), 81
Man with a Movie Camera (Vertov), 120
Marey, Étienne-Jules, 41, 189–91, 193–94
materiality: animation and, 8–9, 30–31, 125, 135, 226; celluloid and, 103; digital and, 183–87; history and, 213, 216–17, 221–23; information theory and, 149–53; lumia and, 66, 79; media and, 18–19, 236n56; medium specificity and, 31–35, 57; phenomenology and, 31; vital, 14, 132
Mathematical Basis of the Arts, The (Schillinger), 144
Matisse, Henri, 49, 124
Matrix I (Whitney), 205
Matter and Memory (Bergson), 84, 133

McCay, Winsor, 40, 177
McCloud, Scott, 125
McLaren, Norman: definition of animation, 4, 101, 202; direct animation, 46, 48, synthetic sound films, 154–55, 157; visual music, 160
McLuhan, Marshall, 216–17
media archaeology, 15–16, 235n44
medium specificity, 31–35, 57
Mekas, Jonas, 102, 112, 131
Mercury (Klahr), 224
Merleau-Ponty, Maurice, 48–50, 95, 99, 124
Meyer, Melissa, 226
Michaud, Phillipe-Alain, 213
Michelson, Annette, 17
Mickey Mouse, 44, 226
microfilm plotter, 177, 187, 192
Milaud, Darius, 165
Miller, Carolyn, 11–12
Miller, Dorothy C., 63
mimesis, 38, 121–22, 226–27; animation and, 30–31, 43, 120; color and, 89–90; hand of the artist and, 41–43, 50, 55; lines and, 44, 46, 51–57. *See also* empathy
modernism and modernity, 16, 32–33, 57; painting and aesthetics and, 32–34, 48–50, 63, 113
Moholy-Nagy, László, 18, 144, 154
Mondrian, Piet, 113, 182
montage, 113, 115–17, 120–21, 128; rapid, 100–104, 134, 222
Montfort, Nick, 184, 186
Mood Contrasts (Bute), 147, 168
Moritz, William, 144
motion (movement): analog computers and, 171–72; animation's play with, 3–5, 13, 121, 221, 226; cinematic interval and, 22–23, 80, 101–9, 116, 128–32; color and, 65–67, 69, 86–87, 90–91; digital computers and, 177–82, 193–94, 196–97, 202–3; line and, 22, 26–31, 35–46, 49–51, 54–57; lumia and, 78–81, 89; Muybridge and Marey and, 189–91; optical devices and toys, 4–5, 103, 108,

ANDREW R. JOHNSTON is associate professor of film and digital media at North Carolina State University.